Texas CURIOSITIES

Praise for previous editions

"No one but John Kelso could find laughs in a tattooed pig, a beer can house, and a washing machine museum. But he did—and you will, too! You'll want it for your Yankee guests."

—Liz Carpenter, former press secretary to Lady Bird Johnson, and author of *Start With a Laugh*

"If Graham Greene lived in Austin, his name would be John Kelso."

—Kinky Friedman, humorist, musician, writer, and author of *Curse of the Missing Puppet Head*

"John Kelso has managed to find some seriously unusual Texas attractions that many chambers of commerce wouldn't touch with a pruning fork."

—Bud Shrake, screenwriter and author of *Billy Boy*

"Kelso drove 13,000 miles to find 'goofy' Texas stuff, and he didn't miss an oddity. Great fun!"

—*Texas Highways* magazine

"If you're looking for insight into the Texas mystique, this book could be the answer."

—*Morning News* (Dallas)

"Some of this you just have to see to believe. And even then, you'll wonder."

—*Morning Star-Telegram* (Dallas/Fort Worth)

Help Us Keep This Guide Up to Date

Every effort has been made by the author and editors to make this guide as accurate and useful as possible. However, many things can change after a guide is published—establishments close, phone numbers change, facilities come under new management, and so on.

We would love to hear from you concerning your experiences with this guide and how you feel it could be improved and kept up to date. While we may not be able to respond to all comments and suggestions, we'll take them to heart and we'll also make certain to share them with the author. Please send your comments and suggestions to the following address:

The Globe Pequot Press
Reader Response/Editorial Department
P.O. Box 480
Guilford, CT 06437

Or you may e-mail us at:

editorial@GlobePequot.com

Thanks for your input, and happy travels!

Texas
CURIOSITIES

QUIRKY CHARACTERS, ROADSIDE ODDITIES & OTHER OFFBEAT STUFF

JOHN KELSO

THIRD EDITION

INSIDERS' GUIDE®

GUILFORD, CONNECTICUT
AN IMPRINT OF THE GLOBE PEQUOT PRESS

INSIDERS' GUICE®

Text design by Nancy Freeborn
Layout by Debbie Nicolais
Maps by Rusty Nelson © Morris Book Publishing, LLC
All photos are by the author, except the following: p. 2: courtesy of David Amsberger; p.
4: Ralph Barrera, courtesy of *Austin American-Statesman*; p. 14: courtesy of Cochran,
Blair & Potts; p. 25: courtesy of Gladys' Bakery; p. 34: courtesy of 4th Infantry Division
Public Affairs Office; p. 87: Mark Green, courtesy of Andy Feehan; p. 88: Jim Armstrong;
p. 102: Lisa Rankin; p. 127: Wally Kulecz, coutesy of Sashimi Tabernacle Choir; p. 129:
Erich Schlegel, *The Dallas Morning News*; p. 145: Gitlings & Lorfing; p. 160: Otto Moore
& Son; p. 180: Samuel R. Esparza; p. 234: Elaine Pearson; p. 238: graphic design by
Craig Denham, courtesy of Mike Woolf; p. 267: Rich Mann; p. 272: Bob Wade, bob
wade.com; p. 284: Susan Lanning, courtesy of Fire Museum of Texas; p. 288: courtesy
of Great Texas Mosquito Festival; p. 333: photo by Jim Willett.

ISSN 1549-6090
ISBN-13: 978-0-7627-4109-0
ISBN-10: 0–7627–4109–0

Manufactured in the United States of America
Third Edition/First Printing

Thanks to my new wife, Kay, and daughter Rachel for keeping me smiling, providing inspiration, and laughing at my jokes and weird sound effects. And yes, Rachel, I'll enter the Shamrock beard contest if you'll clean up your room.

Patrick

I don't know why this type of book reminds me of you and I mean this in a positive way. Your curiosity always amazes me.

Enjoy +
Love
 Tom

Acknowledgments

I'd like to thank all of my bosses at the *Austin American-Statesman* for giving me the time to put this book together. Special thanks to writer Joe Nick Patoski for providing tips on places to visit around the state. Thanks to Alberto Martinez at the *Statesman* for calling the old man in South Texas to make sure the little shrine with the Camaro in it still exists. Thanks to all of the people who took the time to chat with me and therefore made this book possible. And thanks finally to the bartender at the He's Not Here Saloon in Lubbock who didn't hang up on me after the previous bartender had hung up on me five times in a row.

TEXAS

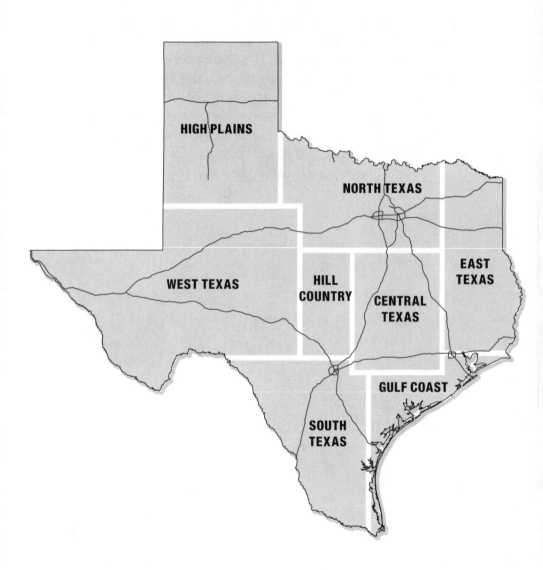

HIGH PLAINS

NORTH TEXAS

WEST TEXAS

HILL COUNTRY

CENTRAL TEXAS

EAST TEXAS

GULF COAST

SOUTH TEXAS

Contents

Introduction

Well, here we go again, updating *Texas Curiosities,* a book that has taken on a life of its own and is now six years old.

Speaking of that, we've suffered some sad losses in the *Texas Curiosities* family in this, the second redo of this book—making this the third version. Some of my favorite items in the book have gone toes-up, so we've had to remove them from the pages of this book. Each time one of these places disappears, it's kind of like losing a crazy uncle.

Which has led me to come up with the *Texas Curiosities* Hall of Fame.

To make it into the Hall, the *Texas Curiosities* item has to cease to exist, and leave behind a treasured legacy. The idea is to honor posthumorously those quirky museums, folks, vacation spots, or whatever that used to be featured in this book but are no longer with us.

You probably thought I meant to say "posthumously," but because of the nature of this silly travelog, I figure posthumorously fits the storyline better.

Our first inductee into the *Texas Curiosities* Hall of Fame is Ted Kipperman's Pawn Shop & Wedding Chapel in Houston. Sadly, the place is now just a regular old pawn shop called Mr. Money Pawn Eleven. Previously, when Ted Kipperman owned it, it was a unique combination business—a pawn shop with a small wedding chapel in the back and a backdrop consisting of a colorful mural of Niagara Falls. So even if you couldn't afford to honeymoon in upstate New York, you could get hitched by Kipperman with a likeness of the famous falls in the background—without the worry of having to go over something tall, wet, and life-threatening in a barrel.

Although some might describe matrimony in just those words. Anyway, years ago Kipperman got his chaplain's license when he noticed that the used wedding rings people were pawning at his store weren't

Introduction

exactly leaping off the shelves. So, he figured if he started marrying people in his pawn shop, that might pick up sales and get rid of those used rings.

I liked the way Kipperman, who was a bigger ham than the ones you'll see on the table on Easter, had huge likenesses of himself in his red and white marrying robes painted on the outside walls of his building.

Now here was a man who knew self-promotion. I remember the day I spent with him when I met him back in 1999. He kept insisting I take more pictures of him. I thought I was going to have to bribe him to get him to let me leave. I tried

A few of the good old boys.

to explain to him there would probably be just one photo of him in the book and we didn't really need to keep taking his picture all over the property. But he just kept posing all over the place until I'd burned up nearly two rolls of film.

Then there was the little red and white guard shack in front of the place that Kipperman said was for drive-through weddings. I'm not sure how often he really used the little building for that purpose. But I always I wondered after seeing it if there was any place in America where you could get a drive-through divorce. Anyway, Kipperman's Pawn Shop & Wedding Chapel is now part of Lone Star State oddball history. I miss the place dearly.

Another wacky icon that has shuffled off and left us standing here in the lurch? How about Harvey Gough's 800-pound statue of Lenin, the one that used to stand in front of his burger joint, Goff's Charcoal Hamburgers, on Lovers Lane in Dallas. The cheeseburger joint has moved to another location. But Lenin didn't make the trip. The guy who answered the phone at the cheeseburger place said the statue had been sold to a restaurant in Arkansas. I hate it when places like Arkansas beat Texas in the culture wars.

Gough is perhaps the most annoying man in the entire state of Texas, and darned proud of it. He'd say to his customers, "Do you want that Coke in a bag to go?" and if the poor schlep at the counter said yes, Gough would just pour the Coke in the bag, like it was funny. He was also a former National Guard guy who thought communism was a piece of garbage. So he put a sign on his Lenin statue that said, AMERICA WON.

Pity. It may have been the only Lenin statue in America that had a sign on it that said, AMERICA WON.

Gough sure went to some trouble to get it back to Texas from the former Soviet Union. He drove all the way from Germany to the Ukraine shortly after the fall of the Iron Curtain to find the thing and pay $500 it.

Introduction

Then he had it shipped back, which cost him another $5,500.

Another major loss, and thereby a *Texas Curiosities* Hall of Fame inductee: Ron L. Sitton is no longer working at the Fort Worth Stockyards with his Longhorn steer, Shiloh, who was trained to turn his head toward the camera when it was time to snap a photo. See, Sitton used to "sit on" Shiloh on the stockyard grounds so the tourists would have something to take pictures of. Get it? A guy named Sitton makes a living by "sitting on" a steer. As they say in the e-mails, "hahaha."

But life goes on, and we've found enough new material to take the places of those we've left behind. We've got a museum in Bandera that features the shrunken head of an Ecuadorian woman; a gigantic concrete structure in dusty Monahans that used to store oil but later was stocked with trout that died from a lack of vegetation; Willie Nelson's golf course where a foursome can be as many as twelve; Texas gubernatorial candidate, author, and character Kinky Friedman's outrageous but successful hiccup cure (him being Texan, it involves money); a bar in Austin where people bet on chicken poop; a cheating scandal at a major chili cookoff; a writing scandal in a small town that still chaps the local newspaper editor; and all manner of other fascinating stuff.

So sit back in the front seat and join me once again as we romp around the Lone Star State, looking for goofy stuff. I'll drive and you watch the map.

CENTRAL TEXAS

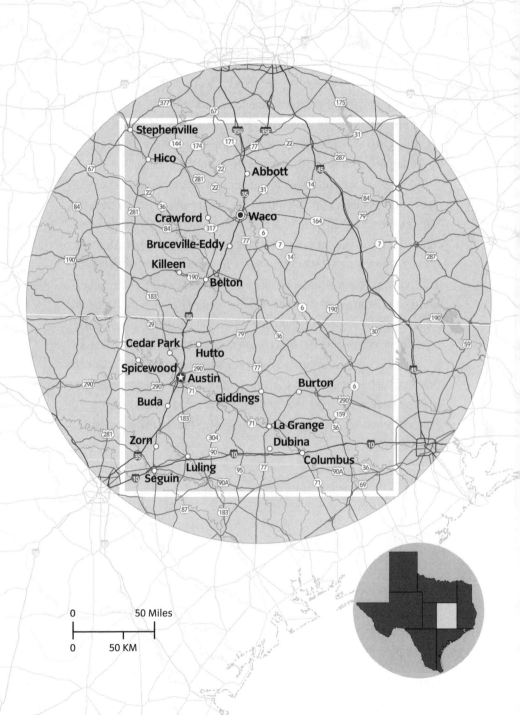

Stephenville

Hico

Abbott

Crawford

Waco

Bruceville-Eddy

Killeen

Belton

Cedar Park

Hutto

Spicewood

Austin

Burton

Buda

Giddings

La Grange

Zorn

Dubina

Columbus

Luling

Seguin

0 50 Miles

0 50 KM

CENTRAL TEXAS

Hey, Abbott!
Abbott

No, this town of about 300 a couple miles off Interstate 35 (FM 1242) is not located next to Costello.

Don't come here looking for Willie Nelson stuff, even though the music giant has a house here and visits occasionally when he isn't on the road (again). The town has no Willie Nelson T-shirt shops, no sign that mentions him, nada. There used to be a billboard out near Interstate 35 that had his face on it, but it's long gone.

"That's exactly the way he wants it," said superintendent of schools Terry Timmons.

If you go by the high school, you can track down the 1950 high school yearbook and find Willie in it, although in the book Nelson is referred to as Willie Hugh Nelson. Willie graduated from Abbott High in 1950. By thumbing through the book, you'll find young Mister Nelson was a pretty busy and versatile kid.

He was number 15 on the football team. The yearbook shows a photo of Willie with his arm cocked, ready to toss a pass. He played baseball and volleyball, was a guard on the basketball team, ran track, worked a couple years on *The Spotlight*, the school newspaper, and, not surprisingly, was the Future Farmers of America songleader.

When Willie comes to town, it's no big deal to the locals, or to him, either. He's just one of the neighbors. "Unless you see him or his pickup, you don't know he's here," Timmons said.

Spamarama
Austin

An outlandish spoof of the traditional Texas chili cook-off, this annual rite held early each spring has featured every dish you could conceivably cram Spam into.

Among the entries, says founder David Arnsberger, have been Spam wurst, Spamchiladas, Spambo (Spam gumbo), Spamalama Ding Dongs, moo goo gai Spam, chicken-fried Spam, Spamachini Alfredo, Piggy pâté, and Spamish fly—a Waldorf salad in which the raisins served as the flies. "Then there's the whole array of cocktails, like the Tequila Spamrise," Arnsberger noted.

Each dish must have some Spam in it to qualify. Spamarama, which celebrated its twenty-fifth year in 2003, also has the Spam Olympics, games played with Spam, such as the Spam Cram. Whoever can eat a twelve-ounce can of Spam fastest wins. The record is sixty-six seconds.

Wayne Roberts presents his Spamagator Gumbo.

Spamarama has even had songs written about it. Sing along to "Mister Spam Man," to the tune of "Mister Sandman":

"Mister Spam Man, make me a dish,
I'm tired of pot pie, and tunafish.
Want eggs and Spam, not eggs and bacon.
What's that new Spam dish that I smell you makin'?"

The most disgusting entry so far? Arnsberger nominates Spampers: a three-month-old girl wearing Pampers smeared with a mix of "Spam and mustard and whatever else pureed in a blender so it looked just like baby . . . poop." The judges lost it on that one, Arnsberger recalled.

For information, try www.spamarama.com.

Famous Cross-Dresser
Austin

Leslie Cochran's digs certainly improved in the year 2002.

Previously, Austin's most notorious homeless cross-dresser—known for hanging out in a thong, literally and figuratively—set up shop downtown on the sidewalk in front of the One American Center, at Sixth and Congress, in the very heart of the city, where he drove some downtown business leaders crazy.

But when the opportunity arose, Leslie, three times an Austin mayoral candidate, moved into a five-bedroom, four-bath house in posh West Lake Hills, just west of Austin. The house even has a swimming pool in its lovely tree-shaded yard. "I spend most of my time by the pool," Leslie said. "I love the pool house. The pool house rocks. It's got something someone of my caliber needs. It's got a bar."

How did Leslie, who has a great set of legs and favors miniskirts, spiked heels, and a matching tiara, move into such a swank place? Well,

it isn't really that swank. The house, owned by homeless advocate Cindy Brettschneider, has mold. Cindy, who was trying to sell the house for $335,000, is allergic to mold. Leslie, who is accustomed to toxic filth, is not. So Cindy moved out and Leslie moved in.

Is Leslie showing off the house to people who come around with intentions of buying it? "No, I don't," he said. "I *did*, but I was asked not to." Hmm . . . Imagine that.

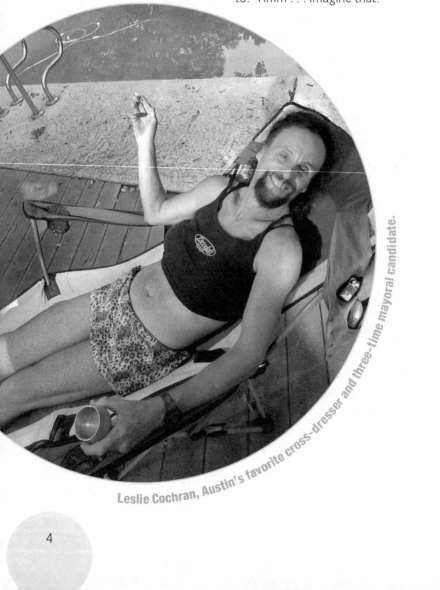

Leslie Cochran, Austin's favorite cross-dresser and three-time mayoral candidate.

SERIOUS SPORTS FAN

The last time Austin attorney Scott Wilson missed a University of Texas football game was in 1977, and he had a good reason.

At the time he was moving into the house he still lives in. Since then, Wilson has attended about 350 UT football games in succession. He's been to every single game for the last twenty-eight-plus seasons—home games, away games, and bowl games. He's traveled to Los Angeles, Pittsburgh, Syracuse, Lawrence, Kansas, and Honolulu to watch the Longhorns, just to name a few of the spots.

Wilson drives to many games in a 1975 burnt orange Cadillac with steer horns mounted on the front. Though a Caddy, this is not a fancy car. There's a wasp's nest in the trunk, Wilson said, adding, "It's been there for a couple of years."

So what would make Wilson miss a game? "That has not been found yet," he said. Keeling over dead comes to mind.

Wilson has season tickets to seven UT sports. It would take a major disaster to keep Wilson from making it to a game.

Once, while Wilson was driving from Austin to College Station for a Texas–Texas A&M basketball game, the engine of his '82 Honda burst into flames. Wilson and his friends dumped a cooler full of ice on the engine, but it didn't do the job. So they opened several beers and poured the contents on the engine to douse the fire. Then they left the car by the side of the road and hitchhiked the rest of the way. They made it to the game by halftime.

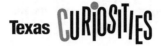

The O. Henry Pun-Off World Championships
Austin

"The best kind are the kind where somebody comes up with something off the top of their head that's almost too good to come off the top of your head," said Gary Hallock, master puntificator and man in charge of Austin's annual groanathon.

An example? The subject was religion and the punsters had to address that subject in pun. The competitor made up a quote as if it were coming from the skinny lips of Nancy Reagan. "The problems with the economy? They're all Deuteronomy," the punster said.

Due to Ron and me. Get it?

The event, held the first weekend in May in honor of short-story writer O. Henry, began in 1977 and attracts large crowds. "They just keep coming back because everybody is so annual retentive, you see," Hallock explained. "The throngs get larger each year, but we don't want more than one throng every year because two throngs don't make a right."

Punsters can compete in two events. In Punniest of Show, entrants get ninety seconds to do a prearranged program. In High Lies & Low Puns, punsters square off against each other two at a time. They're given a topic at random, and they get five seconds to come up with a pun on the subject. When you come up punless, you're through. The last punster standing wins.

The Capital City of Texas is the perfect spot for this event, since, being the home of the University of Texas, it's full of smart-asses and intellectuals—self-proclaimed or otherwise. "Austin is a mecca for pun-sters," Hallock explained. "So sooner or later you've got to get down here so you can meet your mecca."

This doesn't mean you have to be a punster to come and enjoy the program. "We don't mind people who are not punsters in the audi-

ence because we can enroll you in our Witless Protection Program," Hallock said.

Glutton for punishment? Call the O. Henry Museum at (512) 472–1903. Or try www.punpunpun.com.

Roadkill Hat Maker
Austin

In Austin, which bills itself as the "Live Music Capital of the World," you'll find plenty of eccentric musicians. But the late John "Mambo" Treanor was probably the only one who made hats out of roadkill.

So if you saw a guy with a fur hat on that had a Goodyear skidmark on it, it was probably Treanor.

"Some people get mad, but once you explain it was an accidental death, they don't get too mad about it," said Treanor, a percussionist who worked for Grammy Award nominee Abra Moore and others. The raccoon, jackrabbit, and skunk hats were made from 1991 to 1993, while Treanor was serving time for growing marijuana. A cat hat followed soon after. "I found it over here at Twelfth and West Lynn," Treanor said. "People say, 'Twelfth and West Lynn, is that a boutique?' And I say, 'No, Twelfth and West Lynn, by the curb.' "

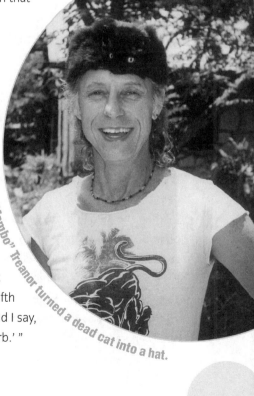

John "Mambo" Treanor turned a dead cat into a hat.

Treanor made these hats for his own personal use. Apparently, there is no market for roadkill hats.

Treanor started skinning roadkill and tanning the hides in the joint to give himself something creative to do. He'd find the animals by the side of the highway while he was picking up trash as part of the landscaping detail.

He had intended to spend his time in prison practicing his music in the prison's music room. But then the prison had no music room.

"What else was there to do?" he asked.

Treanor died in August 2001 after a long battle with cancer.

Fowl Play on the Pool Table
Austin

If you want to watch a chicken unload and maybe win a little money at the same time, the place to be on Sunday afternoons in Austin is Ginny's Little Longhorn Saloon on Burnet Road.

That's when hundreds of people jam into the tiny bar to play Chicken (Poop) Bingo, a game of chance in which people buy raffle tickets and hope Red the chicken goes on their number.

The game begins when bar owner Ginny Kalmbach walks out back of the joint and brings Red the chicken inside the bar from his outside pen.

Then she puts Red on the pool table on top of a numbered sheet of plywood. There are fifty-four 3-inch squares. People line up to buy fifty-six tickets at $2.00 a pop—as opposed to $2.00 a poop. Fifty-four of the tickets are for the numbers, and two additional tickets are sold in case Red drops his package on a line, or on two lines crossing.

There is no way to bet that the chicken won't go, because that's nearly an impossibility anyway.

If the chicken covers your spot, so to speak, you win $112. The house doesn't get a cut because that would be against the law, and the police might come and stick Red in the pen.

And no, the chicken doesn't have any choice whether it takes part or not, even if it's embarrassed about the situation. It's kept on top of the pool table underneath a chickenwire cage.

The funny thing is that Austin bills itself as an intellectual town, a city of bookworms and cappuccino drinkers. But on Sundays it's standing room only inside Ginny's to watch a chicken go to the bathroom. Go figure.

Hope "Red" doesn't go now!

Ginny says the concept for the game came from country and western musician Dale Watson, who commonly performs at Chicken (Poop) Bingo.

"He came up with the idea," Ginny said. "And he asked my husband [Don], 'What do you think about it?' And I didn't know what they were talkin' about at first."

I wouldn't admit I knew what they were talking about, either.

Mexican Free-Tailed Bat Colony
Austin

Question: What critter has the biggest population living under the Congress Avenue Bridge?

Answer: Before 1980, if you had said "wino," you would have been right.

In 1980, construction on the bridge created a 18-inch-deep, ¾- to 1½-inch-wide crevice under it, the perfect size for pregnant bats to hang out in and give birth. In the summer, 1.5 million bats live under the bridge, making it North America's largest urban bat colony.

When the bats emerge from under the bridge at sundown, tourists flock to watch at a bat-viewing area near the bridge on the south shore of Town Lake.

The bats can consume up to fifteen tons of insects a night, according to Arnie Phifer, formerly of Bat Conservation International.

The bat colony has caused a lot of batphernalia to spring up around Austin. The city has a bat statue, which turns in the wind, near the bridge. Saks Fifth Avenue used to sell an Austin snow globe—shake the globe and instead of snow, tiny bats fly about. The *Austin American-Statesman* newspaper has a "bat hotline" (512–416–5700, ext. 3636) that provides bat updates.

The city's minor league hockey club is named the Austin Ice Bats. The Austin Public Library has a mascot bat named Echo for its children's programs.

Concrete Yard Map of USA

Austin

"Everything in here is a symbol of something, to remind you, to make you aware, to make you think," said retired elementary school teacher Ira Poole. "And make you appreciate, hopefully. I show my appreciation anyway."

Poole's busy front yard, which he began decorating in 1964, is something to appreciate, if you love yard art. Poole made a concrete map of the USA, but he didn't include Alaska or Hawaii on the face of it. So Hawaii and Alaska have stand-ins.

"This is Hawaii," Poole said, pointing to a cluster of bushes near the map. "And this big rock here is Alaska," Poole added, speaking of a large stone that stands behind the concrete map. The map is probably 4 feet high and 12 feet across, from California to Maine.

You can't miss Ira Poole's house. Look for the concrete map of the USA and the Statue of Liberty.

Poole introduced the map and the adjacent Statue of Liberty to the press in his front yard on July 3, 1987, to commemorate the 200th anniversary of the writing of the U.S. Constitution. "I thought it would be nice if I just got the people to think about the future we have living here in the United States, the past of the United States, and the future for our youngsters who are living in the United States today," he said.

Poole found the metal Statue of Liberty at an antiques shop on Interstate 20 between Dallas and Shreveport, Louisiana. It is holding aloft a yellow torch. Poole shines a light on the map so passersby can see it at night. Underneath the base the statue stands on you'll find a sea shell–shaped fountain and birdbath, which represents Niagara Falls, according to Poole.

You can visit Poole in Austin at 2400 East Martin Luther King Jr. Boulevard. Incidentally, Poole's yard is featured prominently in a made-for-TV documentary series called *Weird Homes* showing on Canadian TV.

Corn Artifact Collector

Austin

"You cannot look anywhere in this house and not see corn," said Art Edie, who figures he has collected 600 to 700 corn artifacts in his lifetime.

We're talking about things shaped like ears of corn or designed with ears of corn on them. He has a corn pencil sharpener, corn refrigerator magnets, a ceramic corn-shaped bell with a ceramic chicken for a handle, corn Christmas ornaments, the cover from an old *Mad Magazine* that shows Alfred E. Newman eating an ear of corn, a brass corncob door knocker, corn china, and corn soup tureens.

"I don't even know if this thing works," Edie said as he cranked up a small windup toy that looks like a smiling ear of corn. It does, but slowly; it's a geriatric corn windup toy.

"We pretty much live with corn, don't we, honey?" Edie said. "Yes, we do," Molly, his wife, replied matter-of-factly.

There's a corn cookie jar, a ceramic ear of corn with a ceramic mouse riding on it that a friend brought back from France, and even a plate from the Corn Palace in Mitchell, South Dakota, a tourist attraction that is a monument to all things corn.

Edie got into corn at an early age, growing up in Davenport, Iowa. "My first job was detasseling corn," he recalled. That was at the age of eight, but he recalls it well. "You take the tassels off when you want it to go to market; you leave the tassels on if it's going for [pig] feed."

He remembers the time when he was a teenager that his grandmother was about to throw out a corn-shucking device. "She was gonna get rid of it and I said, 'I'll take it, I'll take it.'

"I guess there's just a lot of things about corn that fascinated me," Edie explained. "Like, they can't even find its origin and it can't be associated with any other plant."

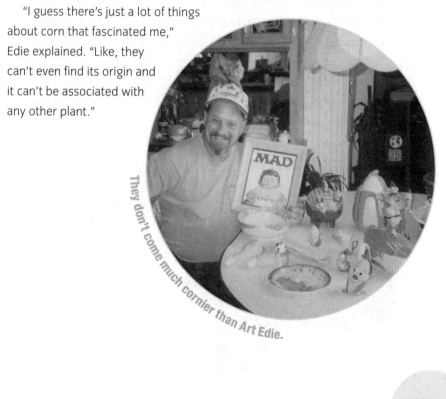

They don't come much cornier than Art Edie.

Cochran, Blair & Potts
Belton

Commonly, ancient stores have dusty inventories to match. But Cochran, Blair & Potts, the oldest department store in Texas, located at 221 East Central in Belton (254–939–3333), is actually a working business. Hey, it ain't Saks, but they do have Red Wing shoes.

Ironically, the store is located near the Texas Department of Aging. "Course, the thing of it is, these locally owned stores are biting the dust," said Shirley Brock, who works in the store's ladies' apparel department. "A lot of times the heirs don't want to have anything to do with it and let it go."

That's not the case here. The store, opened in 1869 in Centerville, has been passed down in the same family for six generations. The founder, Colonel H. M. Cook, was a Confederate colonel. The current president is Robert Roy Potts, Cook's great-great-great-grandson.

The square hole in the ceiling through which cashiers raised the money to the office on the second floor is still there. But the basket and that change-making system are long gone. "Oh yeah, we use computers," Brock said.

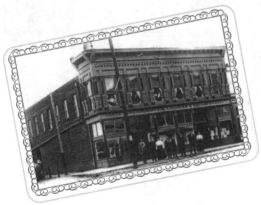

The oldest department store in Texas.

Upstairs in the store museum (no admission charge), you'll see a bunch of old ledgers, typewriters, store tokens, and an ad from a 1923 edition of *The Belton Journal* for the store's Dollar Day Specials—eight towels for a buck, eight bath rugs for a buck.

The store puts out a brochure that outlines its history and lists employees by name, position, and how long they've worked there. Elsie York, an honorary bookkeeper who still comes in occasionally, has worked at the store since 1937.

The Statuary on Interstate 35

Bruceville–Eddy

During the summer of 1998, Kevin Barker had a next-door neighbor problem. His three-acre yard full of concrete yard critters—everything from apes to alligators—sat next to a rental portable toilet business. When you're dealing in yard art, being next to something like that detracts from the beauty of your creations.

"It's not exactly what you'd want to see or smell," said Barker, whose business is on the Interstate 35 access road. "They were rentals. They would bring 'em back used."

By 1999, though, the toilet business was gone and things were rosy at Barker's yard, where you can buy elephants, bears, horses, dinosaurs, yard trolls, pelicans, sailfish, angels, ostrich, deer, and gargoyles.

The largest items on the lot are the 12,000- to 14,000-pound rhinos and hippos. Of course, you can't get one of those in your Suburban. So Barker will come to your house and pour it in your yard for you.

A rhino or hippo will set you back $2,500, if you take it away yourself. If Barker comes to your Texas house and makes it there, the price

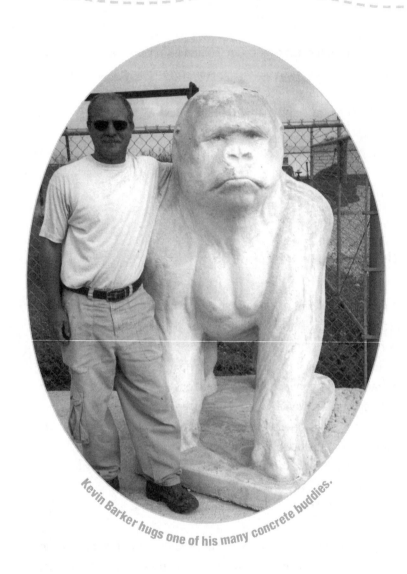

Kevin Barker hugs one of his many concrete buddies.

runs around $3,000. " 'Course, if I have to go to Colorado, it's going to have to be a little bit more," Barker said.

Barker is proud of the fact that the business is "ever-expanding" and now sells a new 8-foot fiberglass chicken.

Ready, Set, Blow!

Burton

"I understand . . . they're going to make bubble-gum blowing a competitive event in the Olympics," said school teacher Mary Zorn, emcee of the bubble-gum blowing contest at the tenth anniversary of Burton's Cotton Gin Festival.

Contestants—there are divisions for both kids and adults—line up on a stage set up under a big tent. Mary hands them the gum. She gives them a while to work it over in their mouths. Then she says, "On your mark, get set, blow bubbles."

Whoever blows the biggest bubble wins. At this contest a panel of grandmotherly ladies sitting in lawn chairs with their feet up on hay bales did the judging.

"Come on, Justin—blow!" a woman in the crowd screamed at a little boy who was competing in the twelve-and-under division.

"Bubble gum blowing is a very individualized sport," Mary explained. "Some people like to chew two or three [pieces of gum]. Some people like to get their mouths so full they can't say their name."

The festival is held in the spring to raise money for the town's 1914-vintage cotton gin. Tours are available daily. Group tours are available with twenty-four hours notice. Visit www.cottonginmuseum.org.

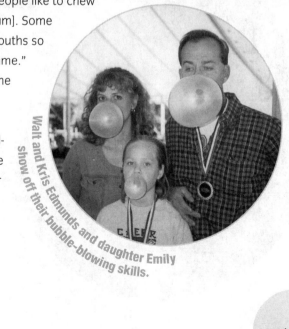

Walt and Kris Edmunds and daughter Emily show off their bubble-blowing skills.

17

Fun with the Furry

Cedar Park

Allie Berry puts baby possums in her brassiere. "I can walk around all day long with them in there," she said. No, this is not part of some exotic dance routine. It's to help save baby animals.

Allie, who works at the Lone Star Animal Clinic in this Williamson County town, is a very dedicated animal rescue worker. Now let's say somebody finds a mother possum dead beside the road, with a bunch of live babies. The person who found the babies can call Allie, and she'll take them in and see that they have a warm place to stay. Like, say, in her bra.

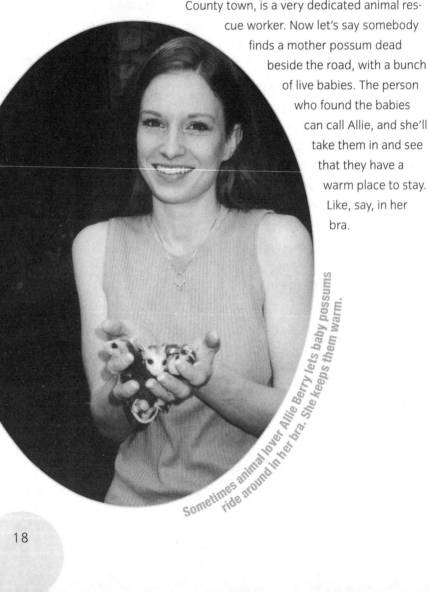

Sometimes animal lover Allie Berry lets baby possums ride around in her bra. She keeps them warm.

"Just whenever the babies come in, it's the easiest way to warm them up," she explained. She has even driven around for hours with animals in her bra.

Doesn't this itch? "No," Allie said. "They get grabby, and sometimes it's a little much. 'Cause when they're on their mom, they have to get grabby. It's instinct. So you just kind of write it off as the thing that's going to happen every now and then." What's the record number of baby possums in her bra at one time? "The most I've had at one time was twelve," Allie said.

Allie has also helped rescue baby squirrels, cottontail rabbits, and kittens by putting them in her bra. She figures over the past six years she's stuck baby critters in her bra seventy-five times.

"The hardest to deal with in my bra are the squirrels," Allie said. "The possums are actually the easiest. They're adorable, beautiful little animals, and since they're used to being in a pouch with their mom, they're used to the feeling. The squirrels, they're not used to it. They're moving around, and every once in a while you hear them squeaking."

Jerry Mikeska's Bar-B-Que
Columbus

Texans love to decorate with dead animals. Perhaps no small businessperson has done it so overwhelmingly as Jerry Mikeska, who has about 175 taxidermied critters in his barbecue place on Interstate 10 off exit 698 (979–732–3101).

This is not the place to eat if you don't like a lot of eyes staring at you.

Among those who cover the walls in the restaurant are moose, squirrels, raccoons, deer, goats, a chicken, wild hogs, fish, elk, mountain lions, and a cape buffalo. Diners are greeted at the front door by a

pair of standing bears holding wicker picnic baskets. It reminds you of that old song from the Big John and Sparky radio show: "Today's the day the teddy bears have their picnic."

Mikeska, who has been in the barbecue business fifty-seven years, says he's only had two complaints from diners in the sixteen years he's been at the current location.

"They just said they didn't like 'em," said Mikeska, a dapper man who always wears a bow tie to work. "I apologized to 'em. But I said, 'Chicken, fish, if you eat 'em somebody's got to kill 'em.' I said, 'Even vegetables have some sort of a life.'"

Mikeska is a hunter, but this is, after all, furniture—at least in the Lone Star State. So Mikeska has bought most of the animals he displays instead of having bagged them himself.

When people want to sell their hunting trophies, friends often tell them, "Hey, there's a barbecue place in Columbus—you can sell 'em over there," according to Mikeska.

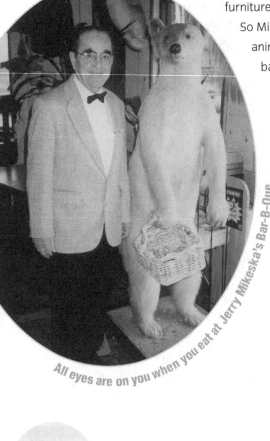

All eyes are on you when you eat at Jerry Mikeska's Bar-B-Que.

CENTRAL TEXAS

Hail to the Cutout
Crawford

You can get your picture taken with the president of the United States at the Coffee Station in Crawford (pop. 705), even when the president isn't around. Crawford is the town near George W. Bush's ranch, the so-called Western White House.

The Coffee Station (254–486–0029) keeps two nearly life-size cardboard cutouts of Bush in the place. The night I visited, one was in the gift shop/convenience store side of the building, on the way to the rest rooms, wearing a souvenir Coffee Station/George W. Bush apron. The other one was standing against the wall in the dining room, next to similar cutouts of former President George H. W. Bush and First Lady Barbara Bush.

Has anybody ever drawn a mustache on one of the George W. Bush cutouts? "No, no, we don't allow anybody to do that," said Kirk Baird, former owner of the only restaurant in town. "We're pretty protective of him." So even in Crawford, security is tight.

People come in all the time to get their photos taken with the cutouts. They say Bush is a little wooden when he speaks, so who would notice the difference? "They get a picture of him here, whether he's here or not," Kirk said. You can move the cutouts around, if you want a different background. The things have been messed with so much that one earlier cutout was worn out by excessive handling. "Just wear and tear," Kirk said. "Cardboard only lasts so long."

This place is just lousy with George W. Bush/Coffee Station T-shirts, mugs, caps, hand towels, even throw rugs. "A friend's brother-in-law makes those," Kirk said of the rugs. Since Bush became president, the Coffee Station has sold 4,000 or 5,000 such T-shirts and 2,000 or so coffee mugs. The president even helps advertise the place when he jogs. "He wears our stuff out at the ranch and runs with it," Kirk said.

21

Crawford has capitalized on Bush's connection to the town. In the summer of 2005, business in the restaurant increased because of the hordes of people in town for the anti–Iraq war protest of Cindy Sheehan. Regardless of point of view, management was glad to see them.

"We presented them with a menu, just like if you came in here," said Dorothy Spanos, who owns the place with her husband Nick. "There were some of 'em who came in here every day that we became not on a first-name basis with but, 'Hey, how are you?' They kept their opinions to themselves when they were in the restaurant." She added that she wasn't sure if Sheehan made it into the place or not.

The real George W. Bush has been in the Coffee Station three times, according to Kirk. He orders a cheeseburger, onion rings, and a diet Coke. He apparently does not get pretzels.

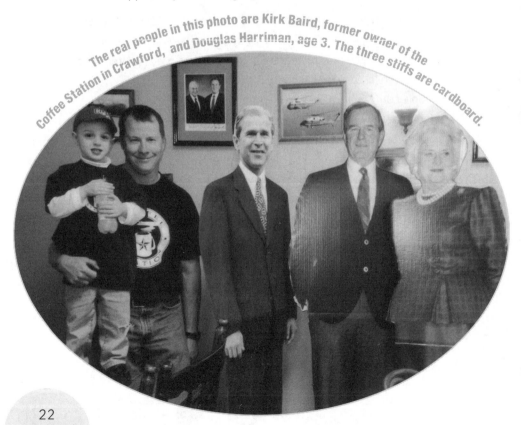

The real people in this photo are Kirk Baird, former owner of the Coffee Station in Crawford, and Douglas Harriman, age 3. The three stiffs are cardboard.

Seafood and Doughnuts

Giddings

Got a hankering for a lobster tail, and a doughnut with pink frosting on the side? Is this the kind of sick puppy you are?

Then the place to go is the Fresh Donuts & Seafood Restaurant on U.S. Highway 290 in Giddings, across the highway from the water tower and Dan's Discount Liquor Drive-Thru.

Not that this eatery normally serves those two items together. At five o'clock in the morning when the restaurant opens, it's mostly doughnuts. Later on in the day, the seafood kicks in. Roya Pheng, the waitress here, points out that the seafood and doughnuts are *not* cooked in the same grease. And no, no one ever gets doughnut sprinkles with their shrimp.

"They ask for it, but they're just kidding," she says. The place added seafood to the menu in August of 2005 after being in business for about six years with the doughnuts. Along with the seafood came the obligatory seafood restaurant decorations: the netting with the sea shells, and the talking battery-powered Billy Bass on the wall.

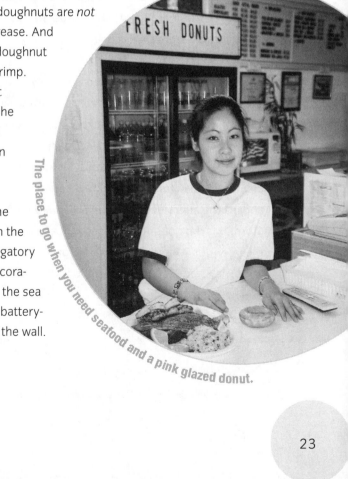

The place to go when you need seafood and a pink glazed donut.

WORLD'S LARGEST FRUITCAKE

I told Gladys Farek Holub, the Gladys in Gladys' Bakery in Dubina, I'd heard she makes a 150-pound fruitcake.

"Oh darlin', do I ever, and it's better than anybody else's," said Gladys, who's not shy. "It's about 50 percent pecans. I sent one to the Pope; I sent one to the boys in the Gulf. My bakery's in a pasture. I talk for a living."

The old joke that nobody eats fruitcake—that there's only one fruitcake on the planet, and that people keep shipping it back and forth to one another at Christmas—is disproved by Gladys.

Obviously, if there's a 5- by 6-foot, 150-pound fruitcake out there, there's more than one fruitcake. I say this because I have never seen a 150-pound fruitcake.

The fact that the fruitcake has to be 5 by 6 feet to weigh 150 pounds seems odd to me. As dense as fruitcake is, you'd think a 150-pound fruitcake would be about the size of a hand grenade.

Gladys has made twelve 150-pound fruitcakes, each one shaped like Texas. She made the first one for former Texas Governor Bill Clements's inauguration. She made another one for U.S. troops aboard the aircraft carrier *John F. Kennedy* during Operation Desert Storm. Maybe under the circumstances they should have renamed the operation Operation Dessert Storm.

"They said 7,000 boys ate it in forty-five minutes," Gladys said. "That's as fast as you can eat it."

Gladys made the big fruitcake for her appearance on *The Tonight Show.* "When I was on Johnny Carson, I talked so much he couldn't get a word in edgewise," Gladys said. "He said, 'What would you like to do after the show?' and I said, 'Take me dancin'.' "

Gladys mixes the 150-pound fruitcakes in a red cement mixer she keeps in the bakery. The concrete mixer is stainless steel. "If you don't say stainless steel, people will probably throw up," she said.

Along with normal-size fruitcakes, the big fruitcakes are for sale in Gladys's brochure. A 150-pound fruitcake will set you back $998. "I didn't ask $1,000 'cause I didn't want to be greedy," Gladys said.

Incidentally, Gladys and one of her 150-pound fruit- cakes made an appear- ance in the summer of 2002 in Six Flags Over Texas's Best of Texas Festival in Arlington. For the occasion, she wore a T-shirt that said, "I'm Talking and I Can't Shut Up."

For information, call (979) 263–5940, or try www.gladysfruitcakes.com.

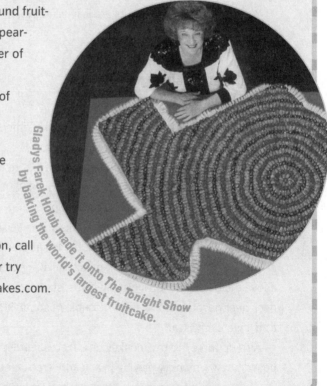

Gladys Farek Holub made it onto *The Tonight Show* by baking the world's largest fruitcake.

Roya says her mother, Than Touch, the restaurant's owner, decided to add seafood to the mix after she was talked into it by family members in Houston who are in the seafood business.

You're not going to find a much more eclectic menu than you'll run across in this joint. When you walk in you'll see a glass bakery case full of pigs in a blanket, eclaires, and kolaches. Look on the menu and you'll notice oysters, shrimp, scallops, catfish, flounder, Cajun gumbo, chicken-fried steak, Buffalo wings, even frogs' legs.

But the prices are reasonable and the food is pretty darned good— the seafood doesn't taste like doughnuts, and the doughnuts don't taste like seafood. "Everything from scratch—even the seafood," Roya said. "We batter it ourselves."

Yes, some of the doughnuts are jelly-filled. No, there are no jellyfish.

Don't Sit in His Chair
Greenvine

Some Texans are remembered for their works, others for sitting around and making sure the furniture doesn't fly off.

Late rancher Alton (Pido) Boehnemann, a fixture at The Green Door beer joint in this narrow spot in the road on FM 2502 about 10 miles west of Brenham, falls into the latter group.

Pido spent so much time sitting on his ample keister drinking Pearl or Natural Light in this place that the bar has retired his chair and put it on display. You can see the chair on a special shelf up in the rafters, above the bar, with Pido's playing cards, straw cowboy hat, and a long-neck beer decorating the seat. A couple of spotlights highlight the chair as if it were an Oscar.

Also up there is a toy monkey on a feed bag from the time Pido sup-posedly saw a monkey playing in a nearby creek feeder, a device that

hurls fish feed into the creek. Regulars at the bar had a hard time believing Pido saw a monkey out this way, since it's a long way to the jungle. So they used to give him a hard time about it.

"They said, 'Ain't no monkey around here,' " said Jerry Vaughn, the bar's owner. He adds, however, that the evidence may have favored Pido's story. "Turns out, there was a man named Old Smitty who had a pet monkey that got away," Jerry recalled.

Nobody in the bar seems to remember Old Smitty's full name, however.

Monkey or no monkey, hardly a day went by when Pido (pronounced Pie Dough) couldn't be found hanging out in here drinking a cold beer, camped out in the same chair. "He would come to the store almost every day. If he wasn't sick, he'd be here," said Vaughn said.

Pido died of a stroke in October 2005. So the next month, the bar enshrined Pido's chair in a ceremony that included a three-hog barbecue and a visit from State Representative Lois Kolkhorst (R-Brenham).

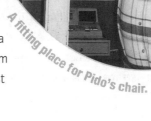

A fitting place for Pido's chair.

You know it's a real ceremony when the cooked hogs outnumber the state representatives three to one.

The chair probably should get extra recognition. After all, it was sat on by a 375- to 400-pound beer drinker. Vaughn says Pido got his nickname from downing groceries as a child.

"When his mamma would bake pies, he liked to eat the pie dough," Vaughn said. Raw, that is.

The story goes that Pido made his first visit to the bar as a baby on the day he was baptised, when his parents stopped in to get something to drink. So when people were sitting in Pido's chair and Pido came in, they would get up and give it to him. "Just out of respect, you know—I guess a seniority kind of rule," said Bob Knittel, a bar regular. "And he'd been drinking here longer than anybody else."

Nobody seems to remember Pido ever doing much in here. Mostly, they just seem to remember him being here, sitting on his derriere.

To get into the beer joint, you have to walk around to the back of the old white wooden building and come through the back door. Maybe this is because of the Baptist church across the road. Maybe the churchgoers don't want to be seen walking in.

By the way, Pido is conveniently buried in the cemetery across the road within eyeshot of the Green Door. For his burial, instead of riding to the cemetery in a hearse, Pido rode in a casket loaded onto the back of his pickup truck. Friends took the empty beer cans and feed sacks out of the truck bed before the casket was placed in it.

"They cleaned up the back of it, but they didn't clean up the inside," Knittel said.

The Green Door is the kind of Texas beer joint where a guy should have his chair put on display. A handmade sign on the bulletin board says, OLD TRACKTER RUNS GOOD, BUT HAS NO SEAT OR STEERING WHEEL. IDEAL FOR PEOPLE WHO HAVE LOST THEIR ASS AND DON'T KNOW WHICH WAY TO TURN. And on

the back of the Green Door T-shirt you'll find the philosophical message, MAKING THE WORLD A BETTER PLACE 12 oz. AT A TIME.

Pido, apparently, did his part to make the world a happier place. "He was here every day they ever opened," Knittel said. Hey, it's a dirty job, but somebody's got to do it.

Billy the Kid
Hico

Hico is ate up with Billy the Kid. Billy the Kid Day is held the first weekend in April, with mock gunfights, people dressed in Western clothing, and sometimes a cattle drive through town. A statue downtown shows Billy the Kid drawing down on somebody with a gun. There's a small Billy the Kid Museum that carries Billy the Kid T-shirts.

Why all the fuss about Billy the Kid? Well, for one thing, it brings tourists to Hico (pronounced HIKE-o). So to keep the visitors coming, the town promotes the legend that Billy died here. Green markers around town recount the story. Without Billy, there wouldn't be much reason to come to Hico.

"I guess Billy and our historical buildings are our only real tourist attractions," said Bob Hefner, who started up the Billy the Kid Museum, at 114 North Pecan Street (254–796–4004), in 1987. "So for our economy, he's been very good to us."

Widely accepted history says Billy the Kid was shot dead at the age of twenty-one in July of 1881 at Fort Sumner, New Mexico, by Sheriff Pat Garrett. Hefner says different. Hefner says Billy the Kid was really Brushy Bill Roberts, who keeled over of a heart attack on the sidewalk at the age of ninety on December 27, 1950, across the street from what is now the Rutledge-Jones Funeral Home.

So do people here really believe Brushy Bill Roberts was Billy the Kid, who had come to Hico to live out his final days? Hefner sure does.

"We can prove real easy Garrett didn't kill him," Hefner said. He says he's done research that shows a warrant went out for Billy the Kid's arrest the year after he was supposedly killed.

The Hutto Hippos
Hutto

Hutto is obsessed with hippos, not the real sort but the statuary kind. First, you've got a $2,000, 14,900-pound concrete hippo on East Street named Henrietta. Then there's Howdy, a $130, 250-pound hippo 18 inches in height who was introduced in 2002 at the town's Hippo Festival.

A new herd of hippos hit Hutto in the spring of 2003. Local businesses ponied up $5,300 for fifty-four concrete hippos that weigh anywhere from thirty to 725 pounds. The squatting, smiling statues can be seen all around Hutto, in front of schools, homes, and businesses.

But the most grandiose of the town's hippo plans never happened.

Hutto's Hippo Project Group had planned to build a $75,000 hippo named Hugo, which would have been 30 feet tall if you counted the 10-foot base. The hippo would have been the largest in the world, said former Hutto Mayor Mike Fowler.

But the suggestion to build the big hippo with sales tax money set off a couple of the town's City Council members, who didn't think using public funds would be appropriate for putting up a 15-foot-wide, 40-foot-long, 20-foot-tall fiberglass-and-steel hippo, possibly on school property, with its own lighting and landscaping and security measures.

So Hugo never occurred.

But this does not deter Fowler, who keeps seeing hippos on Hutto horizon.

"Hugo never happened, but we did deliver a life-size fiberglass hippo to the high school, and we've got three more coming," he said. "But at this point we're just glad to have one there."

Legend has it this all started in 1915, when a hippo escaped from a circus train in Hutto, to be found later wallowing in mud in Cottonwood Creek. Hutto got into the hippo statue game over ten years ago when the Chamber of Commerce put up Henrietta, a photo opportunity since she's equipped with a set of stairs so kids can climb up and sit on her. Henrietta has her own HIPPO XING sign, and she's so popular that people keep stealing her ears.

Fowler is nuts about the hippo concept. When it was suggested to him that Hutto might put so-called Hippo Humps—speed bumps that would look like the tops of hippo heads with big eyes—in its streets, he said he liked the idea. "Anything that enhances the hippo is something that would be very unique to this community," he said.

Hippo-happy former Hutto Mayor Mike Fowler waves howdy to a passerby.

Horn Tree
Junction

Don't lean up against this tree made out of antlers, steel reinforcing rods, and chicken wire, unless you want a hole poked in your jeans.

Texans tend to decorate with animal parts. So when members of the Kimble (County) Business and Professional Women's Club saw a fake tree made out of deer horns in 1968 at the World's Fair in San Antonio, they figured they had to create their own version for display in town.

"Some of the members came home and decided that's what we needed to do," said Frederica Wyatt, curator of the Kimble County Historical Museum. The Junction model stands about 15 feet high and has hundreds of sets of deer antlers, some of them with skulls still attached. Most of the horns are pretty bleached out, so the look is somewhat parched.

You'll find the deer-horn tree in front of Kimble Processing, a deer-processing plant.

Wyatt isn't sure exactly how many sets of deer antlers are on the tree. Let's just say it's covered.

"Oh goodness, I really have no idea," Wyatt said. "I know nobody could tell you. I don't think we've ever counted the numbers." Don't expect to find any elk or moose snuck in there. "It's 100 percent deer," Wyatt said.

A star sits atop the tree. "We try to light it up during the Christmas season," Wyatt said. Heck, in this part of Texas even Santa is bagging Bambi when the season opens in November.

Since the tree has been around for thirty-seven years, it needs constant attention and add-ons.

"You know, with time the antlers tend to deteriorate, so we have to add and replace and what have you," Wyatt said. She says sometimes people from other states write to complain about people in Junction

going out to shoot deer for the tree. But she points out that's not how it works.

"Some of the deer shed their antlers," she explained. "We didn't just go out to shoot deer to get the antlers."

Saddam Ugly It Looks Real
Killeen

Want to see Mickey Mouse? Go to Orlando. Want to see Saddam Hussein? Come to Killeen.OK, so you won't see the real Iraqi despot at Fort Hood, the huge Army base in this Central Texas town. But you will see a life-size 6-foot-1 mannequin of Saddam behind Plexiglas at the Fourth Infantry Division Museum.

And he's not pretty. The museum wanted a doll of the former Iraqi president that looked as miserable as he appeared when he was captured while hiding in a hole on December 13, 2003. So it paid Dorfman Museum Figures in Baltimore $7,655 of your American tax dollars to create a doll that looks like Saddam on a bad day. The Fourth Infantry Division Museum wanted the doll since some of its troops helped catch Saddam.

"We used the photos that were taken very close to the time he was plucked from the hole, so the facial features have that gaunt, thin appearance," said Ceilia M. Stratton, the museum's director and curator.

CAUGHT LIKE A RAT, the sign says. The scraggly beard looks like rats could nest in it. Saddam's hands are cuffed in front of him. "We got those from an MP on post," Stratton said. "He donated to the cause."

Even worse, Saddam the dummy is wearing a pair of cheap sandals purchased at a Wal-Mart near the base. Stratton said Saddam was wearing low-budget sandals when he was nabbed, and the museum wanted to duplicate that look.

"Of course, we couldn't find any Iraqi brown sandals, so we got ours at Wal-Mart," Stratton explained. "Those were the only ones that were cheap enough."

Isn't dressing a mannequin of a world figure in Wal-Mart products a violation of the Geneva Convention?

"I don't see how," Stratton said. "I mean, we aren't asking people to spit on the man." The museum plans to build a re-creation of the spider hole Saddam was hiding in when he was caught. When finished, the hole will be an interactive exhibit for the whole family. "Oh sure, it's going to be a great kid thing," Stratton said. "But we're going to have a lot of adults, too. I'm gonna tell you that. 'Cause people are going to want to get in the same space where he was hiding, and it was not big."

First Saddam, then the spider hole.

Maxwell's Art Gallery and Maxwell Motors
La Grange

"I tell people I moved out here to work here and it was closed," said Sally Maxwell (www.sallymaxwellsart.com), who in 2005 won best of show in the prestigious Gold Coast Art Show in Chicago. The place she was kidding about working for is the Chicken Ranch, the brothel a couple of miles east of town that was shut down by Governor Dolph Briscoe in 1973.

Sally, who runs the art studio, and husband George, who runs the used car business, both at 624 West Travis Street (979–968–5006), think something concrete should be done to preserve the memory of the historic place, which Sally says opened originally in 1844 out of a wagon.

"Mrs. Swine was the first madam, and they called them her piglets because they were not very pretty women," Sally said.

There are some moments in history that you're just glad you weren't part of, you know what I mean?

Anyway, Sally and George believe the Chicken Ranch has historical significance. Sally has done a lovely pen-and-ink illustration of the building, which no longer stands. "It's kinda like the ancient coliseum," Sally said. She sells Chicken Ranch gift notes for $5.00 a package. Each note says, "A Note from the Ranch . . ." on the top. The drawing shows a VW, a Lincoln, a Mustang, and a pickup truck parked in front of the old building.

The license plates on the vehicles in the drawing have been left blank. So if you want, you can get Sally to draw in your license plate number.

"Or your friend's, or whoever you're giving it to," Sally said.

La Grange has done little to preserve the memory of the Chicken Ranch. When some Houston businessmen wanted to build a Chicken

Ranch museum here in the 1980s, Sally did an illustration of the building for them. She says it showed up in *Time* magazine and on *The Tonight Show*, but that's about as far as the project got.

Jailhouse Ghosts
La Grange

"That's the first thing we do when somebody starts working here," said Cathy Chaloupka, former tourism director for the La Grange Area Chamber of Commerce. "We say, 'Let's talk about the ghosts.' "

The chamber has its offices at 171 South Main Street, in the gothic stone building that used to be the Fayette County Jail. The spooky building, built in 1883, was used as a jail until 1985. The chamber moved in in 1995, and it's been one ghostly incident after the next ever since, Cathy said.

The upstairs room where the Widow Dach starved herself to death has had a lot of action. The Widow Dach was in jail in the late 1920s or early 1930s for killing her hired hand, said Margo Johnson, the chamber president. The Widow Dach quit eating. Ironically, this former cell is the room where the chamber now keeps a refrigerator.

Anyway, Cathy said one morning around 6:30, she was putting something in the refrigerator when she looked over at the steel jailhouse door that is the entryway to the Widow Dach's room.

"There was an apparition as tall as the doorway, and I had a tingling feeling on my neck, like I was being watched," Cathy said. Maybe the Widow Dach was looking for the mustard.

Nobody wants to be in the Widow Dach room when the sun goes down. "Anybody who's ever officed here has refused to be here after dark," Margo said. "They just feel something. Like somebody's watching them."

One day, Cathy was in the big, high-ceilinged room on the ground floor where the hangman's noose dangles from the ceiling. (These days it's just a decorative piece.) "I heard the sound of enormous chains dropping," Cathy said. "I got up and looked around, and there was nothing there. It was like a hoist you would use to lift motors. A very heavy sound."

Drawers slam. Footsteps are heard. Paintings get moved. Once a light bulb flew out of a light fixture and landed in front of Cathy.

"One night, when I was here by myself, I heard this horrible crash," Margo said. She looked around and discovered that a large painting had been moved from a wall in the big room to a spot on the floor.

"So if that's where they wanted it, that's where we left it," Margo said.

And it just keeps getting weirder and weirder.

In September of 2005, the hangman's rope that dangles from the ceiling on the first floor started swinging back and forth on its own.

"It just started swinging like someone threw it, and no one was near the rope," said Rachel Bolfik, member services director for the chamber of commerce. "There was nobody back there except these two ladies who were about 20 feet away from it."

So what'd they do? "Started cryin'," Bolfik recalled. "Ran out of the room 'cause it just freaked 'em out."

CAPITOL EXPENDITURE

Is it any wonder that Texans love beef? Hey, if it wasn't for cattle, Texas wouldn't have the lovely capitol building it has today.

In 1882 Texas needed a new capitol, but it was short of money to build one. One thing the state had plenty of, however, was unsettled ranch land just fit for a herd. Boy, did they have land. So the state legislature traded three million acres of land in the Texas Panhandle to pay for the building of a new capitol, completed in 1888.

Texas Hatters
Lockhart

The late Manny Gammage knew how to make a custom Western hat any way you wanted it. He could even make a hat that could cause fistfights, according to his daughter, Joella Gammage Torres, who runs Texas Hatters.

As a youngster in Houston, Manny made an unusual cowboy hat with a felt brim and straw crown. Then he wore it to the rodeo to see what kind of trouble it would get him into.

More often than not, the hat caused a stir. So Manny knew what to do when he got the following letter:

"Dear Manny," the letter began, "I'm a big, ugly tattooed sumbitch with twenty-six years in the Army and I'm queer for hats. I want a hat for me that will scare women and children and start fights in Wyoming bars."

Manny didn't duplicate the felt and straw model for the letter writer. (These days the hat is made by Texas Hatters and sold under the name of "The Half-Breed.") But Manny came up with another model that would do the trick. Joella says her daddy made the customer a brown derby decorated with big silver conchos.

No word on if the man ever wore his derby in a Wyoming saloon or elementary school to test it out. But he was satisfied with the finished product.

"He sent a picture of himself in it and said it was a perfect choice," Joella said.

Not everyone who buys a Texas Hatters hat wants to go a couple of rounds. The store also has made hats to order for President Reagan and the two George Bushes, as well as for Willie Nelson.

If You've Got the Nuts, They've Got the Crackers
Seguin

Looking for some real nuts? If that's your story, then visit this town, where you will find what is billed as the World's Largest Pecan, a 1,000-pound concrete nut statue on the Guadalupe County Courthouse Square.

This is also the home of Pape's Pecan House (www.papepecan.com), a retail pecan shop and the home of owner Kenneth Pape's massive collection of nutcrackers. For thirty years, Pape, a pecan grower by trade, has been collecting both decorative and functional crackers of nuts.

"I've got about 6,000 nutcrackers," said Pape, who picks up nutcrackers while traveling all over the world, from antique shops, and off eBay. He says he really got serious about collecting these things fifteen years ago.

With all those nutcrackers around it's a good thing that Pape likes eating nuts, and not just cracking them open.

"I guess I make my living out of 'em, so I enjoy them," he said. "They're real healthy. I eat quite a few."

I'd always thought that nutcrackers were pretty much exclusively those soldiers you see around Christmas with the tall hats and the military uniforms, but boy was I wrong. You got Bugs Bunny nutcrackers, Mickey Mouse nutcrackers, Easter Bunny nutcrackers, dog nutcrackers, squirrel nutcrackers, alligator nutcrackers, a nutcracker that looks like Charles de Gaulle, an Aunt Jemima nutcracker, a Popeye nutcracker, and nutcracker soldiers with fuzzy hats that serve as barstools. You just sit on the hat. Some of the nutcrackers are risqué. "Here's a caveman," said Pape, pulling out a nutcracker dressed in prehistoric garb and carrying a spear. "He's rated X." Pull the handle on the caveman nutcracker, and a certain part of his anatomy shoots out.

The caveman nutcracker, like most of the good ones, was carved in Germany, Pape said. The Black Forest, Pape says, is a hotbed of hot nutcrackers. Another German model is a nutcracker that looks like a biker. He's got a headband, and he has a "Mom" tattoo on his biceps.

These things don't come cheap. Pape says he's paid as much as $5,000 for a nutcracker—in this case a Merlin the Magician model.

But my favorites are the female nutcrackers. "Here's the girls," said Pape, showing off a bunch of wooden nekkid women carvings from the Philippines. Some of "the girls" have heads, some don't. Some have breasts. Some don't. All have legs. You just spread the legs, insert the nut, and let the legs do the crackin'.

"That's why they call them Naughty Nellies," Pape said of the female nutcrackers. If those aren't for you, there are other kinds. "We've got armadillos, and here's a rooster mounting a hen. I got that in Germany about a year ago."

Nutcrackers have been around as long as there have been nuts that needed cracking. The British, Pape says, have been into cracking their nuts since at least the Elizabethan period. "They used to take them to the theaters to watch Shakespeare," Pape said. "And they'd crack their filberts and throw them on the floor, just like we would with the peanuts."

You kinda get the idea of what you're getting into here when you see the large likeness of a squirrel carrying a big nut like a football on the wall out front of the store.

There are even machines that crack nuts among Pape's collection.

"This is real rare," said Pape, showing off a power-driven pecan-cracking device made in 1926 in San Antonio. "It was called a Jim Dandy pecan cracker. It's an electric motor. It crushes the nuts and drops them down into a box down below."

An illustration on a pane of glass at the top of the machine shows two cartoon elves smashing their nuts with sledgehammers, while a third elf is carrying around one of his big nuts in a wheelbarrow.

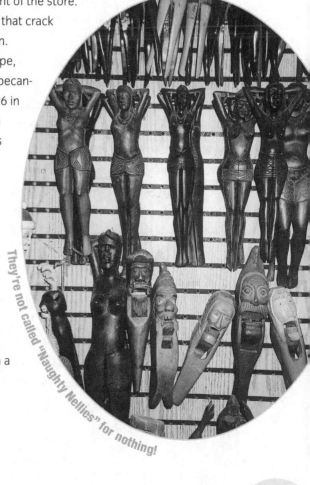

They're not called "Naughty Nellies" for nothing!

ARCHIVES WAR

It would be interesting to speculate what would have happened to the city of Austin if Sam Houston had gotten away with his attempt to steal the republic's records out of Austin and move the capital back to Houston.

Would it mean that Austin wouldn't have developed into the hippie-dippy city that it is today? Would there be no piercing parlors on Sixth Street, the city's music and nightlife area? Would there be no garage bands in the Live Music Capital of the World? Would the University of Texas be in River Oaks, that tony Houston development, instead of in Austin?

In December 1842 Sam Houston, president of Texas, ordered Texas's official records removed from the Land Office in Austin and taken to Houston to reestablish that city as the capital. (Houston had been named the capital in 1837. In 1839, when Mirabeau B. Lamar was president, he moved the capital to Waterloo, a small settlement that later became Austin.)

Houston wanted the capital back in Houston, his namesake. So he dispatched three wagons and about twenty men to sneak the records back to Houston. This was kind of like when the Baltimore Colts took off in the middle of the night and moved to Indianapolis. Except this time, it didn't work. An armed posse of Austinites cut the paperwork thieves off at the pass and took back the records. So the state records stayed in Austin. The so-called Archives War was over, and Austin remained the capital of the Lone Star State.

I bet a lot of conservative state legislators probably wish Houston had been successful in his attempt to get the capital out of the liberal enclave.

Willie's Golf Course

Spicewood

When you're a Texas icon and you own your own golf course, you can make up whatever goofy rules you want.

Which explains why Willie Nelson's Pedernales Country Club Cut 'N Putt—the only country club I've ever seen with a trough urinal in the men's room—lists the following regulations for golfers:

"When another player is shooting, no player should talk, whistle, hum, clink coins, or pass gas."

"Excessive displays of affection are discouraged. Violators must replace divots and will be penalized five strokes."

"Replace divots, smooth footprints in bunkers, brush backtrail with branches, park car under brush, and have the office tell your spouse you're in a conference."

"No more than twelve in your foursome."

"Gambling is forbidden of course, unless you're stuck or you need a legal deduction for charitable or educational expenses."

"No bikinis, mini-skirts, skimpy see-through, or sexually exploitative attired allowed. Except on women."

"Those are some good 'uns," said Larry Trader, seventy-seven, Willie's first booking agent, who says it was tough in the early days to find someone who would hire Willie to play. "Back in those days, they were afraid of the law," Trader said. Perhaps the most remarkable aspect of the course is that you never know who you'll run into. On an October day in 2005, Texas gubernatorial candidate and writer Kinky Friedman was holding a campaign fund-raiser that was attended by Jesse Ventura, the former wrestler and governor of Minnesota.

While schmoozing, Ventura, who was sporting two 3-inch-long beard pigtails that flapped rhythmically when he spoke, addressed a variety of unrelated subjects—the Kennedy assassination (it's a conspiracy, he

says), how he had recently caught a large fish off his dock, how you can trust people with tattoos because they're not putting on airs, and those annoying people who shake your hand too hard.

"I don't like squeezers," Ventura explained. "Everybody thinks 'cause you got muscles they got to squeeze you. That's nonsense." Of course, when you're as large as Ventura is, you can say whatever you want to and nobody will tell you to shut up.

Meanwhile, people were waiting for Willie to arrive so that the Friedman supporters who had paid $5,000 a head to play with Willie could get started. Various tournament officials roamed the parking lot with cell phones in their ears, trying to track down Willie, who eventually showed.

None of this seemed to bother Friedman, who apparently had no intention of playing at his own fund-raiser.

"I find golf stultifyingly dull," he said. "The only two good balls I ever hit was when I stepped on the garden rake."

Moo-La

Stephenville

This is dairy cattle country, so the people here milk it for all it's worth.

As you drive past the Erath County Courthouse, you'll see Moo-La, the fiberglass holstein installed in 1972 to thank the area's dairy cows for all of the moola they have brought to the area.

$223,000,000.00 IN MILK SALES ANNUALLY, says the sign on Moo-La. That's a lot of milk mustaches.

Below Moo-La, at ground level, there's a plaque honoring the Erath County 4-H dairy judging team, which in 1997 won the dairy judging national championship at Madison, Wisconsin.

This was the seventy-sixth annual contest, so when the team of Stephenville High School students became the first Texas team to win the national title, it was a major breakthrough. So major, in fact, that the plaque has a quote on it about overcoming adversity from the late Casey Stengel, the famous manager of the New York Yankees and a master of double-talk.

"They say you can't do it, but remember, that doesn't always work," reads the Stengel quote.

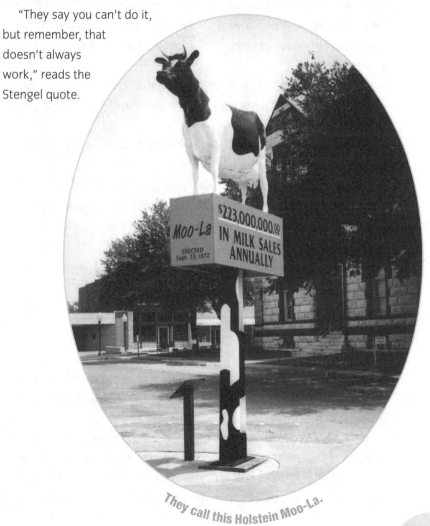

They call this Holstein Moo-La.

Dr Pepper Museum
Waco

Everything you wanted to know about Dr Pepper can be answered here. Almost.

"There are twenty-three flavors in the drink but we—the staff—don't know what they are," said Judy Shofner, the museum's former archivist. "But it doesn't have prune juice. Everybody thinks it has prune juice. It has a very strong apricot base, which people may be mistaking for prune juice."

Listen to the talking animatron of Dr. Charles Alderton, who in 1885 concocted Dr Pepper while working as a pharmacist at the nearby Old Corner Drug Store.

At first, the drink had a different name. "In those days they called it a Waco," the animatron dressed in a charcoal suit tells visitors.

The museum, at 300 South Fifth Street (254–757–1024), has a collection of the various bottles Dr Pepper has used over the years, a bottle-cleaning machine, a soda fountain where you can get an old-fashioned soda fountain–style Dr Pepper, and a gift shop with Dr Pepper hat pins, mouse pads, coin purses, and refrigerator magnets.

South Waco Shrimp
Waco

You know that little glob of fat on the back end of the chicken that some people refer to as the chicken tail? Have you ever had a hankering for an order of those?

If so, the place to go is Krispy Chicken, at 601 South Eleventh Street in Waco (254–754–3869), a take-out fried chicken joint where you can buy an order of fifteen chicken tails with a roll and fries for $3.50. Don't ask me what you're supposed to do with the roll.

Brad Davis, whose dad, Lewis Davis, owns the place, says they refer to these things as "South Waco shrimp." They're quite popular.

"They sell out every day down there," said Brad, who figures the place sells eight or nine orders a day. "You ever eat 'em? We may be the only place in Waco that still does 'em." You mean there used to be other places in Waco that sold chicken tails?

If you want some chicken tails you have to get up pretty early in the morning. "By noon or noon-thirty they sell out of 'em," Brad said. "Usually a lot of people from the VA hospital call in the morning. They pre-order 'em."

Although various other chicken parts are listed on the establishment's plywood signs out front, there is no mention of chicken tails. "They're not even on the menu," Brad said. So it's all word of mouth.

So Brad, do you eat the chicken tails? "No, no, I have before, but I don't anymore," he said. "All it is is fat, honestly."

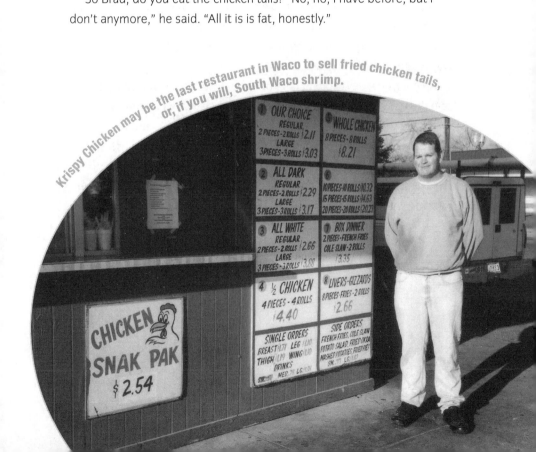

Krispy Chicken may be the last restaurant in Waco to sell fried chicken tails, or, if you will, South Waco shrimp.

The Texas Ranger Hall of Fame and Museum
Waco

"There seems to be more interest in that darned old hair ball than there is in the museum," stewed Stew Lauterbach, former curator of this tribute to the elite law enforcement unit formed in 1823 to protect Stephen F. Austin's colony from the Comanches. The museum is located at 100 Texas Ranger Trail (254–750–8631).

That explains why museum officials took what was billed as a buffalo hair ball off display and put it in storage in a vault. You could say the hair ball has been mothballed.

"Unfortunately, it is what we are known for," said Christina Stopka, the museum's assistant director. "It almost looks like a cannonball, is what it looks like. It's not."

Lauterbach said the other problem with the item is that the museum couldn't identify it as a bona fide, genuine buffalo hair ball. "So we don't want to perpetuate a myth we're not able to substantiate, one way or another," he explained.

Au contraire, says Tom Burks, former curator of the museum. He said the item is an actual buffalo hair ball, once owned by the late Gaines de Graffenreid, another of the museum's former curators.

"Yeah, he was very pleased with it," Burks said. "He thought it was a museum item. And the odd, funny thing about it was people would come in the museum and spot that. And they'd go all over the museum to come see that, more than they would Santa Anna's sword."

Jernigan's Taxidermy

Waco

If you've ever been in a beer joint and seen a mounted deer butt on the wall, there's a good chance it's the work of Byron Jernigan.

Jernigan figures it was more than thirty years ago when he began stuffing deer rears. But he doesn't recall what got him started.

"I don't remember if I did it because somebody wanted one, or I just did it to be doin'," said Jernigan, sixty-seven. But regardless of motive, the deer butts have become a popular item.

"We make up about 300 a year now. Sell 'em all over the country," Jernigan said.

Who is buying these lovely creations? "We wholesale most of 'em out to interior decorators," Jernigan said. "They put 'em in bars and restaurants. If people haven't seen 'em, it gets a lot of attention."

While Jernigan also does traditional mounts, such as the other end of the deer, he also makes jackalopes—rabbit heads rigged with tiny antlers. And he stuffs whole armadillos.

Since 'dillos tend to get run over a lot, is that where Jernigan gets them? No, he said, he gets them from hunters.

"Usually if a car hits 'em, they're pretty flat," he explained.

So what's a deer butt run? "They're about $100 retail," Jernigan said. "Depending on where you buy 'em." Jackalopes? "They're about $95."

Visit Jernigan's at 1801 Franklin Avenue (254–752–3208), or take a gander at the Web site www.bum steer.com.

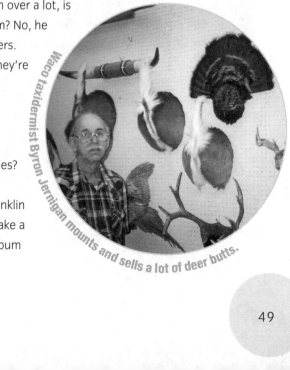

Waco taxidermist Byron Jernigan mounts and sells a lot of deer butts.

The Health Camp

Waco

The most inappropriately named restaurant in Texas, this greasy burger joint at 2601 Circle Road (254–752–2081), on "the Circle" (one of Texas's few remaining traffic circles), sells an item called a Super Health Burger. That's a double-decker bun with two meat patties, lettuce and tomato, two slices of Old English cheese, and "special dressing." Perhaps the closest thing on the menu to health food is the onion rings.

So how did the Health Camp, which opened in 1949, get the aerobics class–sounding name?

"It's a real strange story," said June Smith, the former manager. The name came about when Jack Schivetz, the original owner, was trying to come up with something to call the place. All he could think of, she said, were the words *Health Camp*, which were stamped on top of each egg his mother bought from the farmer down the road, when Jack was a little boy.

So why were the words *Health Camp* stamped on the eggs? "He had no earthly idea," June said.

The place also sells steak fingers, which begs the question: How can there be steak fingers if cows ain't got no hands?

The Zorn Bowling Club
Zorn

When Mary Lou Dean, the bartender, told me that the annual dues at this private ninepins bowling club on Texas 123 (830–379–5247) were "535 a year," I thought she meant $535 a year.

Actually, it was only $5.35 a year—although these days it's shot up sixty-five cents to $6.00. And it's $5.00 a night for club members to bowl. But it sure ain't no $535 a year membership fee.

The bowling alley is about as unautomated as a bowling alley can get and still have electric lighting. They use human pinsetters. Mostly, the children of its members set the pins on the four lanes in the club. The club pays the kids $19 a night, for about a three-hour gig, plus tips—for working two lanes at the same time. Some of the littler kids work only one lane. The pinsetters sit on a perch between lanes behind the pins. As you look down the lanes, you can see their legs hanging down.

Had your pins knocked off lately?

The Zorn Bowling Club has been in operation since 1912. Clayton Roberson, a member of the club's board of directors, said today the club had probably 180 to 200 members. The ninepin game they play is a little different than regular tenpin. Teams of six bowlers square off. Instead of being lined up in a triangle, the pins are in a diamond shape. Each bowler rolls two balls.

The next bowler up has to deal with whatever the previous bowler has left standing. But the team captain sets the order of who bowls when. So he gets to pick which bowler on the team should bowl in particular situations.

Knocking all nine pins down is called a "ringer." A ringer scores nine points. But the ideal thing to do is to leave the pin in the middle of the diamond standing. If you can pull that off, you get twelve points.

There's one significant similarity between tenpin and ninepin. You can drink beer while playing either one. Of course, at the Zorn Bowling Club it's only $1.50 for a beer. But with annual dues of $6.00, what would you expect?

LULING WATERMELON THUMP

So how do you spit a watermelon seed 68 feet, 9⅛ inches? Practice, practice, practice.

"I grew up in East Texas back in the '50s, and we lived in the oil patch," said Lee Wheelis, sixty, who set the former Guinness world record for watermelon seed spitting at this festival in 1989. "And about the only entertainment we had was throwing watermelon rinds at each other and spitting seeds at each other. So it kind of comes natural."

Wheelis, who lives in Luling and recently retired from the Exxon Pipeline Co., described his technique this way: "You just kind of roll your tongue around it and give it a heave."

Wheelis said he didn't know at first that he'd had a good spit when he set the record, which has since been beaten.

"I didn't realize it 'cause there was a lot of people standing around, so I couldn't see where it landed," he recalled. "But when everybody went to hollering and screaming, well then, I knew what had happened."

The Luling Watermelon Thump is held the last full weekend each June. In 1999, the town painted a new water tower to look like a watermelon.

If you're ready to go the spittin' distance, call (830) 875–3214 ext. 2.

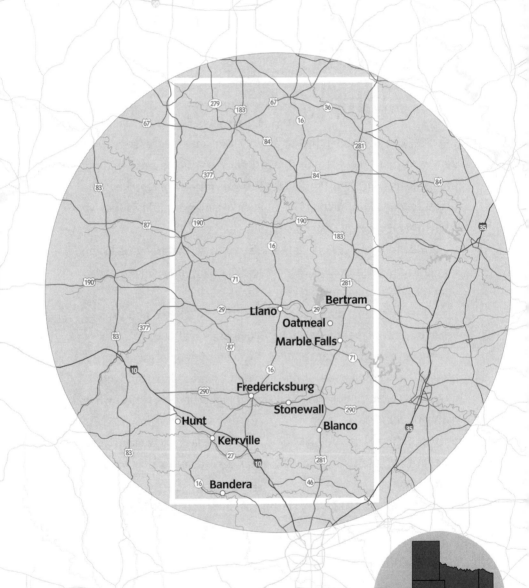

HILL COUNTRY

Bertram
Llano
Oatmeal
Marble Falls
Fredericksburg
Stonewall
Blanco
Hunt
Kerrville
Bandera

0 50 Miles

0 50 KM

HILL COUNTRY

Check Out the Shrunken Head on That Chick

Bandera

One reason you won't want to miss the Frontier Times Museum (510 13th Street, www.frontiertimesmuseum.com) is that the shrunken head has been returned.

The tiny head of a seventeen-year-old Ecuadoran Indian woman went on a road trip back in 2002 when somebody stole the head from the museum, then threw it on the side of the road in San Antonio. Maybe the thief or thieves couldn't get much for the head at a pawn shop. Maybe the pawn shop owner was looking for a larger head. Anyway, after the head was found by a construction worker, police returned it to the museum.

And she's not going away again any time soon.

"Now she's nailed to the counter," said Jane Graham, the museum's manager. You gotta do what you gotta do.

Speaking of heads, another of the museum's highlights is the two-headed goat, displayed in a glass case like the shrunken head.

No small-town Texas museum would be complete without a stuffed version of the small Texas state mammal. "It's amazing how many people come from out of state and want to see an armadillo," Graham explained.

Overhearing Graham, a tourist from Ohio who was visiting the museum immediately proved Graham's point. "We went to Enchanted Rock and saw one dead along the highway," said Mary Warren, the postmaster in Malta, Ohio.

Journalist J. Marvin Hunter built the museum in the '30s to house his Western collection. Since then the collection has gone way beyond Western. Among the items you'll see here are one of those Murphy beds that used to fold up into the wall, a Lone Ranger snow globe, an 1848 Mexican bed roll, a corn planter, an ancient hair curler that looks like a torture device with electrical cords and clips hanging down, and the skull of an Incan woman.

How did the museum come by the skull? "I was told someone in their RV was driving through and they said, 'Will you take it?'" Graham said.

Now that's tiny!

So Many Movie Cowboys, So Little Time

Bandera

If you don't like looking at John Wayne, stay out of the Old Spanish Trail Restaurant at 305 Main Street.

The walls of the back dining room are lined with hundreds of paintings and photos of America's favorite red-blooded Western guy. You've got John Wayne in an Army uniform from *The Green Berets* (even though he never served in the military), John Wayne as Davy Crockett in a coonskin cap from *The Alamo,* and John Wayne in matching high heels and bag.

We just made that last part up. "He's just always been like a hero of mine, and always thought that Bandera was perfect for that room," said Gwen Janes, who has owned the restaurant since 1978. People donate to the collection. Janes says a huge canvas of Wayne was donated to her by a guy in Florida because his wife hated the thing.

"She said, 'Get that thing out of my living room,'" Janes said. "Mamma said it had to go."

Mamma sounds more like John Wayne than John Wayne does.

It should come as no surprise that Janes's ex-husband Rudy Robbins was one of John Wayne's stuntmen. "We're no longer married, but he lives here in Bandera," Janes said.

Conversely, John Wayne never made it into Janes's restaurant. She says customers tell her that she ought to tell people that he ate here. "I say, 'No, I'm not going to lie to them about it'," Janes said. John Wayne wouldn't have lied about it either.

If you don't get enough of John Wayne from the wall hangings, they keep a DVD player in the John Wayne room and play John Wayne movies.

The Hungry Moose Restaurant
Bertram

Anybody who has read the book *Friday Night Lights* by H. G. Bissinger knows that Texans live and die over high school football. Besides, what other state can you name where you'd find a restaurant decorated with an old high school football scoreboard?

"It was sitting on the poles where the field used to be, where they play baseball now," explained Les Ware, owner of the Hungry Moose Restaurant in Bertram (population about 1,200). "It had been in my craw that that thing should be refurbished, and the city gave me permission to get that thing cleaned up. And I did it."

Ware says he invested about $1,000 to have the scoreboard from the old Bertram High football field sandblasted and redone. It's a big metal thing—probably 12 by 25 feet, and mostly maroon—and it covers one wall of the little eatery. The old scoreboard clock has two hands on it. We're not talking digital equipment here, sports fans.

Bertram High closed in 1970. Ware has no idea how old the scoreboard is. And no, the score posted in metal letters on the scoreboard—54 for Bertram and 19 for the "visitors"—didn't come from an actual game.

"It's 19 and it's 54—that's the year the man who made the numbers for me graduated [from Bertram High]," Ware said. Ware says that Ernest Krum, who now lives in Buda, made the numbers for the scoreboard at no charge. So he figured he'd let him put up whatever numbers he wanted.

"I get free numbers, I don't gripe about the numbers," Ware said.

By the way, the scoreboard clock works, and the hands will turn. "Had the motor redone," Ware said. "I can turn it on. All you gotta do is plug it in."

HILL COUNTRY

Along with the scoreboard, you'll find a display of Bertram High team jerseys, letter jackets, and cheerleader outfits, with the names of the people who wore them attached to them on small signs. After the scoreboard went up in the restaurant in 2003, the locals started bringing in their high school stuff. Check out Annie Dell Taylor's cheerleader outfit. She's now the president of Farmers State Bank in Bertram.

"People have really taken pride in bringing things in," Ware said.

And the clock still works!

Dinosaur Made from Auto, Truck, and Other Junked Parts
Bertram

The head is two oil pans rigged up to a windshield-wiper motor. Turn it on and the dinosaur's jaw flaps.

"The teeth are spark plugs," said the late Garrett Wilkinson, the welder who built it. "It has 104 spark plugs, if that means anything."

The toes are off a farm cultivator. "And those vertebrae welded in the neck, those are the rocker arms for your valves," Wilkinson explained.

Wilkinson's built two junk dinosaurs in his lifetime. He built the first one after Bertram city officials asked him to make a beast to go along with the discovery of some dinosaur tracks in the creek at nearby Oatmeal.

"The city asked me if I would build 'em a dinosaur to bring in tourists," Wilkinson said. "I told 'em, 'Well, I don't know how I'd make the skin on it.' But I told 'em I could make the skeleton."

Back by popular demand.

The second dinosaur was built because of popular demand, after he sold the first one to a man from San Angelo. "When I sold it, people would drive by and say, 'Where's that dinosaur? I drove all the way from Houston to see that dinosaur.' So I decided I needed to build another dinosaur."

The dinosaur can still be seen in Bertram, parked on Texas Highway 29 as you come into town from the east, or outside Wilkinson's old welding shop on Vaughan Street. "At Christmastime we put lights on him and plug him in and light him up," said Shirlene Vaughn, Wilkinson's daughter.

An Appetite for Bowling
Blanco

The decor in the big dining room features bowling balls, bowling trophies, bowling bags, and bowling lockers. It's not your average dining setting, but you are eating at the Blanco Bowling Club Café (830–833–4416), a place at 310 Fourth Street that comes with a half dozen ninepin bowling lanes. More than 300 people belong to the private bowling club. The cafe, open to the public, is a big hit around town and in the Hill Country.

"A lot of 'em like the enchiladas," said John L. Dechert, president of the bowling club. "A lot of 'em like the chicken-fried steak. The hamburgers are awful good." And the lemon and coconut meringue pies in the case behind the counter are probably a half foot tall.

On one Sunday morning the place was abuzz with people who all seemed to know one another and who were checking one another out to make sure they'd been to church that morning. "What are you doin' in here? You must be lost," said an old boy in a pair of suspenders to some old gal. "Well, I go to church over here," she answered.

John is proud of the cafe's plastic sign out front that shows a brightly colored illustration of a cheeseburger. "That was a real good investment," said John, who was wearing a George Strait baseball cap. "When it's lit up at night you can see it from the main road. We're sort of off the beaten track. A lot of our business is word of mouth."

They nearly give the food away. A large roast beef plate with mashed potatoes, gravy, green beans, a salad, bread, and a small raspberry cobbler costs $6.50. One reason the club can offer such low prices is that the building is paid for. The club bought the place in 1967 for $1,000 down and $1,000 a year, at 5 percent interest. It made the last payment in 2003.

Bowling club members pay a $10 membership fee and $4.50 an evening to bowl Monday through Thursday evenings. There are no automatic pinsetters. The local high school kids take care of that. "It's a pretty good job," John said. "For three hours of work they get $21, plus tips. And a lot of times the tip is as much as what they get paid." It's certainly enough to gain ten or twenty pounds eating in here.

Only at the Blanco Bowling Club Cafe can you eat in a dining room decorated with bowling bags.

WHO'S WHO

If you ain't from Texas, you ain't—oh, never mind. Let's not repeat that oft-seen bumper sticker cliché. On the other hand, it is true that an inordinate number of famous people are or were from Texas. Let's drop a few names here, without even mentioning Willie: Broadway star Mary Martin, her son Larry Hagman ("J. R."), boxer George Foreman, sausage dude and singer Jimmy Dean, football star Earl Campbell, former Attorney General Ramsey Clark, former Secretary of State James A. Baker III, Tex Ritter, Ernest Tubb, Clay Walker, Mark Chestnutt, Waylon Jennings, actor Tommy Lee Jones, pianist Van Cliburn, race car driver A. J. Foyt, Sissy Spacek, actor Zachary Scott, Kenny Rogers, Roger Miller, Buck Owens, Johnny Rodriguez, Dennis and Randy Quaid, Rip Torn, Farrah Fawcett, Sam Donaldson, Dan Rather, Bob Schieffer, Linda Ellerbee, columnist Liz Smith, Walter Cronkite, TV star Dan Blocker, brother actors Dana Andrews and Steve Forrest, dancer Tommy Tune, movie critic Rex Reed, *Monday Night Football*'s Dandy Don Meredith, TV animator Mike Judge (*Beavis and Butthead*), Mike Nesmith of the Monkees, singer Freddie Fender, J. P. Richardson ("The Big Bopper"), actress Linda Darnell, singer/songwriter Lyle Lovett, George Strait, Joan Crawford, Janis Joplin, Roy Orbison, Olympian gymnast Mary Lou Retton, sports commentator Phyllis George, Olympic ice skater Tara Lipinski, Ben Crenshaw, Tom Kite, Babe Zaharias, actor Patrick Swayze, actress Phylicia Rashad (Bill Cosby's wife on *The Cosby Show*) and her sister dancer/actress Debbie Allen, Selena, country star George Jones, singer Barbara Mandrell, singer Tanya Tucker, cowgirl Dale Evans, singing cowboy Gene Autry, Lee Trevino, bicyclist Lance Armstrong, Nolan Ryan, writer Dan Jenkins, Ben Hogan, baseball hall of famer Frank Robinson, sprinter Carl Lewis, President George W. Bush, and his former press secretary Scott McClellan.

The Cowboy Cook
Fredericksburg

Cowboy cook Crazy Sam Higgins, who owns a bed-and-breakfast in Fredericksburg called the Chuckwagon Inn, has a way of dealing with the occasional vegetarian who stays at his place.

"I have a garden out there and I give 'em a salt shaker and tell 'em to go eat all the jalapeños and tomatoes they want out of that garden," said Sam. Do they ever take him up on it? "Hell no. They just look at you."

Sam, who has a cookbook out called *I'm Glad I Ate When I Did, 'Cause I'm Not Hungry Now*, won't let you leave hungry. At his bed-and-breakfast on Sundays he serves a breakfast he calls "Redneck Sunday": It's homemade biscuits, sausage, gravy, and hash brown potatoes.

Sam can be found at a lot of chuckwagon cook-offs around the state. At these cook-offs, entrants cook out of chuckwagons and aren't allowed to use modern conveniences, such as electricity. They're not supposed to have coolers, but they hide those in teepees set up behind the chuckwagons. Cooking is done with wood, usually oak or mesquite. You see a lot of large pots and cast-iron skillets. And from looking you'd think it's a prerequisite for entrants to wear belt buckles the size of your head, boots, cowboy hats, suspenders, and a gut that hangs down over their belt lines.

Sam, who has his own chuckwagon (you can have one made for anywhere from $8,500 to $17,000, depending on amenities, such as water barrels), can tell you all about the history of chuckwagon cooking as it was done on cattle drives back in the 1800s.

"They didn't eat that much beef," Sam said. "The old boy who was drivin' 'em up from Laredo to Dodge City wanted to get as many up there as he could. He didn't want anyone eatin' 'em along the way." When the trail hands were allowed by the trail boss to eat the occasional head, they had to eat the entire animal, starting with the bad parts.

HILL COUNTRY

These are the kinds of old boys that cowboy cook Crazy Sam Higgins pals around with.

"They took all the gizzards and the heart and the intestines and they called it stew," Sam said. "They wasn't whuppin' up on the hamburgers all the way up, that's for sure."

Sam knows all about cattle drives. "The second highest paid trail hand was the cook," he said. "He got to keep the whiskey, so most of them were drunks."

The food served at today's chuckwagon cook-offs is considerably better than what the hands got in the old days. At a competition at the Star of Texas Fair & Rodeo in Austin, cooks whipped up chicken-fried steak, potatoes, pinto beans, bread, and a dessert made with peaches. Of one particularly good peach cobbler, Sam said, "It'll make your tongue slap your nose off."

Stonehenge II

Hunt

It started out with one large stone. Doug Hill of Hunt was a tile contractor at the time, building a patio. When the job was completed, he had one stone left over.

He asked his neighbor, Al Shepperd, if he wanted it. "He said, 'Let me put on my shoes. I'll show you where I want you to put it,'" Doug recalled. "We brought it over here and put it next to the road, and he said, 'I kinda like this rock.'"

The stone, about 5 feet tall and 8 inches wide, was placed in a big field owned by Al, across FM 1340 from Doug's house. Doug noticed Shepperd really admired the stone.

Doug Hill built this Easter Island figure and the Stonehenge recreation nearby for his late neighbor, Al Shepperd. Shown with Hill are his three kids, Doug Jr. (with bike), Ella (the short one), and Sydney.

"I'd see him driving by real slow, looking at his rock out there," Doug said. "I thought it was a little odd, but he was a little eccentric anyway."

As time went by, Al began mowing larger and larger circles around the stone. Then one day he showed up with an article about Stonehenge, the ancient druid monument in England, and told Doug, "I'd like you to build something behind that stone that looks something like this."

The end result is a 92-foot-in-diameter hollow plaster recreation of Stonehenge, flanked by two Easter Island statues, one on each end of the field. Doug says it took him about four and a half months to build it, with the help of three laborers.

First, five arches of three fake stones each went up in the center. "When that was done, Al came into some money from the sale of a condominium, so we started on the outside circle," Doug said.

So why did Al want this objet d'art put on his land? "I think what inspired him was the publicity," said Doug, who lives across the road from Stonehenge II.

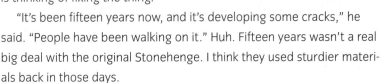

Al, who has since passed away, had his ashes sprinkled on the ground around Stonehenge II.

By the way, you'll find a donation box out by Stonehenge II these days. This is because the place could use some repairs, and Hunt is thinking of fixing the thing.

"It's been fifteen years now, and it's developing some cracks," he said. "People have been walking on it." Huh. Fifteen years wasn't a real big deal with the original Stonehenge. I think they used sturdier materials back in those days.

The Miracle Cottage

Hunt

Why are the crutches stuck in the rock work of the front outside wall of the little cottage on School Road? The story has it that they were put there way back when by Otis Ward, after he finished building the house while he was on crutches. Ward wanted to show the world he didn't need them anymore and that he could walk without them.

"He was told by a doctor he would not walk again and he would always have crutches," said Sharon Fell, who bought the little three-room rock house in 1987 with her husband Darell. "He stuck the crutches in the wall just to prove that was the end of him needing them. I think it was just the testament of persevering. I think that's the true test of a Texan anyway is persevering. I love that about a Texan, and I think that shows what a real Texan really is."

Ward's then-elderly daughters told Sharon the story about their father in 1989 or 1990, while they chatted on the porch. They had come back to the house to pick up some of their father's belongings. Seems that Otis Ward had decided to challenge his infirmity by building a small rock house behind the main house. "He was told he couldn't do anything but sit in a chair, and he made up his mind he wasn't going to do that," Sharon said.

Ward got some heavy knee pads so he could lift rocks while on his knees onto an old railroad station luggage cart. He'd load the rocks onto the cart, then roll them up to the house he was building. While he was working, he got around on crutches.

When he finally finished the house, he walked to the doctor to make a point. "He went to the doctor and he threw his crutches on the floor and he walked in," Sharon said. Then he took the crutches back to his little house and stuck them in the wall. "He was a determined cuss, I'll tell you that," Sharon said. She puts wood preservative on the crutches to keep them in good shape. "Because I like history," she explained.

By the way, the Fells have turned the Miracle Cottage into a bed-and-breakfast.

Real Texans don't use crutches.

PRESIDENTIAL TREATMENT

President Lyndon Baines Johnson had a wicked sense of humor. When people would visit his ranch in Stonewall, outside Johnson City, he loved to take them for a ride in his little blue '62 model Amphicar built in West Germany. Of course, he didn't tell them that the vehicle was amphibious.

As he hollered that the brakes had failed, he'd run the vehicle into the Pedernales River as a joke. The convertible is still on display at the carport at the ranch.

Running his funny little car into the water wasn't President Johnson's only quirk. The late George Christian, LBJ's press secretary from 1966 to 1969, says the president was a gregarious fellow who didn't like being alone and never quit working. So he'd keep talking to his staff "while he was shaving, while he was showering, while he was on the pot, or whatever," Christian said. "He just kept on going."

Christian recalls the time the president accidentally drenched him with his Water Pik.

"One time he was brushing his teeth, and I was standing in the doorway taking notes, and Larry Temple [the president's attorney] was standing right behind me," Christian said. "And he looked up at me while he was using that Water Pik, and he squirted me from head to toe with Lavoris. The president just kept going. And I spent the rest of the day smelling like mouthwash."

Like the Energizer Bunny, Johnson kept going and going and going. "It didn't bother me seeing him naked, which was often, or in his pajamas," Christian said.

Another thing Johnson would do, Christian said, was eat your food as a joke.

"When he was on a diet, which was all the time, he'd reach over and steal your ice cream," Christian said. "He didn't ask you, he just did it. He'd sit there and stare at your dessert, and the next thing you know here comes this big old hand stealing your dessert or your butter."

Hiccup Cure
Kerrville

The only Texas gubernatorial candidate in 2006 with an announced hiccup cure? How 'bout author and humorist Kinky Friedman?

Though not a Democrat, the Kinkster, who ran as an independent, says the solution is to throw money at it.

Friedman's hiccup remedy came to light during a morning visit to Conchita's Mexican Cafe, a small place in downtown Kerrville. While Friedman was in there, Danita Horner, the seventeen-year-old waitress, was having a real problem with hiccups. We're talking a major hiccup attack. You could tell where she was located in the restaurant by tracking the noise. Hiccup, she's in the kitchen. Hiccup, she's in the dining room. Hiccup, she's by the counter.

It didn't take long for the impulsive and inventive Friedman to step in and take action. "Come over here, I've got a cure for those hiccups," he said in a commanding voice.

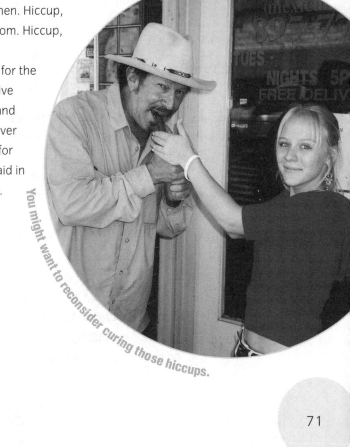

You might want to reconsider curing those hiccups.

Danita quickly stepped over to Friedman's table. Then Friedman pulled his wallet out of his pants pocket, took out six twenty-dollar bills, and fanned them out on the table like a hand of cards.

"One more hiccup and it's all yours," Friedman told the young waitress. She stood there, blinking, trying to squeeze off another hiccup. She couldn't do it. The thought of a quick $120 had driven them out of her.

Friedman says he's tried that trick a half dozen or so times and it's always worked. He thinks he got the idea from an old Kerrville cowboy named Grady Tuck. Either way, Kinky says the size of the bribe you need to use to drive away the hiccups depends on the wealth of the hiccup sufferer.

So for a rich guy, you might have to put up a set of keys to a Hummer.

The Dabbs Railroad Hotel
Llano

Innkeeper Gary Smith gets dramatic when he talks about stumbling across the old abandoned hotel building in 1987.

"The moment I saw it I knew I was in a movie," said Smith, a former roadie for a punk rock band called The Big Boys. "It was like being in a Hardy Boys movie, being lost in the woods and you find the old abandoned hotel down by the river."

Smith bought the twelve-room white wood place for $40,000, talked to the former owners to get the history of it, and restored the railroad hotel to its current rustic condition. It ain't the Holiday Inn, and that's the charm of it. Don't expect HBO, 'cause you can't pick up pay TV without a set, right? This is where you come to get away from it all. "I hear a thousand times, 'Thank you for not putting phones in the rooms,' " Smith said. "No phone, no pool, no pets—but you can smoke cigarettes."

The place has a/c and a lot of history. It opened in 1907 at the spot where the railroad tracks from Austin dead-ended. Smith has a picture from the 1930s showing outlaw Clyde Barrow standing in front of the Dabbs, hiding behind a brand-new Ford V8. You can see Clyde's fedora sticking over the roof of the car.

The hotel is on a dirt road on the banks of the Llano River. "The amenities are like nothing else," Smith says. "Walks down the train tracks to the old spooky train bridge. Moonlight swims in the lagoon. You can raise the window in your room with the cool breeze blowing across your bed, with the sounds of waterfalls in the distance. Winter riverside campfires, ghost stories, s'mores, and roasted marshmallows."

And you can sit around the campfire down by the river and let Smith try to scare you.

"You get a free ghost with every room," Smith said. "I'm usually the ghost storyteller if people want to get spooked before they go to bed."

Smith is proud to run the place just like it ran when it opened. You get the same breakfast now that guests got back then—buttermilk biscuits with sweet cream pepper gravy, bacon, hash browns, sliced garden tomatoes, cowboy coffee, and jams and jellies.

The Dabbs Railroad Hotel is at 112 East Burnet Street in Llano. Call (915) 247–7905 or visit www.dabbshotel.com for reservations.

Dead Man's Hole
Marble Falls

Not a cheery location, Dead Man's Hole, off County Road 401, is a 155-foot-deep natural hole and cave into which murdered Union sympathizers were pitched back around the time of the Civil War and the Reconstruction period that followed.

Former State Senator Walter Richter of Austin said that Adolph Hoppe, his great-grandfather, was one of seventeen people killed and tossed into the hole. Richter was instrumental in getting a historical marker placed at the site.

James Oakley, a Burnet County commissioner, said there used to be a tree limb hanging over the hole. Offending parties were hanged over the hole, then cut loose and dumped into it.

A grate has been put over the hole to keep people from falling in or from being thrown in. "There are people who would delight in using Dead Man's Hole for Dead Man's Hole purposes," Richter explained.

Oakley says he's skittish about standing too close to the hole. "Since I'm the first Republican elected to the Burnet County Commission since the Civil War, I'm a little leery of being there," he joked.

Oatmeal Festival

Oatmeal

There are several stories about how this small town (population twenty) got its peculiar name. Some say it was because of the German named Habermill who settled the place in the 1840s. One version has it that Habermill meant "oatmeal" in German, "but the Germans who speak German say it doesn't," said Carolyn Smith, the former city secretary in nearby Bertram.

Another version has the Scotch-Irish settlers who came after Habermill not being able to pronounce the German name correctly. "Habermill" sounded like "oatmeal" when they tried to say it the way Habermill did.

Either way, each Labor Day there is an Oatmeal Festival. Oatmeal flakes are sprinkled out of small airplanes flying overhead. There is an oatmeal bake-off. And, in the past, there have been oatmeal sculpture contests.

Ever thought about dropping cooked oatmeal out of the plane?

"Plop, plop, plop. I don't know about that," said Polly Krenek, Oatmeal's city secretary. "We'd have a lot of people [saying], 'Don't look up when the oatmeal plane's flying over. You'll get oatmeal in the face.' "

"We still have the wacky games," Krenek added. "The oatmeal stacking and the oatmeal-eating contest and that sort of thing." Oatmeal stacking? "You just take the regular oatmeal boxes and whoever can stack the most and the highest wins," she explained.

Oh, it's easy to tell when you've reached Oatmeal. The town's water tower is painted red and gold to look like a Three-Minute Oats box.

Feeling a little flaky? Call (512) 355–2197.

Guess what's for breakfast?

NORTH TEXAS

OKLAHOMA

Electra
Wichita Falls

Olney

Denton
Frisco
Plano
Addison
Irving
Dallas

Mineral Wells

Fort Worth
Grand Prairie

Strawn

Eastland

Waxahachie

Itasca
Italy

0 100 Miles

0 100 KM

NORTH TEXAS

Mary Kay Museum
Addison

So you're wondering how the late Mary Kay Ash, founder of the global cosmetic empire with $3.6 billion in retail sales in 2004, came up with the idea for a museum dedicated to herself.

Simple. She saw Liberace's museum in Las Vegas and decided she needed one, too. The piano player with the loud outfits had some duds, and I'll wager Mary Kay didn't want to be outdone.

"It was actually a dream of hers," said Lisa Janda, the museum's former tour director. "Liberace had all of his costumes on display, and Mary Kay decided she wanted to do that."

The museum is located off the lobby of Mary Kay's thirteen-story pink granite office building. It's not everybody who has a museum with a life-size mannequin of herself dressed in a gold and black gown, with earrings the size of bass lures. But Mary Kay does.

This place is awash in pink. We're talking photos of the pink Cadillacs the sales directors win for selling so much Night Cream Formula and other products, a glass case holding a pink hard hat, and a model of a pink eighteen-wheeler. "We really do have pink semitrailers to carry our products," Lisa said.

If you visit the museum you will learn that Mary Kay owned a string of little white poodles, who preferred broiled chicken, lobster, and

homemade cookies. "She didn't call them dogs; she called them 'fur people,'" Lisa said.

The Mary Kay Restaurant near the museum is noteworthy because of the two large floor-to-ceiling pillars that look like giant pink lipsticks. The highlight is Mary Kay's office on the top floor, replete with pink drapes, pink carpeting, a pink pen on her desk decorated with a large feather, and her private bathroom with a 14-karat-gold sink and cherub faucet handles. Mary Kay's rhinestone glasses sit on the desk. "The sales force loves to sit at her desk and put on her glasses," Lisa said. It provides a great photo opportunity.

Here's Lisa Janda, the former tour director, showing off with Mary Kay's pink pen and holding onto Mary Kay's rhinestone glasses.

Had enough? If not, I should tell you that new Mary Kay sales directors get their pictures taken at company headquarters while fully clothed in a heart-shaped bathtub. There's no water in the bathtub, so this ain't no wet T-shirt contest.

You can arrange guided tours by calling (972) 687–5720. If you want to see the office, you've got to take the guided tour.

The Cow Goddess
Dallas

"What started all this is I had a pet cow as a kid," said the Cow Goddess, or the Divine Bovine, who has decorated her '92 Chrysler Le Baron convertible named Betsy II entirely in Holstein black and white—with a rubber-hose tail on the back end. There's even ten or so plush cows camped out on the back seat.

The Cow Goddess has a tried-and-true method of attracting a crowd at art-car events, and it's not just by wearing her white-and-black flowing chiffon dress, shoes, and nail polish—she also has a nice set of Holsteins, so to speak—although the matching outfit is a nice touch.

By the way, The Cow Goddess has tried out for the TV show *Survivor*. "The only thing that will probably get me is the food challenge," she said. "I'm willing to eat cockroaches, but I'm not willing to eat a steak." The Cow Goddess is a vegetarian, which is fitting for a Cow Goddess. On the other hand, since when was a cockroach a vegetable?

To sneak a peek, check out the Cow Goddess's Web site at www.cowgoddess.com.

HOW MANY TEXANS DOES IT TAKE TO STUFF A BALLOT BOX?

Lyndon Baines Johnson's political career might have taken a differ-ent turn if it hadn't been for a mysterious voting box in 1948.

Johnson was running for U.S. Senate in a runoff against Coke Stevenson. On August 28, election day, it looked as if LBJ had been defeated by 114 votes. But on September 3, it was announced by Jim Wells County that the votes in Box 13 in the South Texas town of Alice hadn't been counted.

LBJ got 202 additional votes out of Box 13, and Stevenson just 1. I guess they stuffed in that one vote for Stevenson to make things look clean.

Johnson won the election by eighty-seven votes, and later went on to be photographed picking a dog up by its ears.

Adair's
Dallas

Every surface in this funky bar except the floors is covered with graffiti.

Why is that? "They're too #$%^& lazy to bend over," explained Austin pop artist Bob "Daddy-O" Wade, a frequent visitor to this saloon at 2624 Commerce Street.

This place is jammed with college students and alumni on the October weekend when Texas plays Oklahoma in the Cotton Bowl. It's the big hangout for that game. The walls in the men's and women's bathrooms, the cigarette machine, the ceilings, the shuffleboard table, the tip jars, the pitchers, the glasses, the bar stools, the glass on the cigarette machine, the brick wall by the pay phone, the framed photos hanging on the wall, even the felt on the pool tables are covered with graffiti.

"Starkey Loves Fat Chicks," it says in the men's room. "You can go to hell. I'm going to Texas," reads another, paraphrasing Davy Crockett. But most of the scribbling isn't particularly imaginative. The theme is mostly: I was here, I was drunk, and someone else is a big fat jerk.

So what's the cleverest graffiti in here? "It's on the men's room and I think it says, 'I had so much to do today that it was noon before I could get to Adair's,' " said owner Lois Adair.

TEXAS STATE SYMBOLS

Texans are so proud of their state that they have forty-eight official state this's and state that's.

- The armadillo is the official small state mammal, and, if a state roadkill is ever named, the armadillo will probably end up with two state positions. (One upright and the other upside down beside the highway.)

- The longhorn is the official large state mammal. The state musical instrument is the guitar, on which you can play the official state song, "Texas, Our Texas," although most people in the Lone Star State don't know the words to "Texas, Our Texas" and figure the state song is "The Eyes of Texas." But it's not, because that's a University of Texas song.

- Chili is the official Texas state dish, although it probably ought to be actress Sandra Bullock, who has a house in Austin.

- The state grass is sideoats grama, although in liberal Austin there are probably some hippies who think it oughta be wacky tabacky.

- The state sport is rodeo, having apparently edged out the tractor pull.

- The Mexican free-tailed bat is the official state flying mammal. Want me to stop? Tough.

- The lightning whelk is the official state seashell.

There are so many designated official state things in Texas that a move was afoot in 1997 to name an official state fungus.

State Senator Chris Harris of Arlington filed a bill to name the Devil's Cigar fungus the official state fungus of Texas, because this fungus has been reported only in Texas and Japan. The bill made it through the state senate but, tragically, died in the house.

NORTH TEXAS

Waterfall Billboard
Dallas

The 800-square-foot sign is equipped with a 35-foot-tall waterfall made out of hay-bale-and-plastic rocks. A pump circulates the water from a 10,000-gallon tank. It overlooks the busy Stemmons Freeway. But some people think it's the beach.

"The hardest part we have is keeping people off of it," said Arnold Velez of Clear Channel Outdoor, the owner of the sign. "It's a landmark and people say, 'Wouldn't it be cool if we went out there and went swimming in it?' I can't imagine it. It's pretty grungy water." It's also one heck of a climb.

That doesn't stop them, though. "We've run people off who have been sunbathing," Velez said. "People will just get on the rocks and act like they're on a waterfall in Hawaii somewhere."

Sometimes during the weekend of the Texas-Oklahoma football game, the water gets a color job. If the OU fans get there first, it's dyed red; if the Texas fans beat them to it, the water turns up orange.

III Forks
Dallas

The aptly named III Forks restaurant is a fancy place located at 17776 Dallas Parkway (888–336–7571). It features a cigar room, a wine cellar, and a 25,000-square-foot building that looks more like a funeral home than a restaurant. Eating here would probably require at least three forks.

But a full-page ad for the restaurant that appeared in the *New York Times* had a note at the bottom that seems a little out of place for a business that touts fine dining: "Houston, Texas, Residents Pay a 3.27% Surcharge," says the message at the bottom of the ad.

So why insult a city of 4.5 million people?

"People call on the phone and we tell 'em it's a joke—it's a J-O-K-E," said Dale Wamstad, III Forks's founder.

What's weird, though, is that the joke has nothing to do with the usual rivalry between Houston and Dallas. It's a joke based on history, Wamstad said. See, Wamstad, a history buff, doesn't like Sam Houston, the famous president of the Republic of Texas in the 1800s.

Wamstad says he is miffed with Houston for double-crossing the Cherokee Nation. For a time, Sam Houston lived with the Cherokees in Arkansas. The Cherokees called him Big Drunk. John Bowles, a Cherokee chief, even gave Sam Houston a sword and scabbard with a red sash in 1835, Wamstad said. But when Texas decided to run the Cherokees out of the republic in 1839, Houston turned his back on them.

So to get back at the people who live in the city named after Sam Houston, Wamstad put the surcharge line in his ad.

Wamstad said that if customers say they're from Houston the restaurant will charge them the 3.27 percent surcharge and donate the money to the Cherokee Nation.

How many people has he actually charged?

"Nobody," he said.

Some Houstonians have called to complain, however.

"I got a letter from an attorney in Houston who said, 'I'm not coming to III Forks,' " Wamstad said. "I thought, 'Well, it's working.'"

WHAT'S THAT YOU SAY?

Sam Houston and Mirabeau B. Lamar, two of the four presidents of the Republic of Texas, hated each other's guts. "Part of it was personal animosity," said Dick Rice, historical interpreter of the Sam Houston Museum in Huntsville. Part of it was diverging viewpoints on issues. "They had a completely different view on the Indians," Rice said. "Houston had supported the Cherokees north of Nacogdoches. And Lamar ran 'em out."

Suffice it to say that the two men did not get along. So at Lamar's inauguration as the president of the Republic of Texas in 1838, outgoing president Houston decided to gum up the show.

Houston showed up for the occasion dressed up in a silly outfit that was "elaborate" and "mostly green, with gold trim," Rice said. The outfit included a green cap, which the museum has on display.

Houston then proceeded to give a speech that supposedly went on for three hours. The story has it that Houston was so long-winded that Lamar never got a chance to speak at his own inauguration.

Tattooed Pig
Denton

It was 1977 when Andy Feehan, an art graduate student at North Texas State University in Denton, wanted to tattoo a pig as part of his master's thesis.

"Nobody knew what to do with him, so they gave him to me," said Feehan's professor at the time, Bob "Daddy-O" Wade. These days Wade, who lives in Austin, makes very good money creating and selling large, silly art objects made out of polyurethane. He is known for his *Tango Frogs*, a group of large frogs playing musical instruments, which used to sit on top of an eighteen-wheeler mounted on a roof at Carl's Corner, a truck stop near Hillsboro.

Feehan approached Wade about the pig project, and Wade said he told him that academia would "have to accept it—there's a lot of far-out stuff going on these days." So Feehan rounded up a pig. (Actually, he rounded up two pigs, because the first one got eaten before it could be tattooed.) Then he found a top-notch tattoo artist named Randy Adams and got a veterinarian to put the pig under for the artwork.

The tattoo was to be a set of wings on the sides of the pig.

"He was doing all these paintings of flying pigs," Wade recalled. "So he thought the best thing to put on a pig was a pair of wings."

Feehan got his master's. "My thesis was 'The Tattooed Pig as Aesthetic Dialectic,'" Feehan recalled.

But there remained one problem. What to do with the tattooed pig?

Wade suggested to Feehan that he call Stanley Marsh 3 in Amarillo, a wealthy eccentric known for enjoying this sort of caper. "And he did," Wade recalled, "and Stanley said, 'I'd love to have it.'"

Wade says that Marsh took to feeding the pig M&M's and champagne. The pig, now taxidermied, is still in Marsh's cluttered office, lying on the floor. But the wings aren't apparent.

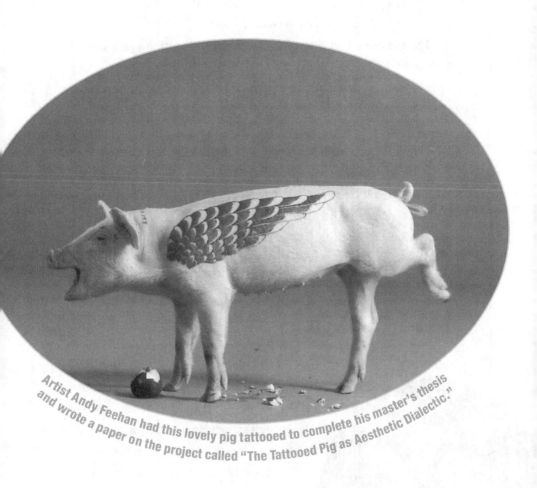

Artist Andy Feehan had this lovely pig tattooed to complete his master's thesis and wrote a paper on the project called "The Tattooed Pig as Aesthetic Dialectic."

As the pig grew up and got bigger, Wade explained, it was kind of like what would happen if you drew a design on a balloon and blew it up. "So the wings got a little bit funky," Wade said.

OLD RIP

If People for the Ethical Treatment of Animals had been around in the 1800s, this particular incident would have caused a fuss.

Legend has it that during the 1897 dedication of the Eastland County Courthouse building in Eastland, Justice of the Peace Earnest Wood put a horned toad in a small hole chiseled in the cornerstone of the building. Then on February 28, 1928, when the courthouse was torn down to make room for another one, 3,000 people gathered on the courthouse square to see how Old Rip was doing.

After the horned toad was brought out of the hole, Judge Ed S. Pritchard held the toad upside down by his tail for all to see, "and his leg twitched and he came alive," said Bette Armstrong, known around town as The Toad Lady. After that the horned toad became famous, toured the United States, and met President Calvin Coolidge in Washington. Old Rip died on January 19, 1929, of pneumonia.

This tale is big stuff in Texas, where the horned toad is the state reptile.

Armstrong takes this Old Rip business to heart. She used to wear a costume of Old Rip that she made herself in parades, and she has appeared at an Easter egg hunt in the suit with the Easter bunny. She also visited schools in her toad suit.

"I just like Old Rip," she explained. These days a deceased horned toad is on display in a little plush-lined casket at the courthouse. So if his leg twitches again, we'll have a real news story.

Old Rip is standing on the left, not the right.

Electra Goat BBQ

Electra

Is there an annual goat cook-off in this small oil patch town near the Red River because there are a lot of goats around?

"Yeah, there's uh . . . really, there's not that many," said former Mayor LaJune Lewis, changing her mind in mid-sentence. "They have to sometimes go to the store and buy 'em. We say that the dog population gets scarce this time of year."

Mayor Lewis said the goat barbecuing competition started up "to put Electra on the map." The goat cook-off started in the mid-1980s on the banks of the Red River as a private affair, when some oil company employees "bought some goats, got some beer, got drunk, got in a big fight, and everything got stuck," recalled Steve Cochran, who entered the goat cook-off with his dad under the team name of Bubba and Elmo.

These days the cook-off is run by the chamber of commerce. "It's a little tamer now," Cochran said. Really? "It's in town, anyway," Cochran said.

Why the chamber picked goats to cook at this event is a mystery to Sherry Strange, the chamber of commerce manager. "I guess it's an oddity because most of the stuff around here is beef," she said.

Incidentally, instead of tasting like chicken, goat tastes more like Pomeranian.

The National Cowgirl Museum and Hall of Fame

Fort Worth

The first thing you notice when you walk into the National Cowgirl Museum and Hall of Fame is the horse coming out of the ceiling over by the gift shop, with the cowgirl hanging onto the horse's neck.

That's a re-creation of Wild West show rider Mamie Hafley, who dove on her horse, Lurlene, from a 50-foot platform into a 10-foot pool of

water. She did this more than 640 times from 1908 to 1914, mostly during shows on the East Coast.

If either got hurt, it's not documented. Animal rights activists need not get fired up, either. Apparently the horse enjoyed the stunt more than the rider.

"The interesting story is Lurlene absolutely loved it and Mamie could not swim," said Susan Fine, the museum and hall of fame's former marketing and development director. "So she would hang onto Lurlene's neck until they came back up."

The hall of fame, located in a brand-new, $21 million building, has 176 honorees of various sorts, such as writer Willa Cather, horse opera queen Dale Evans, Lewis and Clark guide Sacagawea, country singer Patsy Cline, artist Georgia O'Keeffe, and former Supreme Court Justice Sandra Day O'Connor.

"She was a rancher and a trail blazer in her own right," Fine said of O'Connor. "She grew up on a ranch—the Lazy B. She drove cattle."

It's a fun museum because of all of the interactive stuff. You can get your picture taken and put into a Western movie poster that you can pick up later in the gift shop for $5.00. You can ride on a Plexiglas bronc on a spring and get a ten-second video of yourself made riding the thing, then download it from the museum's Web site—www.cowgirl.net. Check out the horse head over the Reel Cowgirls theater upstairs—where you can see a retrospective about cowgirls in the movies. The horse interacts with the film. His head, eyes, and lips move as he talks.

The museum is located at 1720 Gendy Street (817–336–4475).

SO YOU'RE NOT FROM AROUND HERE?

You'll run into the occasional snooty native Texan who will tell you, "If you weren't born in Texas, then you ain't a Texan." This is horse hockey, as proven by the Texas Declaration of Independence.

On March 2, 1836, at Washington-on-the-Brazos, fifty-nine delegates gathered to write the Declaration of Independence from Mexico. Of those fifty-nine, just two—count 'em, two—were Texas natives. Does that make the other fifty-seven a bunch of Yankees? I think not. But if some Texan gets in your face and gives you that malarkey about birthright, wave this page under his nose and tell him to tend to his own U-Haul.

By the way, things have changed at Washington-on-the-Brazos since then, in that there are a bunch of naked people hanging out there at a nudist colony.

Green Bay Packer Office Ceiling Dome

Frisco

In Texas rich guys with huge offices filled with dead lions they bagged in Africa are a dime a dozen.

But Jerry Szczepanski, former owner of Gadzooks, a chain of clothing stores for teens, has to be the only man in this Dallas Cowboys–adoring state who has a Sistine Chapel–like dome honoring the Green Bay Packers built into the ceiling of his office at home.

The dome-mural is probably 10 feet in diameter and 3 feet deep. It is lighted. The artist had to use a scaffold to paint it.

"When you sit at the desk, you look at Vince," said Szczepanski, speaking of legendary Packer coach Vince Lombardi, whose face is featured in the dome, along with several other Packer greats. "There are probably nine Hall of Famers up there," Szczepanski said.

The players from the old days, such as Ray Nitschke and Forrest Gregg, are done in black and white, while the newer guys—among them Reggie White and Brett Favre—appear in Packer green and gold.

Szczepanski, who hails from Racine, Wisconsin, has lived in Texas since the 1970s. But he still has no use for the Cowboys, even though the gated golfing community he lives in sits in the Dallas suburbs.

"I hate 'em. I absolutely hate 'em. I've hated 'em all my life," he said.

World Championship Pickled Quail Egg Eating Contest

Grand Prairie

"It's great to see adults out there completely uninhibited and making a fool of themselves in public and they just don't care," said Allan Hughes, director of general services at Traders Village. The flea market held its thirtieth pickled quail egg eating contest in April of 2005.

Contestants get sixty seconds to down as many pickled quail eggs as they can, one at a time. "When the whistle blows, you have to show the judge a clean mouth," Hughes said. Lester Tucker of Grand Prairie holds the all-time record with forty-two quail eggs consumed in a minute. Tucker, who works for a telephone company, won the 2003 contest, making him the champ for seven years in a row. "He has a rather unique technique in that he swallows them whole, which there's nothing in the rules that says you cannot do," Hughes said.

Has Tucker ever got one stuck while eating? "Yessir, I have, absolutely," he said. So how does he handle that? "Put another one right behind it and shove it down; that's the only way you can do it," he said. "Just don't panic."

How big is a quail egg? "It's about the size of a giant olive," Hughes said. "But one of the things that sets it apart from a hen egg is that proportionally you have more yolk than you have in a hen's egg. So when you start chewing 'em up, the yellow gets dry."

Traders Village started the contest to attract larger crowds. Chili cook-offs were a dime a dozen, so Hughes wanted something different. Coincidentally, at the time the advertising company that Traders Village was using had connections with a fowl farm that had a lot of quail eggs. "I said, 'OK, get me 1,000 eggs,' " Hughes recalled. "I didn't have any idea what I was going to do with them. I thought at first about an egg toss."

Traders Village has had some other goofy events over the years— such as the Cousin Homer Page Invitational Eat and Run Stewed Prune Pit Spitting Contest. "I've kind of retired it in favor of the Team Tortilla Tossing and the Head to Head Banana Racing Contest," Hughes said. "As you can see, it doesn't take much to entertain people in Texas."

Dallas Cowboys Cheerleader Tryouts
Irving

Most folks probably figure that all you've got to do to make the famous dance squad is kick high, look good, and smile until your lipstick cracks. But you also have to show some brains.

The tryouts include a written test. No, one of the questions isn't who is memorialized at the Lincoln Memorial. But in the 1999 tryout semi-finals, gals trying to make the squad had to take a half-hour quiz: eighty-five questions about football rules, the history of the Cowboys and the cheerleaders, and current events.

So what were some of the questions?

"Who won best actress at the Oscars this year and for what movie?" said Rachel Durbin, former special events coordinator for the Dallas Cowboys Cheerleaders. "And then there's the football questions, like, 'How many points do you get for a touchdown?' We don't want them cheering when they [the Cowboys] just fumbled the ball."

Come to think of it, who did win best actress? If you know the answer and think you have what it takes, call (972) 556–9932.

That's Amore
Italy

This town of 2,200 does have a little Italian flavor to it.

No, there is no Italian restaurant. Instead, for a few months there, you could dine at Starship Pegasus, which served pizzas and subs, had a miniature golf course, and had a building shaped like a space ship out on Interstate 35. It even featured a concrete bench out front with four adult aliens and an alien baby, for photo purposes.

Though the restaurant is closed, the space-ship building is still sitting there empty—waiting for a taker.

"What does an Italian town do with an empty space ship?" asked Susan Delephimne, president of the Italy Chamber of Commerce. "That is the question."

On the other hand, Italy does have a sometimes annual Italian Festival with a spaghetti sauce cook-off, a bocce ball tournament, and a very messy spaghetti-eating contest.

Karen Mathiowetz, formerly with the chamber of commerce, recalls watching the spaghetti-eating event. "That was absolutely a scream, because the spaghetti sauce was pretty bad and it was cold," said Karen, whose dad, the late Mike Maida, used to be the only Italian in town. "And if you threw it, it would stick against the wall."

Karen said contestants wore garbage bags over their bodies with their heads sticking out—sort of a garbage bag bib. Then they would stick their heads into the plates of spaghetti and get after it.

"They had to try to eat with their face 'cause they could not use their hands or any other part of their body, and the longer you chewed the bigger it got," Karen recalled. "And we always gave a $50 prize for the winner." Incidentally, this is the town where Dale Evans grew up, which explains Dale Evans Drive.

You're a What?

Itasca

If you attend Itasca High, you're a Wampus Cat. That's the school mascot. The cat part everybody can figure out. It's the wampus part that throws folks off.

A wampus cat, says school secretary Diane Barnes, is a fierce, supernatural Indian-legend critter that's half-man, half-cat.

"We've got like a fault line outside of town with little hills, and the kids say, 'You know, I saw a wampus cat out there,' but nobody knows

what that means because nobody's caught one," she said. "There's really no such thing, but we won't tell anybody that."

So how did the school come up with this name? "There's two different stories," Barnes said. "They got the name back in the 1920s, and it was either a cheerleader that named it, or a football player." One story has Itasca High football player Travis Burks crowing after a successful football game, "Boy, we played like wampus cats tonight." And the other story has cheerleader Donna Farrow picking the winning name in a contest to come up with a mascot for the school.

"Since both of those people are dead, it's kinda hard to prove it," said Barnes, herself a Wampus Cat since she graduated from Itasca High.

"It's hard to explain, but it's a great nickname," Barnes said. By the way, the name of the high school yearbook is The Mowana. Barnes admitted she had no idea what that means. "We don't have any usual names around here," she said. "Everything's got to be weird."

Washing Machine Museum
Mineral Wells

Fred Wilson isn't cleaning up on his collection of old washing machines on display in his laundromat, named The Laumdronat, at 700 West Hubbard Street (U.S. Highway 180). This is because he doesn't charge admission. Economists would probably go round and round with Wilson on this practice. But let's cut the puns, and move on to some actual information about the museum.

Wilson started his collection by buying an old wooden washing machine. "I had so much fun showing it to people, and one thing led to another," he said. Wilson has close to fifty old machines; the oldest dates back to about 1885. Wilson buys the machines in antiques malls and shops.

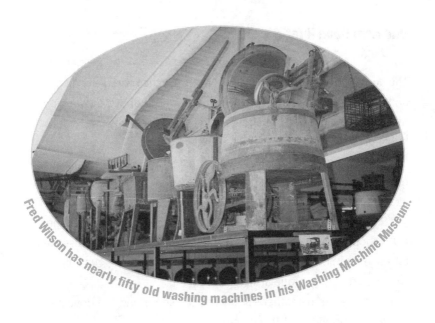

Fred Wilson has nearly fifty old washing machines in his Washing Machine Museum.

"I treat myself to a new one every month or two," he said. "After spending so much money, you just keep spending it and quit worrying about it."

The collection includes various brands you've never heard of, such as Pohr, Minute Wash, and Easy Wash, and some brands you have heard of, including Black & Decker. I didn't know Black & Decker made a washing machine. "I didn't, either," Wilson said.

Some of Wilson's washing machines don't look like washing machines. One of them is a wooden barrel with a crank on the side. "I bought it down in Houston," he said. "I thought it was a butter churn. And another one I bought, I thought it was a pressure cooker."

Either way, Wilson's hobby is unique. "There's not many washing machine collectors," he said. "I've found one in West Virginia, and Denver, I believe."

One Arm Dove Hunt

Olney

The hunt started in 1972 when Jack Northrup, the retired city manager, and former Young County Commissioner Jack Bishop were swapping tales at the local drugstore about the types of guns they use for bird hunting.

Both Northrup and Bishop are missing an arm. "Bird season was coming up pretty quick," Bishop recalled. People in the next booth were eavesdropping so the two started hamming it up.

"Once we found out they were listening, we kind of stretched the truth about the kinds of guns we use," Northrup said. The two started talking about how they used bolt action and pump guns, guns that would be tough for a one-armed guy to handle.

One thing led to another. "So we started some kind of a dove hunt for the one-armed guy," Bishop said.

At the time, Bishop said, there were six one-armed people in Olney (pop. 3,300). "And there were ten more from out of town. We had sixteen that first year."

These days, they send out 550 to 600 invitations for the One Arm Dove Hunt, Bishop said. The hunt is held the Friday and Saturday after Labor Day. It attracts a lot of one-armed hunters, but hunters with both arms are welcome.

Bishop jokes around about missing an arm. "How'd you know which one was me?" he asked me when I walked up to him in a local restaurant. At the time he was the only one-armed guy at the table.

Bishop said that he and Northrup are a team. "He's got his right arm off, and I got my left one off," Bishop said. "I call him my left hand."

Bishop lost his arm to cancer when he was fourteen months old. How'd Northrup lose his? "He said he wore it off playing piano," Bishop said. "But I think he's lying. Don't you?"

The dove hunt comes with a trap shoot, a one-armed golf tournament, country-and-western music, "and the next morning we have a ten-cent [a finger] breakfast," Bishop said. "It don't cost much even if you have three arms."

"We'll probably have a shoe-tying contest this year," Northrup added.

For further information, check out www.onearmdovehunt.com.

The Cockroach Hall of Fame Museum
Plano

"People call up. I tell 'em, 'Don't go out of your way. It's not the Smithsonian,'" said exterminator Michael "Cockroach Dundee" Bohdan, who wears a fedora hatband lined with dead Madagascar hissing roaches.

The museum consists of about two dozen little three-dimensional scenes that feature dead celebrity roaches dressed in costumes. The roaches are on display in the front of Bohdan's pest control business, The Pest Shop, at 2231-B West Fifteenth Street. You've got Liberoachi, Marilyn Monroach, and Ross Peroach, to name a few.

"It's a love-hate relationship," Bohdan said of the way people feel about roaches. "People hate bugs, but when they're dressed in a tutu, they're not so bad."

The dressed-up roaches were entries in a contest held by Combat bug control products to find the best-dressed roach in the United States. Bohdan traveled the country in the 1980s to run the contest. Those on display are some of the winners.

The Liberoachi scene is really quite elaborate. A dead roach sits at a toy piano decorated with a tiny candelabra. Liberoachi is wearing a white cape. It plays music when Bohdan hits a button.

Then there's the Combates Motel, a takeoff on the Bates Motel in the Hitchcock movie *Psycho*. The Combates Motel is a tiny roach-sized house. The roach is carrying an itsy-bitsy dagger.

To this day Bohdan still gets folks bringing in new roach displays for his collection.

"I've found out that people want their own roaches in here, so someone brought in a Norman Roachwell," he said. "It's got a picture of a roach painting a roach that's laying down on a table. I've noticed one thing. Roaches are truly nude. They don't wear clothes, both the roach and the artist."

He's also thinking of doing a Pete Roach diorama. "Pete Rose can't make it into the real Hall of Fame, but I'll bet if I could get Pete Roach in the Cockroach Hall of Fame, I'd make it onto ESPN," he said. "My wife calls me sick. I call myself eccentric."

Bohdan used to have a Last Supper roach display. "There were twelve roaches at a little table, and they all had plates," he said. But somebody stole it.

Bohdan has written a pest control book called *So What's Buggin' You?* In it, he rates bug movies on a scale of one to five roaches. "One of my favorites was *The Wasp Woman* from 1959," he said.

Bohdan also hands out packets of Larvets Original Worm Snax— seasoned insect larva—for museum visitors to try out if they want. "The kids always eat 'em, but the parents won't touch 'em," he said.

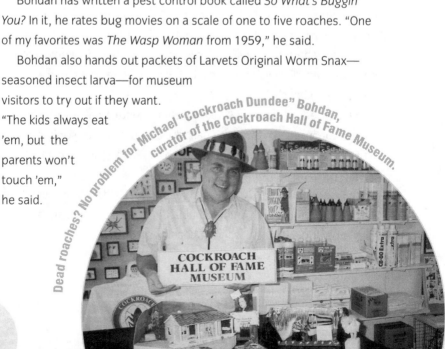

Dead roaches? No problem for Michael "Cockroach Dundee" Bohdan, curator of the Cockroach Hall of Fame Museum.

COCKROACH HALL OF FAME MUSEUM

ANOTHER TEXAS FIRST

You've got to wonder if, in the beginning, teenagers hung out at Highland Park Village, commonly referred to as the first shopping center in the United States. When the center opened in 1931, was it an immediate magnet for teens, the way malls are today? Did they drive the security guards as nuts back then as they do today?

There was no Pac-Man in 1931, when architects Marion Fooshee and James Cheek began creating Highland Park Village, in tony Highland Park, a small city surrounded by Dallas. It took more than twenty years to finish the shopping center, during which time construction was interrupted by the Great Depression and, later, World War II.

It would be several decades before the mall idea took off all over the United States. So, if it wasn't for Highland Park Village, people all over the United States wouldn't be walking around mall parking lots right this minute, trying to find their cars.

Dung Beetle Sculpture
Strawn

A dung beetle isn't the kind of insect you would think would make sellable art. After all, this is a bug that rolls up animal dung into a ball and lays its eggs in the ball so the larvae can feed on it.

This is not the sort of thing that would make a great high school mascot. Still, Marc Rankin makes artwork dung beetles out of scrap metal that he finds in salvage yards. "The junkyard is his favorite place to hang," said his wife Lisa, who says she doesn't know a lot about dung beetles.

"Marc knows what there is to know about 'em," she said. "I just know they roll little turds up." Isn't that enough?

So far Marc has built about seven dung beetles, Lisa said. Each is a two-piece work—the actual bug, and the ball of poop that the bug rolls around. One of the dung beetles Marc put together is the world's largest dung beetle, according to Lisa, at 6 feet tall and 4½ feet wide, with a dung ball of 48 inches in diameter. It was bought by a business in Granbury for $1,800.

This metal dung-ball-rolling beetle is the handiwork of sculptor Marc Rankin.

Not all of the dung beetles are large. Lisa says a teacher in Houston called and ordered a small, desk-sized dung beetle so that the school principal's face could be placed on the dung ball. The teacher who ordered it even sent a photo of the principal for the artwork.

"Apparently the principal has no kind of sense of humor," Lisa said.

So why make dung beetle sculpture? Marc says it's because they are Texana. "People in Texas are proud of Texas and they really do like that kind of stuff," he said. But there's a more practical reason.

"Somebody asked for one," Lisa said. "That was how he started making 'em. Somebody asked if he could make a dung beetle, and he said, 'Yeah, I guess I can.' "

Munster House
Waxahachie

Sandra McKee is such a huge fan of the '60s-vintage TV horror send-up *The Munsters* that she decided to build a new house that looks just like the one on the show. And now she's living in it with her husband Charles.

Oh, it's not an exact replica. The kitchen looks pretty normal. "I couldn't do one like theirs cause they had cabinets falling down, and I didn't want cabinets falling down 'cause I'd have to live here," Sandra said.

The suit of armor at the top of the stairs doesn't rotate yet like the one on the TV show, and the creepy stairs leading up to it don't lift up yet, either. But one day, Sandra said, the stairs will rise eerily when the pneumatic equipment is installed. And eventually the suit of armor will twirl. See, Sandra and Charles, a plumbing contractor, still have a lot of work to do before the 5,825-square-foot house is finished. So far they've invested $325,000 in the project.

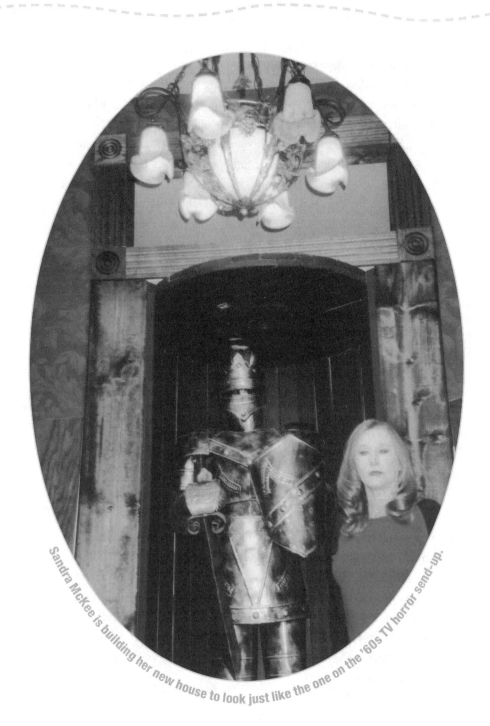

Sandra McKee is building her new house to look just like the one on the '60s TV horror send-up.

But they do have the dungeon in. "We don't have a basement, since this is the 100-year flood plain," Sandra said. "So we had to get a storm shelter and sink it so we could have a dungeon. 'Course, we did get in it a few weeks ago when we had tornado warnings around here."

Sandra McKee is a *Munsters* nut. She watches the reruns twice a day on TV—at 8:30 in the morning and at 10:30 at night. "There's some shows I love more than others," she said. "And even if I can't watch it, I love to have it on and hear it. I dunno. It's relaxing to me." She owns all seventy episodes of the series, whose main characters—the Munster family—were a collection of horror-movie rejects.

"They're just an average American family," she said. "Herman went to work. Lily was the housewife. Eddie went to school. Marilyn went to college. They were a very honest, clean family. They never hurt people. They just ate different things." Like what? "They had, like, centipede salad and yak," Sandra answered.

Sandra came up with the design for the interior of the house by rewatching episodes of the show. "It's amazing how much you have to research when you're doing a project like this," Sandra said. She and Charles started building the place in 2001, and they moved in in 2002. On Halloween 2002 they had a big Munsters party. Al Lewis, who played Grandpa Munster, and Butch Patrick, who played Eddie Munster, were invited and showed up, along with 500 to 600 other folks in costume.

"[Lewis] actually had tears in his eyes when he came inside," Sandra said. "He said it brought back a lot of memories."

Oh, that downstairs closet door that appears to be made out of a coffin isn't really made out of a coffin. "A funeral home wanted to donate a coffin but I said nah," Sandra said. "They said, 'You'd get used to it,' but I said, 'I don't want to get used to it.' I don't want to come downstairs and see a coffin sitting there."

NEIMAN MARCUS COOKIE YARN

Legend has it that a woman liked the chocolate chip cookies at the tony Dallas department store's restaurant so much that she asked for the recipe. The waitress gave it to her.

The story goes that later the woman got a bill for $250 on her credit card. In some versions of the story, it's a Visa credit card. Neiman Marcus points out it only takes its own card and American Express.

In fact, Neiman Marcus didn't even serve cookies in its restaurants until after this urban legend began circulating years ago.

Anyway, here's the recipe, straight from the store.

½ cup unsalted butter, softened
1 cup brown sugar
3 tablespoons granulated sugar
1 egg
2 teaspoons vanilla extract
½ teaspoon baking soda
½ teaspoon baking powder
½ teaspoon salt
1¾ cups of flour
1½ teaspoons instant espresso powder, slightly crushed
8 ounces semisweet chocolate chips

Cream the butter with the sugars until fluffy. Beat in the egg and the vanilla extract. Combine the dry ingredients and beat into the butter mixture. Stir in the chocolate chips. Drop large spoonfuls onto a greased cookie sheet. Bake at 375° F for 8 to 10 minutes, or 10 to 12 minutes for a crisper cookie. Makes 12 to 15 large cookies.

If you use this recipe, you will be billed by the author of this book at the rate of $150 per cookie.

Just kidding.

Bar-L Drive-Inn
Wichita Falls

According to Sunshine Payne, the former bartender at this drive-in at 908 Thirteenth Street (940–322–0003), there are only two places in Texas where you can get curb service beer brought to your car—at the Bar-L and the nearby P-2, also known as The Deuce. So you can sit in the parking lot underneath the carport and order a beer from a carhop. And she'll bring it to your car. And you can sit in your car and drink. And as long as you never leave, there's no problem. Because as far as I know, there's no law in Texas against PWI—parking while intoxicated.

You don't have to drink outside, though. You can go inside the Bar-L and drink at the dimly lit bar, if that's your choice. A sign out front said, SMOKING ALLOWED. I'm surprised it didn't say, SMOKING REQUIRED.

The pork ribs are great here, and the beer of choice is a kind of breakfast beer called a red draw. It's about an inch of tomato juice in the bottom of a frosty mug, topped off with draft Bud. I suppose the idea is that if it has tomato juice in it, that means it's okay to start drinking early.

Wacky Car Ads
Wichita Falls

No one can ever accuse Dan Gomillion, general manager of Lipscomb Chevrolet Pontiac, of being overly sophisticated when it comes to TV ad campaigns.

"We're fixing to do one where we actually blow up a car," Gomillion said. "We got an explosives professional that's coming by. It'll look like a car bomb going off. I don't know what kind of car we're going to blow up, but it definitely won't be a Chevrolet or a Pontiac."

A THRONE FIT FOR THE KING

Cathye Bullitt may be the only person in Texas to receive through the mail a toilet seat allegedly used by the King himself, Elvis Presley. She's definitely the only person in Wichita Falls.

"That's probably the most unique gift I ever got," said Cathye, who works in child protective services for the state of Texas. Let's hope so. Cathye is an Elvis fan who started collecting Elvis stuff as a child, after seeing the 1960 movie *G.I. Blues* at the drive-in.

Let's swivel-hip forward to 1980. By then, Cathye was working at Wichita Falls General Hospital. She had a friend named George Redheffer who was working for the American Retirement Corps in Nashville, Tennessee. That company was converting an old Hilton Hotel in Mobile, Alabama, into retirement condos. While it was a hotel, Elvis would stay in a suite on the top floor, Redheffer said.

"What happened is he [Redheffer] knew I liked Elvis," Cathye said. So while the remodeling was going on, Redheffer dismantled the toilet seat in the suite where Elvis used to stay and mailed it to Cathye at the hospital in Wichita Falls as a keepsake.

Did she know the toilet seat was on the way? "Oh no, I had no idea," Cathye said. "When it arrived, there were a lot of nurses and staff standing around. And when we opened it, we couldn't stop laughing."

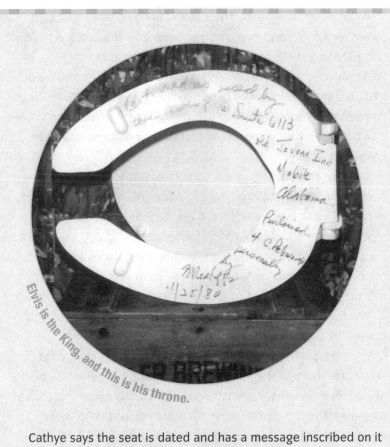

Elvis is the King, and this is his throne.

Cathye says the seat is dated and has a message inscribed on it that says Elvis used it.

In the spring of 1999, Cathye loaned the seat to the Boat House, a warehouse/party room in Wichita Falls where boats are remodeled.

"It's well seen by various people around town," Cathye said.

When a competing dealership used a talking horse in its ad campaigns, Gomillion says his dealership simply stole the idea and began using a talking horse, too. "They were using a horse as their spokesman, so we took a similar-looking horse and sold him a car on TV," Gomillion said. "Showed him driving off in our vehicle." The other dealership called its talking horse Clyde the Horse, so Gomillion's dealership just borrowed the name and called their costumed ad horse Clyde the Horse, too.

Gomillion has a history of this sort of thing. When he was working at another dealership in Wichita Falls, its ads were voted the most annoying commercials by the students at Wichita Falls High School.

Perhaps the best ad Gomillion's former dealership put out showed the salespeople wearing shock dog collars while dealing with customers in what Gomillion laughingly referred to as "our new training method."

"We basically put the dog collars on the salesmen, send them out toward the customer, and then we shock them," he recalled.

He said his salespeople thought they weren't really going to be shocked while the ads were being made. Hah. Big surprise. "We actually shocked the salespeople when we did this," he said. "They trusted us enough to put the collar on, thinking we wouldn't do it. But of course if they've got it on you've got to shock somebody."

Other ads made it appear, in a low-budget sort of way, that either Gomillion or his former partner Ron Rittenhouse were getting run over, tossed, or pulled apart. Dummies were used to achieve this effect. "One of us gets the raw end of the deal every time," Gomillion said. "It could be having your arm pulled off by two cars going in different directions, or being lassoed and dragged down the street by a car."

Gomillion says one ad his former dealership aired simulated Rittenhouse being pitched off the roof of the dealership.

"We threw a dummy off the top of the building," Gomillion said. "People still remember that commercial. People still come in and ask if we'll jump off the building for them."

Gomillion added that the dealership got a complaint when one of their ads showed the Energizer bunny being smashed.

"The vice president of marketing for Purina called up and asked us to get that one off the air," he said.

These ads were so bad that Gomillion said the National Rifle Association even called to complain when one of the ads showed a simulation of Rittenhouse being shot off a blimp at 300 feet in the air.

"The NRA asked us not to show that type of violence on TV," Gomillion recalled.

Wichita Falls Waterfall
Wichita Falls

You're next to U.S. Highway 287 with traffic whizzing by. You have just walked down a wooded trail decorated with a sign that warns you it's against the law to leave dog poop behind. Above you, though you can't see it from your vantage point, is a cemetery.

Where are you?

You are standing at the base of the Wichita Falls Waterfall, a man-made waterfall that was turned on June 5, 1987, by Niagara Falls Mayor Michael O'Laughlin.

If O'Laughlin had gone over these falls in a barrel, he probably would have survived. The four-tiered waterfall, constructed of rocks, is 54 feet high. A seventy-five-horsepower pump circulates water out of the muddy, red Wichita River for the falls.

The falls cost $418,817 to put in, $230,000 of which was donated by folks and businesses.

Why such a crying need for a falls? See, the real waterfall for which the town was named was washed away by a flood in 1886. So the town needed another falls. Otherwise, the name of the place might have to be changed to Wichita Flats.

World's Littlest Skyscraper
Wichita Falls

I couldn't find anyone who could verify the legend behind this tiny building at Seventh and LaSalle Streets in the city's historic district.

The story goes that the "skyscraper" was the result of an oil boom scam in the early part of the century, according to Carole Woessner of the Wichita County Heritage Society.

The "world's littlest skyscraper."

Oil had been struck in nearby Burkburnett, prompting people to flood the area to seek their fortunes. Meanwhile, back in New York, the newspapers were reporting a shortage of office space in Wichita Falls, and a prospectus began circulating offering stock in a skyscraper to be built in Wichita Falls.

A drawing of the would-be building showed it reaching into the sky, dwarfing other buildings. Supposedly, $200,000 in stock was sold to build it. The story goes on to say that in 1919 the little building was built by J. D. McMahon, a construction engineer from Philadelphia.

McMahon avoided legal problems by building the building to scale— in inches instead of feet.

McMahon then quickly left Wichita Falls.

Regardless of how it got here, the brick, tower-shaped building is 16⅝ feet by 10 feet by 40 feet high and too small for an office. Woessner said it doesn't even have a stairwell.

EAST TEXAS

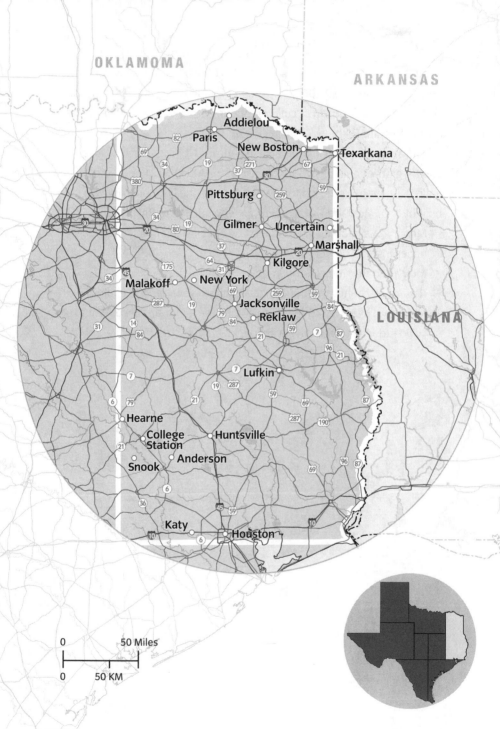

OKLAMOMA

ARKANSAS

LOUISIANA

Addielou

Paris

New Boston

Texarkana

Pittsburg

Gilmer

Uncertain

Marshall

Kilgore

Malakoff

New York

Jacksonville

Reklaw

Lufkin

Hearne

College Station

Huntsville

Snook

Anderson

Katy

Houston

0 50 Miles

0 50 KM

EAST TEXAS

One Bad Bull
Addielou

Bodacious is buried on Sammy Andrews' ranch now, but he used to be big in rodeo. He even made it onto a Wrangler T-shirt, and a breeding consortium was distributing his semen. Heck, even Mick Jagger can't make that claim.

There was a time when you didn't want to mess with the rodeo bull billed as "The World's Most Dangerous Bull." And that ain't no bull.

This bull had one message for mankind: Get off of my back. This bull was so bad that in 1999 he was inducted into the Pro Rodeo Hall of Fame in Colorado Springs. This bull was so bad that Andrews, who raises rodeo bulls for a living, retired him in 1995 before he could mangle again. See, Bodacious handed out serious injuries to several riders and sent folks to hospital emergency rooms.

"We'd had several warning shots and just didn't want to take the chance on him killing somebody," Andrews explained. "Not that he would have, but we just didn't want to take the chance. Bull riding is kinda how we make a living, and we didn't want to be the ones wiping out bull riders."

Only six bull riders out of 135 managed to finish their rides on Bodacious. Tuff Hedeman, one of the few riders who managed to stay aboard Bodacious for the full eight seconds, got his face smashed in another Bodacious ride. He called Bodacious "the baddest bull there has ever been." When Hedeman drew him again later, he decided not to get on.

Bodacious was known as the "Yellow Whale," giving him nearly Moby Dick status. "You mention Bodacious to people in New York or Los Angeles and everybody knows what you're talking about," Andrews said.

Still, many riders just couldn't resist. "Oh, he was kinda the superstar at that time," Andrews said. "So kind of like a big gun fighter, if you wanted to make a big name for yourself, you tried him."

These days Bodacious rests in peace in a fenced-off area on the ranch.

"The Astrodome gave us a bucking chute that Bodacious had bucked out of at the Astrodome for his tombstone," Andrews said. "So he has a pretty decent grave marker now."

Beer Can Collector

Anderson

The former Grimes County Commissioner used to be so adept at spotting beer cans on the ground that he could pick them out at high speeds from behind the wheel of his pickup.

"When I was really into it, I could be going down the road at 50 or 60 miles per hour and a beer can would catch my eye," said Marcus Mallard. Mallard has a collection of more than 2,000 different kinds of beer cans—including many that held beers you may never have heard of. Like, say, Walter's—"the beer that is beer," it says on the can. Then there's Hi Brau Premium, Pickett's of Dubuque, and Our Beer from Wisconsin.

Most of the cans are stored in the 1885 vintage Santa Fe railroad depot Mallard bought so he would have a place to store his beer cans. It's loaded with cans, bottles, and all manner of beer signs and beer boxes.

"I paid $3,500 for the depot and $7,500 to move it," Mallard said. "I call it the world's largest den."

The can collecting started in 1976, when Mallard and his girlfriend jumped in his pickup truck and drove north, looking for beer cans in beer joints, stores, and by the sides of roads.

"We went up in the Midwest as far as North Dakota and whatever's west of that," Mallard recalled. He soon found a problem with collecting —beer is often sold by the six-pack. So even though he'd want just one of a certain can, he filled the back end of his pickup with six-packs.

With the weight of all that beer in the back end, the truck rode funny. "The headlights were almost straight up in the air," Mallard said, perhaps exaggerating.

WHAT'S IN A NAME?

Surprisingly, Texas didn't get its name because it fits well on a bumper sticker. It just worked out that way.

This Texas business started when early Spanish settlers met the Hasinai Caddo Indians of East Texas. The Hasinais used the word tayshas, meaning "friends" or "allies," as a greeting. In Spanish the word came out tejas, which eventually became Texas. How "howdy" came along is another matter, however. And why Texans call oil "all" is still another.

That Texas means friends, though, is fitting, because this is a friendly state. In West Texas it's customary for people to wave at each other from their trucks, even if they don't know each other. This is often done with the one-hand wave—a wave accomplished by lifting the fingers of the hand without letting go of the steering wheel.

In Austin, drivers are more likely to give the one-finger salute, but it's a big state and it has its cultural differences.

THE DECEASED MASCOT FLAP

The Texas A&M Aggies are as serious as a case of the hives about their traditions, and they have more of them than a used car lot has salesmen in cheap suits.

It's a tradition for the Aggies to stand up during football games. It's a tradition for the guys to kiss the gals in the stands after A&M touchdowns. It's a tradition for the Corps of Cadets to wear burr haircuts. Traditionally, the male cheerleaders are called "yell leaders."

So it should have been no big surprise in the summer of 1997 that some Aggies were outraged when the graves of four of their deceased canine mascots were moved across the street from Kyle Field, the football stadium, and reburied next to the statue of the Twelfth Man (another A&M tradition that says the fans in the stands at football games are the twelfth man on the field for A&M). The four Reveilles—three collies and a stray—were relocated for the $30 million expansion of Kyle Field.

The reason some were miffed when the dogs were moved from a place near the stadium to a spot across the street? Tradition at A&M says the dogs are to be buried paws and faces pointing toward the stadium's north tunnel, so they can see the scoreboard inside the stadium. And in their new location, the dogs' line of sight to the scoreboard was blocked, so they could no longer see the score.

To fix this, a small scoreboard that the dogs can see from their graves has been erected on the side of the stadium.

EAST TEXAS

Mount Aggie
College Station

Leave it to the Aggies to be at the leading edge of the unusual. Is this the only ski slope in Texas?

"I can't really answer that—it's the only one I know of," said Frank Thomas, chairman of Texas A&M University's physical education activity program.

It's the only one I've ever heard of. Mount Aggie—actually, Mount Aggie II—is an artificial ski slope for beginning and intermediate snow skiing, two of the most popular physical education courses at Texas A&M.

Located outdoors near the varsity tennis facility, Mount Aggie II is not the kind of slope to set you to yodeling. But it is 35 feet high, with a 140-foot run. The slope, a pile of dirt with a concrete base, is lined on top with an Astroturf-type surface and lubricated for downhill runs by a sprinkler system. It has a rope tow that takes skiers to the top. Sadly, it does not come with a St. Bernard carrying a tiny keg under its neck.

Mount Aggie II replaces an earlier Mount Aggie that was 21 feet high and had two 90-foot runs. Thomas said that before it was torn down, the original Mount Aggie was a popular spot for Aggies to bring visitors from out of town to show them that you can ski in College Station.

The East Texas Yamboree
Gilmer

Held the third Wednesday, Thursday, Friday, and Saturday in October, this is the festival for folks who have a hankering to decorate a yam.

The yam decorating contest is for children, but "I guess adults could join it, I don't know," said Charlotte Denson, former secretary of the Gilmer Area Chamber of Commerce.

What do the children decorate their yams to look like?

"There's always a Dolly Parton, and there's always some whales, porpoises, penguins, airplanes," Denson said. "Their imaginations run wild."

The festival, which Denson says attracts about 100,000 each year, used to have a bicycle race called, you got it, the "Tour de Yam."

All right, I'll quit yammerin' on. Call (903) 843–2413 for more information.

Aunt Jemima's Gravesite
Near Hearne

No, there is no truth to the rumor that the Pillsbury Doughboy is buried in Weatherford. (Somebody ate the Pillsbury Doughboy.) But the Hearne Chamber of Commerce says that the last woman to tour the country for the Quaker Oats Company playing the part of Aunt Jemima and promoting pancakes is buried in a country cemetery northeast of Hearne.

In 1988 the Hearne Heritage League put up a grave marker for Robertson County native Rosie Lee Moore, who, the chamber says, toured the country from 1950 to 1967 plugging Quaker Oats' pancakes.

The grave marker says that Moore, born June 22, 1899, and died February 12, 1967, served as Aunt Jemima for Quaker Oats for twenty-five

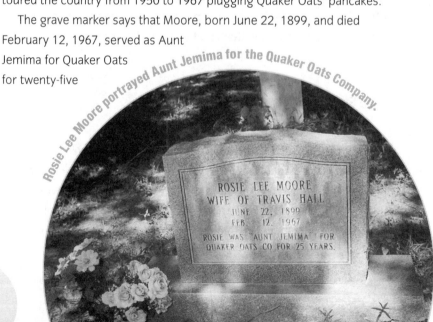

Rosie Lee Moore portrayed Aunt Jemima for the Quaker Oats Company.

years. The chamber of commerce used to hand out a brochure with a map of how to get to the gravesite, along with a list of motels where you can stay if you want to visit. Imagine planning your vacation around this trip. But Kent Brunette, director of the chamber of commerce, said they quit doing the brochure because of complaints from the black community. He says if people ask about the gravesite they'll tell them how to get there, however.

The brochure said that Moore left Robertson County in her twenties, after a failed marriage, and moved to Oklahoma City, where she went to work for Quaker Oats and was discovered while working in the advertising department. The trouble is that according to the Oklahoma City Historical Society, there was no listing of a Quaker Oats facility in the Oklahoma City city directory in 1950 through 1953. So this story has some mystery to it.

Allison Harmon, a spokesperson for Quaker Oats in Chicago, says there were six women who played Aunt Jemima over the years at state fairs and other events, and that one of them was a Rosie Moore Hall, Rosie Lee Moore's married name.

Rosie Lee Moore grew up with thirteen brothers and sisters on a farm 10 miles east of Hearne, according to her sister, Luejean Moore.

Luejean's only keepsake of her sister was a formal photo portrait of a handsome woman dressed to the nines. "I had one with that head rag on with that Quaker Oats," she added. "But somebody has done got it."

To get to the gravesite, take FM 391 east out of Hearne, go 4 miles, head north on FM 2549 for a couple of miles, then go east on County Road 229, a dirt road. About a half mile up that road on your left, you'll see the Hammond Colony Cemetery. Aunt Jemima's marker is toward the rear of the cemetery, under an oak tree. Veer slightly to the right as you walk through the front gate. It's kind of hard to find because it's not marked with a large jug of syrup or anything unusual.

The Crooked E

Houston

Remember that so-called Crooked E in front of Enron's 1400 Smith headquarters that you used to see on the TV news all the time after the company's accounting practices helped take out the U.S. economy?

Well, these days the stainless steel and neon E is sitting in the Stan and Lou Advertising Agency in Houston. Lou Congelio, the company president and a mild-mannered bearded guy, bought the 4-foot E at an auction of Enron stuff in December of 2002 for $8,500. The E is now sitting near the pool table in the ad agency's fun room. Lou bought it strictly as pop-art. At the auction Lou bought a lot of other Enron memorabilia, too—a wall-hanging E for $5,000, a bunch of lightbulb-shaped toys with the Enron logo stamped on them, and Ken Lay's brass telescope. The telescope now sits in Lou's office.

"This chair is from Enron," said Lou, speaking of the chair he was sitting in behind his desk. "Thanks to Enron, I've been able to decorate my office."

The big $8,500 E was in such bad shape that after Lou bought it he had to pay a sign company to refurbish it. The Crooked E has icon status in Houston, apparently. "The sign company was really funny," Lou said. "They put their best man on it. It was as if it was a piece from the Sistine Chapel or something. Only the best man could work on it."

By the way, $8,500 might sound like a lot for an E. But the sign company people told Lou that Enron probably paid $50,000 when they bought it originally. "They went first class," Lou said. Which was part of the problem.

By the way, the women of Enron who posed for *Playboy* after the company's demise also posed around the 4-foot E that Lou bought. So as a joke, he got three of his female employees to pose around his E for a photo. At the time, he referred to them as "The Girls of Stan and Lou."

Lou Congelio of Stan and Lou Advertising in Houston paid $8,500 at auction for this 4-foot Enron "Crooked E."

The Beer Can House

Houston

From 1968 to 1988, the late John Milkovisch covered his entire house at 222 Malone Street with flattened beer cans, says his son Ronald.

Dad, an upholsterer for the Southern Pacific Railroad, was a big beer drinker who generally kept eight cases of beer in the garage, Ronald recalled. "He even had a Shiner distributor stop by once and ask if he wanted beer delivered."

The house is covered with flattened beer cans, except for some spaces up under the eaves. John Milkovisch developed a method that involved making panels of fifteen beer cans each. Then, the panels were tacked to the house, label side out, so you could tell what he'd been drinking.

Many of the labels you'll see on the house are discount brands, some of which don't exist anymore: Texas Pride, Pabst Blue Ribbon, Jax, Falstaff, Buckhorn, and Southern Select.

"He used any beer that was on special, just to try to save a dime, 'cause he bought a lot of beer," Ronald said.

The project began in the early 1970s, when John Milkovisch made strings of beer can tops to dangle in front of the west and south sides of his house to keep the steamy Houston sun off it. "There was an ulterior motive, other than being eccentric and a little bit crazy," Ronald said.

The strings of can tops tinkle merrily in the breeze. Actually, the pop top strings have been removed temporarily because of Hurricane Rita. Wouldn't want to lose those in a high wind.

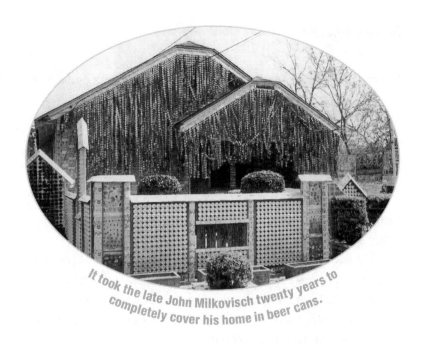

It took the late John Milkovisch twenty years to completely cover his home in beer cans.

"But it's cool because you get to see what's underneath those things, and that's aluminum siding twelve ounces at time," said Allen Hill, media and marketing coordinator for the Orange Show Center For Visionary Art. The art foundation has purchased the Beer Can House to turn it into a museum. It's supposed to open in 2007. Currently no one is living in the Beer Can House. The last person to live there was the late Mary Milkovisch, John Milkovisch's widow. Even the mailbox is covered with beer cans—in this case, Bud Light. So you could say that no surface has been left uncanned.

Otto's Barbecue
Houston

The sign behind the counter at Otto's Barbecue used to say, WHAT PART OF "NO" DON'T YOU UNDERSTAND? What it should say is, READ MY LIPS.

Otto's, at 5502 Memorial Drive (713–864–2573), is where former President George H. W. Bush comes when he wants to eat some barbecue. Bush lives about 5 miles away from the place, said Mike Jenkins, the former manager.

Jenkins said Bush comes in so often that the place has a George Bush Plate on the menu. That's pork ribs, beef, and sausage, with potato salad and beans.

While in the place, Jenkins says, Bush often hands out tie clips, pens, and other souvenirs decorated with the presidential seal to customers.

Nothing stuffy about George when he shows up for barbecue. "He's very approachable," Jenkins said. "He wouldn't think about cutting in line. He wouldn't think about having his meal 'comped.' In fact, he buys for his Secret Service guys frequently."

The Orange Show
Houston

Starting in the mid-1950s, the late Jeff McKissack, a Houston mailman, collected wagon wheels, tile, rocks, hunks of metal, and other junk found on his downtown delivery route. Then he built a monument out of it, which he called the Orange Show.

McKissack thought the orange was the perfect food. Hence the name. The junk, however, has made the magical leap to art. Today the Orange Show Center for the Visionary Arts (713–926–6368), a nonprofit arts organization with a $1 million annual budget, looks after it, teaches art classes in it, and conducts tours of it.

I guess you could say the Orange Show has moved from the dump to docents.

At one time McKissack considered building a plant nursery, a worm farm, or a beauty salon on the site, at 2401 Munger Street. These days, the place has a lot of whirligigs that make noise, and you can sit in tractor seats McKissack found to watch a working steam engine.

The Orange Show Center for the Visionary Arts puts on the world's oldest and longest art-car parade on the second weekend of May, featuring decorated cars, such as Richard Carter's spectacular Sashimi Tabernacle Choir, a mid-1980s model Volvo covered with roughly 250 singing fish and lobsters. "You remember those annoying singing fish that were popular at Christmas?" Carter asked. "That's pretty much the foundation."

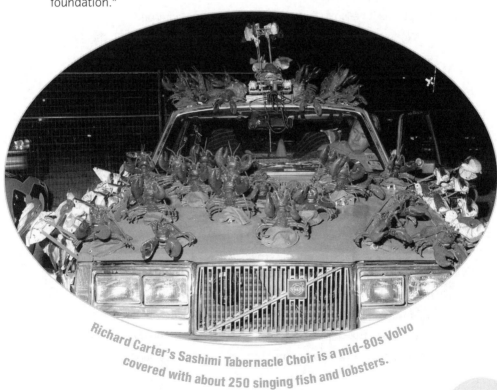

Richard Carter's Sashimi Tabernacle Choir is a mid-80s Volvo covered with about 250 singing fish and lobsters.

Carter, who works for an engineering company, settled on the singing fish car idea because "it was too good to pass up," he said. "I knew I somehow had to make it happen." He made it happen by buying a bunch of singing fish and lobsters at a Walgreen drugstore. "The clerks really loved me there," he recalled. "They wanted me to buy more so they wouldn't have to listen to the damn things." He said his fish and lobsters sing everything from the theme song from the TV show *Rawhide* to a couple of operatic numbers.

Surfing Next to a Tanker
Houston

Hey, at least he isn't surfing in a sewage treatment pond.

When a tanker churns on by in the Houston Ship Channel, the surf's up for James Fulbright. That's right, the Houston Ship Channel, the brunt of many jokes about skanky, smelly water.

So what do people say when they hear about a guy surfing in the waves created by a tanker in a huge dredged-out shipping ditch? "The first couple years, it was just absolute disbelief," Fulbright admitted.

For the past nine years Fulbright has been surfing the waves created when the big freight hauling ships go by. Fulbright won't say exactly where he does this in the ship channel, just somewhere between Galveston and Houston. He keeps it a secret, he says, because there's not enough room for everybody to surf here.

Like this is going to draw a crowd.

Face it. Tanker surfing is not exactly like riding the 20-footers off the north shore of Oahu. The waves the tankers make, James says, usually run from about "knee high" to 5 or 6 feet tall.

But since the ship channel is 30 miles long and the tankers go from one end to another, sometimes the wave is loooooooonnnnnnng.

This suits Fulbright just fine, because he'd like to break the record for world's longest surfing ride.

"I've tried to find the longest possible ride you can find so I can possibly be in the *Guinness Book of World Records*," said Fulbright, forty-eight, who has a surfing shop in Galveston called Surf Specialties. "Right now it's 7 miles, and that's in South America in the Amazon River. And we are trying to beat that."

And he thinks he can. "So far our longest documented ride is 4½ nautical miles," Fulbright said. "We do have the ability from my research to beat the record. It's difficult, but it is possible."

Not a lot of people around the world surf in waves made by tankers. "We're putting Texas on the map—not so much for ocean surfing, but for tanker surfing," Fulbright said. "It's pretty unique to our area."

It's hard to mention the Houston Ship Channel without somebody making a joke about grunge. Isn't it a bit disgusting to surf in this stuff? Don't you have to hold your nose?

Going for a record in tanker surfing.

"No, not really, not at all," Fulbright said. "The water is perfectly fine. It's a really large body of water. It's a gigantic bay. So it's not a small body of water that is subject to stagnation."

With a smaller body of water, he said, "I could see stuff festering back there."

As nutty as Fulbright is about surfing, I suspect he would surf even where it was festering. He enjoys the challenge of surfing where surfing seems unlikely.

"We get so addicted to surfing and we love it so much we're going to try to surf any way we can, even when the surf is flat," he said. "If you can figure out a way to surf every day, you're going to take it. That's the way it is."

It's not that dangerous, he added, because you're not really surfing that close to the tankers. The biggest ships weigh about 50,000 tons. So they're heavy enough and causing enough water displacement that you can surf a long way from them.

"You're surfing kind of parallel to the ship, but you're a very safe distance away—a couple of football fields. You're a good 200 yards from the vessel."

And no, you don't just paddle out to a spot behind a tanker and jump up on the board, either. "You chase the wave in a chase boat," Fulbright said. "And then the surfer jumps out and catches the wave and rides it as long as he can."

The National Museum of Funeral History

Houston

If things are a little dead, why not stop in at the National Museum of Funeral History?

Opened in 1992, the museum, at 415 Barren Springs Drive (281–876–3063), shares the building with a school for morticians and boasts "fantasy coffins" from Ghana in the shapes of a Mercedes, a chicken, a bull, a fish, an outboard motor, a lobster, a KLM jet, and a shallot, to name a few.

The sign said the airplane would be a casket "for someone who had never flown." You'd think it would be the other way around.

"That shallot would be for a family that raised onions and sold them in an open-air market," explained Gary L. Sanders, a mortician by trade and the museum's former director.

The museum's motto? "Any Day Above Ground Is a Good One." Visitors to the museum—about 6,000 people a year visit the place—can buy baseball caps and coffee cups decorated with that chirpy reminder.

Any interactive exhibits? Nope. "We try to keep it in good taste— that's our deal," Sanders said.

Among the more interesting exhibits? Check out the Packard Funeral Bus, one of many funeral vehicles on display. Built circa 1916, the bus was used just once—in a funeral in San Francisco. It was hauling the casket, the pallbearers, and twenty mourners. When it tipped back from the weight, the pallbearers fell over the mourners, and the casket overturned.

Are we having fun yet?

Variety Fair 5 & 10
Houston

If you ever need a set of wax lips, a hand buzzer, or a Betty Boop bobble-head doll, this is the place to go.

This old-fashioned five and dime, at 2415 Rice Boulevard (713–522–0561), even sells Chinese finger traps, those devices that grab your fingers when you stick them in the ends. Is there anything that this living museum of the 1950s doesn't carry?

"No. See, we even have the kitchen sink back here," said Cathy Klinger Irby, who has worked in the store off and on since 1963. Her parents, Alice and Ben Klinger, opened the place in 1948.

"People told my father one too many times, 'You have everything but the kitchen sink,' " Irby explained. "So he had a kitchen sink put in here."

The store carries spools of thread, kitchen gadgets, brands of chewing gum you haven't seen in years (including Black Jack and Clark's Teaberry), and all sorts of toys that make noise. During a visit, a plastic frog croaked, a plush rabbit sneezed, and a woman played with one of those moo cow devices that goes off when you turn it upside down.

There are also rubber roaches, Spider-Man lunch boxes, toy army men, Pez dispensers, and NunZilla, a windup nun toy that appears to spit fire as it clanks along.

I've been looking for one of those.

THE LAST SUPPER

You can order anything you want for your last meal, as long as it's available in the kitchen. So forget the lobster. And no fair ordering a bucket of chicken from the Colonel, either. No deliveries are allowed.

In Texas, which leads the nation in executions, the Department of Criminal Justice in Huntsville keeps a detailed list of every last meal ordered by its death row inmates. From December 7, 1982, through July 18, 2006, that was a list of 369 last meals. The department used to keep this list on line, but it has quit doing that.

"We got a number of complaints from people who thought it was in poor taste," explained Michelle Lyons, a department spokeswoman. "The irony is, the reason we put it on the Web site in the first place is that it was the piece of information most requested of us."

Last-meals information is still included in execution press packets, though, she added. Some of these guys eat like there's no tomorrow.

"This guy tomorrow is unbelievable," said Larry Fitzgerald, former public information officer for the Department of Criminal Justice. He was speaking of Hilton "Uncle Hilty" Crawford, who was executed July 2, 2003. "He ordered twelve beef ribs, three enchiladas, chicken fried steak with cream gravy, crisp bacon sandwich, a bowl of ketchup, a loaf of bread, any kind of cobbler, three Cokes, three root beers, french fries, and onion rings," Fitzgerald said. "This guy is not worried about cholesterol."

Some of the last meal requests are, well, untraditional. "One guy requested dirt," Lyons said. She said the inmate ordered the dirt for some sort of voodoo ritual, so the request was denied. " He did not get dirt, he got yogurt," Lyons recalled. "That to me is the one that always stands out."

CONTINUED

On March 12, 1986, Charles Bass ordered a plain cheese sandwich. On January 22, 1992, Joe Cordova ordered fried chicken, french fries, hot sauce, rolls, salad with Thousand Island dressing, and ice cream. And on February 26, 1991, Lawrence Buxton ordered a filet mignon, pineapple upside down cake, tea, punch, and coffee.

So what's the favorite? "A double-meat cheeseburger with french fries," said Fitzgerald.

Anybody ever order a veggie burger? "No, but we've had 'em order yogurt," Fitzgerald recalled.

No cigarettes are allowed with that last meal, however. For health reasons, cigarettes have been banned from the entire Texas prison system, including death row, since 1995.

Wouldn't want anyone being taken out by secondhand smoke.

Holy Smoke

Huntsville

The official name of the church at 2601 Montgomery Road is the New Zion Missionary Baptist Church. But it's better known as the Church of the Holy Smoke.

This is because of the barbecue business right next door to the church with the barrel-shaped cooker out front.

Sometimes there is so much oak wood smoke pouring out of the cooker that it looks like somebody ought to call the fire department.

This all started back in the mid-'70s when some of the deacons were painting the church. "The ladies went out to fix dinner and they had this old pit they started a fire on," said the Rev. Clint Edison, the church pastor. "And they was just making a day out of cleaning the church."

The aroma from the fire and the meat cooking began attracting passersby. "And people began to stop and ask was they selling barbecue," Rev. Edison said. "They said they couldn't even fix their husbands dinner for people asking if they were selling barbecue."

The next week, Rev. Edison said, some of the church members borrowed $50 from the church to buy meat, then started up a barbecue business. "And it's been going ever since," he said.

There's no barbecue on Sunday; don't want to distract anyone.

At first the barbecue business didn't even have a building. "They just had a pit outside," said Horace Archie, who runs both the church's Sunday school and the barbecue operation. He pays the church weekly rent to keep the place going, "whether we make any money or not." Barbecue is sold Wednesdays through Saturdays. The barbecue isn't going on Sundays because it could be a distraction to the flock next door at the church.

"When you're smelling food, your mind drifts," Horace explained. You can order pork ribs, chicken, beef brisket, and sausage. It's all you can eat for $10.

The little barbecue building isn't much to look at. A small, handmade poster out front tells the hours of operation and says MAY GOD BLESS YOU. A bench near the cooker consists of a warped piece of plywood set on top of a couple of stumps.

Inside, you'll sit at long picnic tables that have advertisements for local businesses laminated on top: Oliphant's Furniture, CP Electronics, the Mattress Factory. Each place setting comes with two pieces of white bread wrapped in cellophane. The barbecue is heavy with sauce, which explains why you'll find rolls of paper towels on every table.

When Sam Houston State is playing a home football game, sometimes the visiting team will show up to eat. One time it was about thirty-five guys from the McNeese State squad, Horace recalled. Did they eat him out of business? "They didn't clean us out, but they got close," he said.

On some Sunday mornings the barbecue place puts on a Bible quiz for a prize. This consists of Horace or another church member asking a Bible question on one of the local radio stations. "Whoever answers the question gets a meat plate," Horace said. A picture of some of the contest winners decorates one of the restaurant walls.

But you don't have to be of a religious bent to eat in here. "There's some regular Hell's Angels that come by in the summer," Horace said. "They didn't do no cuttin' up."

EAST TEXAS

Texas Prison Museum
Huntsville

The Texas Prison Museum is a great place to take the old ball and chain, if you want to see the old ball and chain. But the centerpiece of the museum is Old Sparky, the oak electric chair that went out of business in 1964 after zapping 361 death row dwellers over forty years.

Old Sparky isn't plugged in, by the way. This is not an interactive exhibit. Children are discouraged from climbing on Old Sparky, even though that photo would make a great Christmas card, huh? On the other hand, you can put on a black and white–striped jacket available at the museum and get your picture snapped behind bars in the 6-by-9-foot cell just like the one Texas prison inmates live in.

Senior citizens who stop in to visit just love doing that, according to Janice Willett, the museum's treasurer. "They wear these shirts and they just think it's hilarious," she said.

Just like in real prison, a toilet sits right out in the open inside the cell, providing absolutely no privacy but a great opportunity for an unusual Christmas card photo.

"We get these high school kids in here all the time and they want to get [pictures of] their friends sitting on the toilet," said Jim Willett, the museum director and a former warden of the state prison system's Walls Unit.

The museum moved into a brand-new 8,000-square-foot building in 2002 after being in a much smaller space on the Walker County Court-house Square. Moving the museum cost about $1 million, and you can't miss the new location. It's the place with the guard tower out front, near Interstate 45. The new museum even comes with a conference room. Huntsville is a company town, so lots of people work for the prison system, which explains why this room gets plenty of use. When I went to the grand opening of the new location, word was an

assistant warden was planning to have his wedding reception in the conference room.

This museum, which opened in 1989, ironically has been visited over the years by some former prison inmates who have dropped in to take a look. You mean these guys really come in on purpose? "Oh, absolutely," Janice Willett said. "When we were downtown, we were one block from the bus station. So when the parolees got out, they would come to the museum. That was a daily occurrence."

The place even has a souvenir shop. I was particularly fond of the striped T-shirt you can purchase that says, "I Did Time in Huntsville." They also sell a shirt that says "Pen State."

This ain't no Holiday Inn.

EAST TEXAS

Sam Houston Statue
Huntsville

The president of the Republic of Texas (1836–38 and 1841–44) is big in Huntsville, literally and figuratively.

The 67-foot, 30-ton statue of him next to Interstate 45 about 2 miles south of town is the world's largest free-standing figure of an American hero. The white sculpture, done by Huntsville native David Adickes, is so big that you can see it from 6½ miles away from the south. Actually, it kind of makes Sam Houston look like Col. Sanders.

This town is ate up with Sam Houston, who retired here after serving as Texas governor. The gift shop at the visitor center near the statue was selling Sam Houston throw rugs, miniatures of the Sam Houston statue, Sam Houston statue shot glasses, Sam Houston statue T-shirts, "I Saw Big Sam in Huntsville, Texas" bumper stickers, and a T-shirt that explains it all with this message on the front: "It's a Texan thing. Y'all wouldn't understand."

Also, if you look in the Hunstville phone book, you'll find listings for The Sam Houston Group, Sam Houston Chevron, the Sam Houston Antique Mall, and the Sam Houston Washateria.

Huntsville is the home of Sam Houston State University, Sam Houston's gravesite, the Sam Houston home, and the Sam Houston Memorial Museum.

AND THEY CALL IT THE RODEO

"The inmates really did like the thing," said former Texas prison system spokesman Larry Fitzgerald, speaking of the now-defunct Texas Prison Rodeo, a piece of Texas history that started up during the Depression and was canceled in 1987.

No wonder the inmates liked performing in their own rodeo. Not only did the cash prizes for bull riding, bareback bronc riding, and steer wrestling give the winners some spending money, but it also gave them something to do and provided them with a chance to escape.

Around 1940, two inmates escaped from the prison thanks to the rodeo. The two stole some civilian clothes out of the prison laundry, mingled with the rodeo crowd, and eventually dropped down into the stands and fled.

"A guard who was standing around thought they were two civilians who were trying to sneak in," Fitzgerald said. The guard admonished the two men for not paying their way into the arena and shooed them off.

The rodeo, held in the 26,000-seat arena next to the Walls Unit in Huntsville, was billed as "The World's Wildest Show Behind Bars," Fitzgerald said. "Most of the guys came into it with nothing to lose. So they went all out."

One event featured a Bull Durham sack full of money tied to a bull's horns. "Whoever took the Bull Durham sack off the horns got to keep the money," Fitzgerald said. During the history of the rodeo, at least two inmate cowboys were killed in bucking bronco accidents. And during the 1956 rodeo, veteran inmate rodeo clown Snuffy Garrett was pitched about 20 feet over a fence by a bull, breaking three of Snuffy's ribs.

Apparently, the bull didn't think he was funny.

EAST TEXAS

The Tomato Bowl
Jacksonville

"The story is it was built as a WPA [Works Progress Administration] project in 1934," says Matt Montgomery, who does the radio color commentary from the sidelines on Friday nights at this stadium, once named in a newspaper article as one of the top ten places in Texas to watch a high school football game. "It still has the original stone walls around it. It's basically an old downtown stadium. There's horrible parking. But it's real tight, real cozy."

The Tomato Bowl not only is the only stadium in America named after a BLT ingredient, it also comes with a lot of traditions. The railroad track runs behind the north end of the stadium, providing a perch for some of the locals to sit on so they can watch the game without paying to get in.

"But trains come by all the time, so they have to get up and move," said Deena Brand, Jacksonville High's secretary of athletics.

Three or four trains come by each game, Montgomery added.

"The trains always honk and make a ruckus," he said. Whenever that happens, John "Skipper" Reese, a local character and a Tomato Bowl fixture, gets out there near the tracks and waves the train through by whipping his arm around like he's directing traffic.

"I always mention on the radio that tonight's train is directed by John Reese," said Montgomery, an investments advisor who played quarterback in the Tomato Bowl for the Jacksonville High Fightin' Indians.

Check out the totem pole with the ten lightbulbs out front of the stadium. "When we win, the whole team and the whole crowd goes up after the ballgame and they put a blue light signaling a win on the totem pole," Montgomery said. "If we don't win, we obviously don't go out." After a loss, white lightbulbs go up—eventually. But not right after the game.

The name of the stadium comes from the '30s and '40s when Jacksonville was the self-proclaimed Tomato Capital of the World. "Tomatoes were kind of huge here," Montgomery said. "They're not so much anymore, but the name stuck."

Hey, it beats the Zucchini Bowl, right?

TomatoFest

Jacksonville

Festival goers may be disappointed that the Battle of San Tomato no longer occurs at this annual festival held the second Saturday in June.

In past festivals, teams of twenty-five students from Jacksonville College and Lon Morris College slung tomatoes at each other. Each team got twenty cases of tomatoes to hurl.

"It was always the highlight of the day," said Mandy Johnston, economic development assistant for the Jacksonville Economic Development Corporation. "I think we gave 'em five minutes, but it was a long five minutes.

"Some of 'em would wear war paint and camouflage on their faces, and T-shirts—something they didn't want to get messed up," she added. "They'd bring trash can lids and all sorts of things to protect themselves from being hit."

The Battle of San Tomato has been replaced by a tomato-eating contest that usually involves about a dozen participants. "They have two minutes to eat as many tomatoes as possible," Johnston said. She added the entrants often make unusual requests regarding their tomatoes. "Some of 'em want them to be chilled. Some of 'em want salt and pepper. Some people want salad dressing. Whatever kind of request they have, we try to do it to make 'em eat as many tomatoes as possible."

Not that catering to the entrants does any good. "There isn't a lot of tomato eating that goes on," Johnston admitted. "Mainly there's a lot of cheating. One year a lady put them inside her hat she had on. And one year a lady tossed them over her shirt to keep from putting them in her mouth. We've had some characters."

Other events include tomato basketball and tomato golf. "We have this little putt-putt thing set up, and they have this little cherry tomato they use as a golf ball," Johnston said.

Forbidden Gardens

Katy

Want to see 6,000 terra cotta replicas of Chinese soldiers lined up for battle? How about a scale model replica of the Forbidden City in Beijing?

Then this park, off Interstate 10 at 23500 Franz Road, is the place for you. The eighty-acre park (forty have been developed) is owned by Ira Poon, a Chinese businessman who has homes in Seattle and Hong Kong. The park, which opened in 1996, includes thousands of terra cotta soldier replicas crafted to look like the ones dug up about 1½ miles from the tomb of Emperor Qin, who ruled China in the third century B.C.

Everything's under control in Katy.

MARVIN ZINDLER

On Friday night during his restaurant health report, Marvin Zindler has been known to holler dramatically. "Sliiiiiiimmmme in the iccccc-cce machine."

The KTRK-TV consumer reporter buys about twelve huge white pompadour hairpieces a year and isn't shy about mentioning it. His TV delivery on the evening news is that of a preacher working a tent revival. He wears sapphire blue, tinted sunglasses and plantation-owner white suits. He ends each of his reports at 6:00 and 10:00 P.M. with the signature sign-off, "MARRRRRRR-VIN Zindler, EEEEEYE-Witness NEWSSSSS!"

He's been with the Houston station since 1973, and he's not the guy you want in your face with a TV camera if you're a business owner who's jacked around a customer. He loves charging into an office with a camera, feigning righteous indignation, and getting people's money back. He's kinda like Mike Wallace with a rug.

But the flamboyant Zindler will go down in Texas history as the man who closed the Chicken Ranch, the famous brothel in the small Fayette County town of La Grange.

In 1973, when Zindler reported on his show what everybody in the state legislature already knew—that there was a whorehouse 65 miles east of the Capitol—it forced then-Governor Dolph Briscoe to shut the place down.

The man who closed the Chicken Ranch, the famous brothel in La Grange.

The Chicken Ranch became even more famous after it went out of business. The brothel was glorified in *The Best Little Whorehouse in Texas,* both a musical and a movie starring Dolly Parton and Burt Reynolds.

Comedian Dom DeLuise played Zindler in the movie. Zindler, not a bashful fellow, thinks he could have done a better job himself. "He was silly, all right," Zindler said. "But if I'd played me straight, that was even funnier than trying to be funny."

Expect to keep seeing Zindler, now in his eighties, on KTRK. He has a lifetime contract that he intends to honor.

"I'm going to make 'em know what a lifetime contract is," he said. "I'm probably going to die on the set."

Rangerette Showcase Museum
Kilgore

So what does it take to become a member of the Kilgore Rangerettes, America's first football halftime show precision drill team?

"You know what the common thread is?" asked Lynne Oberthier, the nice lady who works in the museum. "They know how to smile and project to the public. But they do have to be able to get their foot up over their head."

She's talking about the famous kick-line routine the Kilgore Rangerettes have performed for over a half century at the Cotton Bowl in Dallas. To make it onto the team of seventy young women, you have to be able to loft your white boot above your hairdo.

There is one other common thread among the Rangerettes: As you will see from the photos that line the walls of the museum, most of them are pretty darned cute.

The museum centerpiece is a sixty-one-seat, seven-row theater where you can watch a ten-minute movie about the history of the Rangerettes, who were formed in 1940. In the movie you see the Rangerettes dancing to the song, "Can You Feel a Brand New Day." This movie has more syrup than the Aunt Jemima factory.

Perhaps the most famous Rangerette of them all? Alice Lon, Lawrence Welk's first Champagne Lady, was a Kilgore Rangerette.

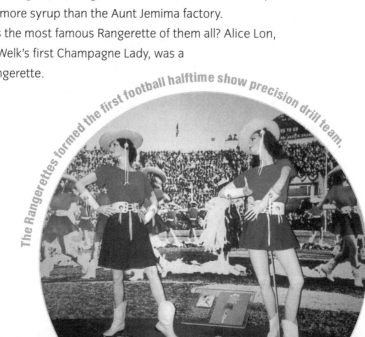

The Rangerettes formed the first football halftime show precision drill team.

"THAT'S ONE SMALL STEP . . ."

The story goes that after Neil Armstrong made his "one small step for man" remark to mission control after walking on the moon, he added the mysterious comment, "Good luck, Mr. Gorsky."

The story continues that for years when asked about this, Armstrong would smile but not explain.

The story concludes that in 1995, twenty-six years after man's first moon walk, Armstrong came clean to reporters because Mr. Gorsky was finally dead.

Seems that as a child Armstrong lived near Mr. and Mrs. Gorsky. One day while young Armstrong was playing baseball with a friend, the friend hit a ball, which landed under the Gorskys' bedroom windows. Supposedly, as young Armstrong stooped down to retrieve the ball, he heard Mrs. Gorsky holler to Mr. Gorsky, "Sex! You want sex? You'll get sex when the kid next door walks on the moon."

Horse hockey, NASA says.

"It's generally accepted it's an urban legend that's thrived and grown over the years," said NASA spokesman Ed Campion. "It's one of those things that started off as a joke, and with the Internet it proliferated and took on an urban legend life."

Paul Nerren's Junk Barn

Lufkin

"I like to get unusual stuff nobody else has got," said the scruffy Paul Nerren, bearded and wearing overalls.

Nerren lives up to his business motto, "If You Can't Find It in Your Barn, Come Look in Ours." Of course, some of the stuff you can't find in your barn, you might not want to find. One time Nerren bought a glass-topped casket with a skeleton still in it. "Old boy pulled up out here and said, 'I hear you'll buy about anything,' " Nerren recalled. "I bought that casket with a skeleton in it for about $100. That old boy said he had it for a coffee table, but his girlfriend didn't like it."

Paul Nerren's Junk Barn, at 4500 U.S. Highway 59 North, is a two-acre lot behind chain-link fence with band uniforms, camper tops, wagon wheels, rusty tools, garden watering cans, refrigerators, water coolers, a wild hog trap, hay rake teeth, keys, bed springs, license plates, and thirty-five dead school buses full of junk.

"Cheap storage," Nerren said, explaining why he buys used-up school buses from school districts.

B. A. Goodwin, a frequent customer and friend who manages Barrett Brothers Motor Company in Lufkin, said that when something turns up missing, the law starts looking out here.

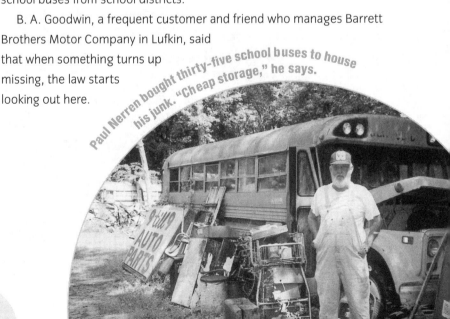

Paul Nerren bought thirty-five school buses to house his junk. "Cheap storage," he says.

"The constable comes by frequently to see what's been ripped off," Goodwin said. "When somebody files a report, this is often where they start."

Nerren is proud of the railing that allegedly came out of the Astrodome in Houston. It has a big dent from where a laborer fell from the ceiling and landed during the construction of the facility. That's the story Nerren tells, in any case.

"It's a helluva talk piece, anyway," Nerren said. "If a man had a gift of gab, he could make a whole lot of money showing it at safety meetings, couldn't he?"

If you can't find it in your barn, call Paul at (936) 632–2580.

Fire Ant Festival and Ugly Face Contest
Marshall

Like any town in Texas, Marshall has a fire ant problem. But its festival to the biting bugs gives the town a leg up on a sequel.

"If we ever do get rid of 'em . . . we will do a memorial festival to them," said Pam Whisenant, former tourism director for the town of 25,000.

Held the second weekend in October, the festival has a fire ant calling contest. "No one knows what a fire ant sound is, or if they make a sound," Whisenant admitted. "But we decided people should make three different calls: one for food, one that's an alarm call, and one that's for mating. And it's pretty fun what they come up with."

Then, for the daring, there's the fire ant roundup. Contestants are provided with plastic milk jugs to put the fire ants in. The person who collects the most fire ants in two hours wins $150.

"Which probably will cover some of their medical expenses," Whisenant commented.

Who counts the fire ants to see who wins? "We don't actually count them; we end up weighing them," Whisenant said. "I think the most we've gotten is ten ounces. You know the size of ants. That's a lot of fire ants."

Another highlight of the festival is the Ugly Face Contest, in which contestants put their heads through a toilet seat and make an ugly face.

The late J. J. Stachowiak of Ore City, who won the ugly face contest seven times, said it's all in the technique.

"I just kind of bring my lower lip up to my nose, and kinda suck my face in a little bit and cross my eyes," said Stachowiak. "All I have to do is hold it for fifteen to twenty seconds."

Jim Bowie Statue
New Boston

No, the 8-foot-tall bronze of the Alamo hero in front of the Bowie County Courthouse doesn't have a little pinch between its cheek and gum, like Walt Garrison suggested in the old TV ad for Skoal chewing tobacco. But the knife-toting statue of Bowie, who died defending the Alamo, is done in the likeness of the long-since retired Dallas Cowboys running back.

"Walt Garrison did pose for it," said former Bowie County Judge Ed Miller. So the statue is wearing Jim Bowie clothes. But it has Walt Garrison's chiseled visage.

Miller said the statue caused him some amusing embarrassment. When a reporter for the *Texarkana Gazette* was interviewing him about the upcoming unveiling, Miller said he used the term "the erection of the James Bowie statue." Miller said it showed up that way in the newspaper, "in heavy print."

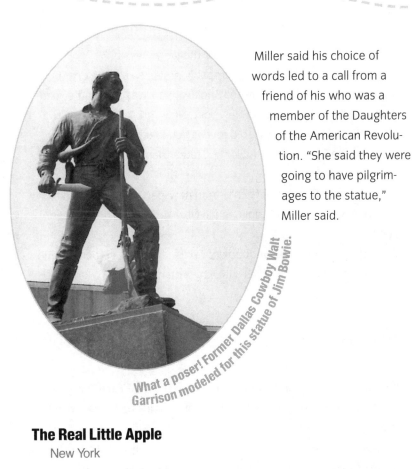

Miller said his choice of words led to a call from a friend of his who was a member of the Daughters of the American Revolution. "She said they were going to have pilgrimages to the statue," Miller said.

What a poser! Former Dallas Cowboy Walt Garrison modeled for this statue of Jim Bowie.

The Real Little Apple
New York

It's not like that other New York back east. There's no Statue of Liberty. There are a lot of cows. There are no cabbies honking at you. The population is about twelve. Crime? What's that?

"We were broke into about ten years ago," said Carolyn Reynolds, who owns Reynolds New York Store, a fertilizer and feed store, with her husband Dewey. "They stole some tires and stuff. That was the only time we were ever broke into."

New York, on FM 607 about 11 miles east of Athens, has the feed store, the New York Baptist Church, the New York Cemetery, a few houses, and that's about it.

So which is better? This New York or the larger version?

"Well, at the time that I went, I probably preferred the big one, but now I prefer this one," said Rowena Sholars, who lives across the road from the feed store. She was in New York, New York, in July 1961. "I went to a Broadway show called *Camelot*," she recalled. "We went to Wall Street, the Empire State Building, Staten Island, had a drink at the Waldorf."

Every so often Rowena gets calls from newspaper reporters on New Year's Eve asking her what's going on in New York, Texas. Her answer: "Not much."

According to the *New Handbook of Texas*, the town, settled around 1856, may have been named as a joke by a man called T. B. Herndon.

Eiffel Tower Replica
Paris

Unlike the 984-foot-tall original in France, the 65-foot-tall Eiffel Tower in this Texas town doesn't have an elevator that you can ride up to the top in.

In fact, you are not even allowed to get on this Eiffel Tower. DO NOT CLIMB ON EIFFEL TOWER. IT IS AN UNSAFE ACTIVITY, the sign says. On the other hand, the original in France doesn't have a huge red cowboy hat on top, either.

The idea to build an Eiffel Tower cropped up in the mid-1990s, when Gary Vest became director of the Lamar County Chamber of Commerce.

"Kind of facetiously, I started asking everybody, 'Well, where's our Eiffel Tower?'" he recalled. "We use this promotion that says this is the second largest Paris in the world." Vest said there are fourteen Parises in the world, and, at 25,898 people, this one is the world's second-largest Paris.

Vest began talking about an Eiffel Tower with Rick Thomas, then plant manager at the Babcock & Wilcox boiler plant. Members of Boilermakers Local No. 902 built the tower for nothing out of scrap materials at the plant. Later, Daon Wall, who used to have a company called Wall Concrete Pipe, told Vest, "I'm gonna build that hat for you."

The 1,300-pound steel tower went up in 1996, and the hat was added in 1998.

Other than the Eiffel Tower and Culbertson Fountain downtown, there isn't much French in this town about 10 miles south of the Oklahoma line. I looked around for a French restaurant, and all I could find was Le Colonel Sanders, Le Waga Bag, and Le Long John Silver's. So I ended up dining at Rustlers, a barbecue place that has—yes, French fries.

By the way, Paris is in a dry county. So this Paris ain't gay.

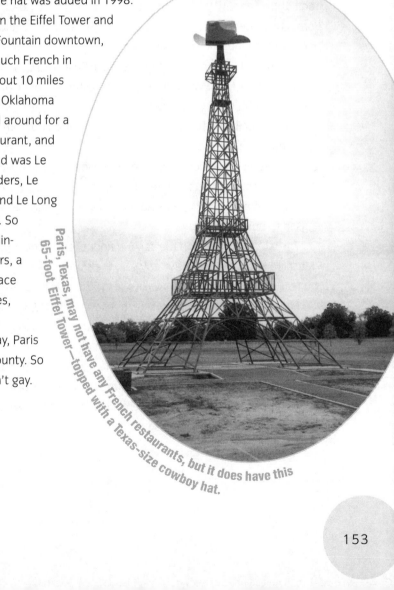

Paris, Texas, may not have any French restaurants, but it does have this 65-foot Eiffel Tower—topped with a Texas-size cowboy hat.

Ezekial Airship
Pittsburg

In 1902, a year before the Wright Brothers got off the ground, a bizarre aircraft designed by Baptist preacher Burrell Cannon flew here—but not very well.

"According to the witnesses who saw it, it went up about 10 feet and drifted about 100 feet, and it was vibrating pretty bad, so they brought it down," said D. H. Abernathy, who as of 2006 had been the mayor of Pittsburg for fifty-two years.

The Ezekial Airship is so-called because Reverend Cannon got the idea to build it from passages in the Old Testament book of Ezekial that mention flight: "And when the living creatures went, the wheels went by them; and when the living creatures were lifted up from the earth, the wheels were lifted up."

This prompted Reverend Cannon to raise money to build an airship. In 1900 a group gathered in the local opera house to create the Ezekial Airship Company. Stock was sold for $25 a share, and $20,000 was raised to build the ship.

The work was done on the second floor of the Pittsburg Foundry and Machine Shop. Mayor Abernathy said the ship was so big that they had to tear out part of the south wall to get it out of the building.

Perhaps the airship's longest flight occurred in 1903, when a tornado blew it off a train car in Texarkana. The airship was on its way to the world's fair in St. Louis, but it never made it.

A replica of the airship can be seen hanging from the roof of the Northeast Texas Rural Heritage Museum. It's a funny-looking machine with fabric wings, a hydraulic system, wooden paddles, an eighty-seven-horsepower engine, and one seat.

ARMPIT MUSICIAN

Russell Slaton of Malakoff didn't have to attend the Julliard School of Music to learn his unusual musical talent.

The super-serious University of Texas football fan can play the "Aggie War Hymn" under his armpit. He says it's a trick he picked up in grade school. He's a little shy about it, too—even though his unique talent earned him an appearance on *The Tonight Show with Jay Leno*.

"I get asked to do it every once in a while, but it's on rare occasions that I do so—and not drunken either," said Slaton.

Slaton usually performs the trick only for close friends. The world would be a better place if he'd do it for the halftime show at the annual Texas–Texas A&M game.

If you listen closely, when Slaton plays his armpit, it does sound like the fight song of the University of Texas's bitter rival. Then again, it also sounds like someone is repeatedly and rapidly squeezing a toad.

Slaton accomplishes his feat by cupping his right hand under his left armpit and flapping like a buzzard. Slaton, who has a journalism degree from UT, can also play the University of Oklahoma song, "Boomer Sooner." But don't ask him to perform "The Eyes of Texas." He refuses to make fun of his own school.

Cluckingham Palace
Pittsburg

Architecturally speaking, the spectacular home of chicken magnate Lonnie "Bo" Pilgrim is a combination of Louis XIV and Palm Harbor Mobile Homes. But it's a darned sight bigger than a double-wide.

According to Pittsburg Mayor D. H. Abernathy, the house has 20,000 square feet of living space and sits on a fifty-acre spread. Twenty-six of those acres are landscaped.

"It takes five men full-time to keep the yard," said the mayor, a friend of the CEO of Pilgrim's Pride, the chicken and feed company that dominates this town. Pilgrim made himself famous in 1989 when he handed out $10,000 checks to some members of the Texas Senate on the Senate floor, two days before the Senate voted on a workers' compensation bill Pilgrim favored.

Pilgrim's huge home is right on U.S. Highway 271 where anyone driving by can see it. You can't miss it. It's the great big beige place with the four little statues in the front yard. You have to look closely to see the statues, though. They're small. They're of Bo's grandchildren.

A statue of Bo at the company's new freezer plant on US 271, 5 miles north of Pittsburg, shows Bo reading the Bible, accompanied by the company mascot, Henrietta the chicken. So it looks like Bo is reading the Bible to a chicken. Bo built the Prayer Tower and Witness Park in town for $1.5 million, the mayor said. It has a Big Ben–style clock on it, and it sits across the street from Pilgrim Bank.

Cluckingham Palace was used for an afternoon and night to raise $109,000 for George W. Bush when he was running for governor, Mayor Abernathy said.

"[Pilgrim] charged $125 a head to eat supper out here in the yard, and he charged $500 to get in the house," the mayor recalled.

Abernathy added that one of the ponds in the backyard has a fountain that shoots water 30 feet in the air, and that the color of the water can change from red to blue to amber.

Then there's the swimming pool. "The east side of the pool is air-conditioned, and on the west side you can take a sun bath," reported Mayor Abernathy.

JESUS IN COWBOY BOOTS

The grave marker for Willet (1828–1881) and Belinda (1824–1909) Babcock in Evergreen Cemetery in Paris proves that in Texas, if you're not dressed country, you ain't doodley.

The Christlike figure carrying the cross on top of the monument has a cowboy boot protruding out from under his robe. The only boot you can see is the left boot. The right one is covered by the robe. So we don't really know if the figure has a running shoe on his other foot.

Gary Vest, director of the Lamar County Chamber of Commerce, said people don't know much about Mr. Babcock. But Vest figures he must have been a pretty powerful man to be able to get away with having a grave marker that shows Jesus in footwear proper for the rodeo.

Sodolak's Country Inn

Snook

Things are not only bigger in Texas, they're also greasier.

It's hard to imagine a more artery-clogging food than the chicken-fried bacon served at this rustic steak house. Frank Sodolak, the owner of Sodolak's Country Inn on FM 60 (979–272–6002), believes he invented the dish: six double-breaded bacon strips, deep-fried in oil, served with a bowl of cream gravy. Ever since Sodolak's treat was mentioned in a newspaper article, it has been a big seller.

"Business has been skyrocketing—I can't keep up with it," said Sodolak, who figured he sells thirty-five to forty-five pounds of bacon a week, as opposed to the ten or fifteen pounds a week he sold before his item was publicized.

It's a tasty treat. But it's enough to make the food cops throw their tofu-covered mitts in the air in horror.

"I've never heard of anything worse," said Jayne Hurley, senior nutritionist at the Center for Science in the Public Interest in Washington, D.C., the same group that warned us about the dangers of Mexican food. "They've taken fat, they've double-coated it in fat, they've fried it in more fat, and then served it with a side order of fat."

Yeah, well, so what? This is Texas, where men are men and their arteries are clogged. Sodolak said some of his customers even order the chicken-fried bacon as an appetizer, to go with their chicken-fried steaks.

State Line Avenue

Texarkana

The message on the water tower here says, TEXARKANA IS TWICE AS NICE, but perhaps what it should say is "Texarkana Is Twice as Confusing," or "Texarkana Is Schizophrenic."

State Line Avenue, which runs right through the middle of town, is just exactly what it says it is—the state line, between Texas and Arkansas.

The Texas side of the street is dry; the Arkansas side of the street is wet. All of the liquor stores are on the Arkansas side of State Line Avenue. So you've got The Party Factory in Arkansas right across the street from the Baptist Book Store in Texas.

The area code on the Texas side of the line is 903. On the Arkansas side it's 870. But it's not a long-distance call from one side of the street to the other. So if someone from the Baptist Book Store calls The Party Factory, he doesn't have to pay a long-distance fee. Not that anyone from the Baptist Book Store would have a reason to call The Party Factory.

State Line Avenue runs right up to the federal building, then goes around it. So the state line runs right through the middle of the federal building. Half of the post office on the ground level is in Arkansas, and the other half is in Texas. The federal courtroom for Texas districts is on the Texas side of the building; the federal courtroom for Arkansas districts is on the Arkansas side.

When streets run across State Line Avenue, they often change names or numbers. For example, at State Line Avenue, Arkansas Boulevard changes into Texas Boulevard. So even though Texarkana has only 60,000 people and isn't exactly what you could call huge, it's still easy to get lost.

Arkansas has a state income tax, while Texas does not, which leads to more confusion. According to the Texarkana Chamber of Commerce,

U. S. POST OFFICE AND FEDERAL BUILDING, TEXARKANA, ARK., TEXAS

© TEXARKANA, TEXAS

MAN IN ARKANSAS AND HIS ASS IN TEXAS

This famous postcard from the 1930s shows a man and his ass at the state line of Texas and Arkansas. The joke is that the man's ass is in Texas while the man is in Arkansas. Hah!

Arkansas residents who live inside the city limits of Texarkana, Arkansas, are exempt from the Arkansas income tax, regardless of where they work. Texas residents who live inside the city limits of Texarkana, Texas, and work inside the city limits of Texarkana, Arkansas, are also exempt from it. But residents of Texarkana, Texas, who work in Arkansas outside the city limits of Texarkana, Arkansas, are not exempt from the Arkansas income tax.

And if you can follow that, you're eligible for a desk job at H&R Block.

Of course, like every other tourist who passes through here, I got the security guard sitting in front of the federal building to take my picture by the Texarkana state line marker, which is shaped like Texas on one side and Arkansas on the other. "This will be the first time I've ever done this—today," said Lonnie E. Doss, the guard on duty when I stopped by on a Sunday morning.

HOW DO YOU SPELL THAT?

The name of the town (population 327) at the intersection of Texas 204 and U.S. Highway 84 is "Walker" spelled backward.

Gilbert Stafford, Reklaw's former mayor, said the town's name came about around the turn of the twentieth century. The town's original settlers were named Walker and wanted to name their town the same. But there was already a town named Walker, so they settled for spelling it in reverse.

There's a similar situation in nearby Sacul, the mayor pointed out. Sacul is "Lucas" spelled backward. The people named Lucas who settled that place ran into the same problem and came up with the same solution, Stafford said.

The Draughon/Moore Ace of Clubs House
Texarkana

It's fortunate local lumberman and Confederate Captain James Draughon wasn't betting on pro football before he built this mansion in 1885 in the shape of a playing card. Otherwise he might have built this house to look like Texas Stadium, with an enormous hole in the roof.

Legend has it that Draughon, an early Texarkana mayor, built the floor plan in the shape of the ace of clubs because he won a large pile of money in a poker game by drawing that card.

As the literature on the mansion says of the floor plan, "Three octagonal and one long rectangular rooms are arranged around a central octagon, which serves as the rotunda of the home." The floor plan mentions a music room, a parlor, and a library, but, strangely, no pool hall. You'd think a card player would have had one.

When you walk in the front room, you are struck upside the eyeball with those black pillars decorated with gold fleurs-de-lis. The spiral staircase is incredible and is mostly freestanding.

The house, located at 420 Pine Street (903–793–4831), is part of a museum system and can be toured. Admission is $6.00 for adults, $5.00 for seniors, $4.00 for students, and free for kids under five.

The place has a gift shop, but no T-shirts that say, "You Bet Your Ass I Visited The Ace of Clubs House" or anything of that sort. If I had a gift shop in this place, I would sell that shirt.

EAST TEXAS

All That We Know

Uncertain

We can be certain of one thing about the town of Uncertain (population 150): On cypress-dotted Caddo Lake, it's certainly in a beautiful location. With its backwaters, swamps, gators, and aquatic birds, Caddo Lake looks more like your cliché vision of Louisiana than it does of what Texas is supposed to look like.

After that, details about Uncertain become uncertain. The story about how this town 18 miles northeast of Marshall on FM 2198 got its funny name is a little fuzzy.

The late historian Fred Dahmer, author of a book about the lake called *Caddo Was . . .* , was not certain how the town came to be called Uncertain.

Dahmer said he heard from friends who were on the town council at the time that the name came about because of a paperwork problem. Council members were filling out the papers to apply for township. When they came to the blank where you put in the town name, they put in the word "uncertain" because they had yet to make up their minds about what to call the place.

But when the form was sent to Austin, the state capital, it was named Uncertain. So Uncertain may be Uncertain because the former town council members "didn't know how to leave a blank."

There are some aspects of Uncertain that are certain: We can be certain that over at Ms. Betty's Caddo Grocery, you can get a Brown Cow, a chopped beef sandwich. And you can go on a tour of the lake given by Robin Holder in a boat that holds thirteen people. Tours, which last an hour and a half to two hours, run seven days a week, year-round. It's $20 for adults, and $10 for kids twelve and under.

"We'll be happy to stop and let you take pictures at any time," Betty Holder said. "It's very scenic."

That much is certain.

WEST TEXAS

COLORADO

KANSAS

OKLAHOMA

NEW MEXICO

Anson

Abilene

Andrews

Tarzan

Winters

Notrees

Kermit

Odessa

El Paso

Wink

Mentone

Monahans

Eden

Van Horn

Fort
Stockton

Eldorado

Valentine

Fort Davis

Marfa

Langtry

Terlingua

Lajitas

MEXICO

WEST TEXAS

The Abilene Country Club
Abilene

OK, so it sounds a little, uh, adventurous, but at the country club here you can get your lobster tail chicken-fried—that is, battered and deep-fried.

Edward Grothaus, the general manager, doesn't see what's so special about treating a lobster like a piece of rump steak. "It's been around West Texas forever," he said. "You can fry anything in West Texas." Some people just like to show off.

So do they serve it with cream gravy? "It just kind of depends on what everybody wants," he said. "We've seen it come with tartar sauce, cocktail sauce, cream gravy. It just kind of depends on their personal taste." Wonder if anyone has ever put Miracle Whip on it.

Actually, the chicken-fried lobster is somewhat of a novelty. Grothaus said the country club probably sells a half dozen chicken-fried lobsters a month and they generally run $26.95, depending on size. "This is kind of a delicacy, I guess you'd say," he said. "Kind of a dare sometimes. People say, 'You gotta try this,' and, of course, they can't believe it. But once they've had it, they're impressed."

Are these Maine lobster tails? Grothaus wasn't sure. "Typically we don't have the great selection of fresh lobsters around," he said. Hey, out this way maybe they're stock-tank lobsters.

Buddy's Drive-In

Andrews

The words STEAKFINGER HEADQUARTERS are painted in blue letters on the side of the little white building with the carport out front at 106 East Broadway (915–523–2840). And that's no lie.

Eating steak fingers at Buddy's is a religious experience, though not a weight-loss program. The order is enormous, and it costs just $7.50. The pile of tender, tasty steak fingers probably stands a half foot high. Steak fingers, in case you didn't know, are breaded and fried strips of beef.

I should also mention that the steak fingers come with a bowl of cream gravy for dipping. Very few people can finish an order all by themselves, said Marion Chapman, a waitress here for nearly thirty years, so many people share.

"This one man, he had never ordered steak fingers," she said. "And when I brought them out, he said, 'Oh ma'am, I didn't know you were going to bring the Last Supper.'"

Buddy's has been around since 1969. Yes, there is a Buddy—Buddy Coleman, the former owner.

When someone dies in Andrews, Buddy's sends the family large roasting pans of steak fingers— and cream gravy—to help them through their loss.

At Buddy's you can count on generous portions of steak fingers—and generous hearts.

NO DANCIN' IN ANSON

The trouble with sex is that it could lead to dancing breaking out. Hence, a ban on dancing on campus at Baylor University in Waco. That prohibition finally came to an end after 151 years with a street dance on April 19, 1996.

But Baylor isn't the only place in Texas that has stomped out dancing over the years. Until 1987, when a group of parents called the Footloose Club challenged a fifty-four-year-old law that banned public dances, there was no dancin' in the West Texas town of Anson. "No Dancin' in Anson" became an oft-used headline around the world. The Footloose Club parents wanted their children to be able to have their own prom. The fight got pretty ugly, with a Baptist preacher pointing out that girls could get pregnant on the dance floor.

Hey, girls could get pregnant at the laundromat, but that doesn't mean you should stop washing your clothes.

You're probably wondering at this point if the Anson ordinance was ever enforced. You bet your ballet slippers it was.

"I know at least one year the chief closed down a proposed prom," said Ricardo Ainslie, educational psychology professor at the University of Texas and the author of No Dancin' in Anson: An American Story of Race and Social Change. Ainslie says the chief of police showed up at the mid-1980s prom before dancing could break out. So the prom was moved to a Catholic church outside the city limits.

The Anson ordinance, passed in 1933, made dancing a $5 to $15 fine, quite a chunk of change during the Depression. The ordinance was written in such a way that you could get busted for dancing more than once in the same day. So if you were caught dancing two or three times in the same day, it could have gotten pretty expensive.

Texas CURIOSITIES

Beer Joint? What Beer Joint?

Eden

Long before Jayson Blair and the scandal at the *New York Times,* a former writer for the *Chicago Sun-Times* named Wade Roberts allegedly came to this small town and did a feature story on a Dallas Cowboys–Chicago Bears football game from a local bar called Bonner's.

Trouble was at the time—mid-November 1985—there was no beer joint in Eden called Bonner's. In fact, there was no beer joint in Eden at all, and still isn't, said Kathy Amos, publisher and editor of *The Eden Echo,* who is still chapped about the scam.

"Only when people like you bring it up again is it remembered," said Kathy, who has been the newspaper editor in this small town on the edge of West Texas since 1978. "Otherwise, we blissfully let time erase it. It's just maddening when somebody pulls a scam on you, whether it's a harmless thing or a bad thing. You feel kind of helpless."

It may not have been a true story that Roberts wrote, but it was very well written. Good ol' boys had gathered in this Bonner's bar that had pickled eggs to watch the Bears kick the snot out of the Cowboys, 44–0. The owner of the place was named Jefferson Davis Bonner (you can't make this kind of stuff up; wait, yes you can). There was a guy in the bar named Les Smalley, "a craggy, weathered rancher known as Buster."

As the boys were gathered around the bar's TV set, they tried to enlist Smalley in a bet. "'Sorry,' said Smalley, looking timid all of a sudden, 'done made my bet today.' 'Just who and what,' demanded Bonner, 'are you bettin'?' 'The wife. The Cowboys win, and she don't bother me the rest of the season. The Bears win, and I don't get no football 'til the Super Bowl.'"

Toward the end of the story the distraught Smalley is described with "his lower lip hanging lower than his Mack truck belt buckle." Then

168

there's the perfect finale when somebody punches E7 on the jukebox and they all accompany Bobby Bare in a round of "Drop kick me Jesus through the goalposts of life."

There was no jukebox. In fact, after the article came out, Roberts came to Eden and spent two days with his boss trying to find Bonner's so he could clear himself.

No such luck. The newspaper asked Roberts to split.

Amos didn't remember the name of the writer but she put it this way: "It was somebody who didn't want to work that weekend or something. Nothing like that existed here. A restaurant or two served beer, but there was not your basic beer joint, no."

Pity. The story read so well it made me want to eat a pickled egg and take the Cowboys and the points.

Fact? Fiction? Or just too much beer?

On Your Mark, Get Set, Goat

Eldorado

Most of the talk around here of late has been about the polygamy compound that sprung up in 2003 north of town.

"Oh man, that's somethin', isn't it? We don't know what to think of 'em," said Jim Runge, a local character who inadvertently diverts attention from the multiple wives situation by putting on the Elgoatarod, an April Fool's Day weekend goat-oriented celebration. "We think they're crazy for wanting to have more than one wife."

Probably a lot of people think Runge is crazy for promoting goat racing.

The central event of the Elgoatarod—a takeoff of the Iditarod, the 1,170-mile cross-country Alaskan dogsled race— is a series of four goat races held around the courthouse square. Goats pull "sled knockoffs" about 200 yards, Runge said.

"It's not a long thing; it's not like the Iditarod," Runge said. Of the sleds the goats pull, he said, "one is a chariot, one is a galactic goat— it's like a space ship—one is like a covered wagon. We've had 'em bring inverted dollies and little red wagons, and a converted riding lawn mower with everything taken off but its wheels."

Along with an April Fool's Day parade, the Elgoatarod features a goat pill flipping contest, a chigger catching contest, gnat races, and a goat fry cookoff. Goat fries are fried goat testicles.

So what do they taste like? "I don't know," Runge said. "I'm just like a drug dealer. I just sell 'em. I don't eat 'em."

Then there's the ugliest goat contest. "Ugliest goat wins, but it has to be a goat," Runge said. "Cain't be a human. A wife brought her husband and said, 'He's an old goat,' but it has to be a goat. Cain't be a husband."

The Fundamentalist Church of Jesus Christ of Latter Day Saints, the group that built the polygamy compound, doesn't have a goat-racing

team in this event. But they have built a temple outside Eldorado that is larger than the Mormon temple in Salt Lake City, said Randy Mankin, editor of *The Eldorado Success,* the town's weekly newspaper. You can't drive up to the temple, but you can see it from County Road 300 from several vantage points, he says. Maybe the polygamists would let a fella drive up to it if he had eight women in the back seat.

The newspaper was selling ballcaps that said, "Eldorado, the Polygamy Capital of Texas," as well as Texas polygamy marriage licenses, with one line for the man, and several lines for the women. "And for $5 extra you could get a divorce kit, which was a stick of whiteout," Mankin added.

The H&H Car Wash and Coffee Shop
El Paso

You can get your car washed by hand while you're sitting at the counter eating a carne picada burrito, an item so good that it was featured in *Saveur,* a cuisine magazine.

Ain't too many combination car wash–1950s-style dinettes that make it into fine-cooking publications. Come to think of it, ain't too many combination car wash–dinettes, period. But it must be working since this place, at 701 East Yandell Drive (915–533–1144), has been in downtown El Paso since 1958.

"It was quite a unique idea my dad came up with, which has been for the most part real successful," said Kenneth Haddad. Kenneth owns the coffee shop, and he and his brother Maynard own the car wash.

You get all sorts of characters coming into this place, which has a counter, three tables, and a bumper sticker on the ice machine that says, STOP GLOBAL WHINING.

The Camino Real Hotel

El Paso

They ran a tight ship when they opened what was then called the Dream Hotel on Thanksgiving Day, 1912.

According to literature put out by the hotel, house rules included:

"If you wet or burn your bed, you will be thrown out."

"You are not allowed downstairs in the seating room or in the kitchen when you are drunk."

"You must wear a shirt when you come to the seating room."

The lovely hotel is considerably looser now and even provides dirty movies on its cable television system.

Before it became a hotel, the spot, 101 South El Paso Street, was the site of a saloon operated by Ben S. Sowell, who became the first mayor of El Paso on August 15, 1873. The first official act of Sowell and his aldermen was to make it illegal to bathe in the city's drinking water supply, an acequia that ran about 150 feet north of where the hotel is today.

El Paso was a rough-and-tumble town back then. A plaque on the hotel tells about how four men were shot dead in about five seconds at this location on April 14, 1881.

The hotel itself is a jewel. A 25-foot-diameter colorful Tiffany stained-glass dome can be found in the ceiling above its large, circular bar.

The hotel is just six blocks from Mexico. In the old days hotel guests gathered at the rooftop ballroom and patio—to watch the Mexican Revolution in progress across the Rio Grande.

These days, the rooftop is inaccessible to the public for liability reasons. Damned lawyers. About the only reminder of the revolution in the hotel is the Pancho Villa Room, one of the hotel's meeting rooms.

wEST TEXAS

Rosa's Cantina
El Paso

Every goofy guidebook ever written about Texas talks about how Marty Robbins's 1959 hit single "El Paso" was talking about this place when it mentioned Rosa's Cantina:

"Out in the West Texas town of El Paso
I fell in love with a Mexican girl.
Nighttime would find me in Rosa's Cantina,
Music would play and Faleena would whirl."

Personally, Roberto Zubia, who owns the Mexican food place with the horseshoe-shaped bar at 3454 Doniphan Drive (915–833–0402), could give a rat's hind end one way or another. All he knows is that he has to work his butt off, and that he is a slave to this establishment. He's had the place over forty years.

"She owns me. She owns me, 'cause I have no time for nothing else," he said. He was on his hands and knees working outside on a water heater on a hot day in July. "I'm the dishwasher, I'm the maintenance man, everything."

Many people know the legend of how Marty Robbins supposedly was riding by Rosa's Cantina on then-Highway 80 on his way to Arizona when he noticed it and put the name in his song. The song stayed at numero uno for seven weeks.

I should also mention that Rosa's Cantina has really cold beer and reasonably priced Mexican food. But regardless of what the song said, the whole time I was there, there was no gal named Faleena whirling.

Roberto Zubia said he named the place Rosa's Cantina because he used to have two sisters working here—one named Trini and the other named Rosa. "So we just put cantina on the last," he said. "Who knew Marty Robbins was going to raise up and write this song about El Paso?"

Rocketbuster Boots USA
El Paso

I have a couple of problems with these distinctively designed and knockout-colorful boots. First off, they're so out there that wearing them into the airport would be asking to get frisked. "You fit the profile in these boots, pal." Second, when you've got on a pair of boots that costs anywhere from $750 to $5,000, your life is ruined if you step in a puddle.

But you've got to give Rocketbuster Boots an "A" for abnormality. They can make any kind of boot you want. If this isn't the only boot maker that sells a boot with the Beluga Caviar logo on it, I'd be real damned surprised.

"One banker said he wanted a show-me-the-money boot," said Nevena Christi, who owns the business with her boyfriend, Marty Snortum. They made a pair of boots out of gator that look like $100 bills. Same color, same design. "It's called Mint Condition," Nevena said of that model. Her name is on the boot. "I made myself secretary of the treasury."

You can shop at this custom-made boot shop, at 115 South Anthony Street (915–541–1300, www.rocketbuster.com), by appointment only. So don't just show up and expect to be fitted. They've made boots for Sharon Stone, Steven Spielberg, Dwight Yoakam, Sylvester Stallone, Jeremy Irons, and Oprah Winfrey. "We sold four pair to Billy Bob Thornton," Nevena said.

The colors will knock your eyes out. And they're quality boots. No cheap nails in these boots. They use lemon-wood pegs. "They're made the oldest, hardest, most ridiculous way of boot making," Nevena said.

WEST TEXAS

Perhaps Rocketbuster's most spectacular accomplishment was making the world's largest real cowboy boots. The boots, decorated with Indian heads, are 5 feet tall and weigh about fifty pounds apiece. "Ours are a 328D," Nevena said. The to-scale boots, completed on January 13, 1999, after two months of work, set a Guinness record for being the world's largest real custom cowboy boots.

Oh yeah, almost forgot. Nevena and Marty might not even be in the custom boot business if Marty hadn't been in a bar one night, talking with a German guy. The German owned a boot company that wasn't doing so well, and Marty, a photographer, owned a Cadillac hearse he used for shoots. They traded even up, the German getting the hearse and Marty getting the boot company.

I think Marty got the better end of that deal.

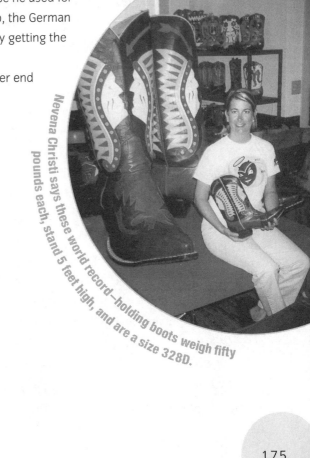

Nevena Christi says these world record–holding boots weigh fifty pounds each, stand 5 feet high, and are a size 328D.

THE HUMAN BLOCKHEAD

When a guy makes furniture for a living, he's going to have plenty of nails around, right? So why shouldn't he put one up his nose every once in a while for entertainment purposes?

Seriously, D. Alan Calhoun, who had a custom furniture business called The Ranch Home Furnishings in El Paso, really can hammer a 6-inch nail up his nose. I saw him do it. In his office. Actually, the day I saw him do it, he did it with a 4-inch nail, because he didn't have a 6-inch nail around.

He just put that nail in his nose and tapped on it with a hammer. Tink, tink, tink. In seconds the nail was in his head, and the head of the nail was even with his nose hole. No blood. No screaming. No fuss. No muss.

"When I'm in practice I can do both nostrils," Calhoun said. "That's a real show-stopper."

Carnival workers showed Calhoun how to perform this stunt, known in the carny trade as the Human Blockhead. "I used to work with the freak show trade, painting these big canvas banners," Calhoun said. "You know, those banners that say stuff like, 'See Fat Girl.'"

"There have been quite a few human blockheads through the years," Calhoun pointed out. "It's similar to sword swallowing." The nail stunt works because people have a nasal cavity behind their noses. That's where the nail goes. The main concern? "You sort of have to know where to stop," Calhoun said. Otherwise, you could run the nail into your spine.

So kids, don't try this at home, on the road, or anywhere else. Take up something safer, like bungee jumping.

Just kidding. Don't do that, either.

When custom furniture builder D. Alan Calhoun gets a little bored, he hammers a nail into his nose.

Alligator Sculpture
El Paso

Why is there a monument to marshland reptiles out on the Rio Grande, where there is no marsh? Well, according to a book called *City at the Pass: An Illustrated History of El Paso,* by Leon C. Metz, it's because in the 1880s, El Paso developer Fisher Satterthwaite built a fountain and pond in what was then called Public Square—now called San Jacinto Square—downtown, and put at least two alligators in it.

Why did he do this? Maybe he had a couple of extra alligators that he didn't know what to do with. Regardless, there were alligators in the pond until 1967. Today in their place is a statue of alligators, one with his nose thrust toward the sky. The day I vis-ited the plaza, many pigeons were sitting all over the alligators like they owned them. So sculptor Luis Jimenez created a lovely, though unusual, $50,000 pigeon perch right in the middle of downtown El Paso.

Memorable Gators by Luis Jimenez.

THE FIRST THANKSGIVING

The first Thanksgiving in what would eventually be known as the United States? Most ill-informed Yankees figure it was put on by those funny-hatted Pilgrims in Massachusetts. But some folks in Texas will tell you it happened in what is now far West Texas on April 28, 1598, twenty-two years before the Pilgrims hit Plymouth Rock.

Texas's version of the first Thanksgiving occurred when a group of Spaniards, led by Spanish explorer Juan de Onate, feasted on the banks of the Rio Grande after arriving near what is now El Paso.

The Spaniards had just made it through a 350-mile trek from Santa Barbara, Mexico, across the Chihuahuan Desert, so they had plenty to celebrate.

In 1990 the Texas legislature passed a resolution recognizing San Elizario, Texas, on the outskirts of El Paso, as the site of the first true Thanksgiving.

The Lineaus Athletic Company
Fort Davis

"Right now I make the best medicine ball in the world," said Lineaus Lorette. "I really do. I make a Cadillac. I make a Maserati. A Ferrari medicine ball."

Today, hardly anyone uses the big, clunky, heavy balls anymore. But Lineaus keeps making them anyway. He believes in them as a way to build upper body strength. He sells about thirty to forty of them a year.

"As long as there's leather, I'll be making medicine balls," Lineaus said. They're hand-sewn in a shop next to Lineaus's house, surrounded by the Davis Mountains. Lineaus used to make a twelve-sided ball. But he's upped it to a thirty-two-sided ball because it's a better ball.

"To make a round ball to last twenty years, you have to make small panels," he explained. His standard model is 13 inches in diameter, weighs usually ten to twelve pounds, and sells for $400.

So is Lineaus making a living doing this? Nope. His main occupation is certified public accountant.

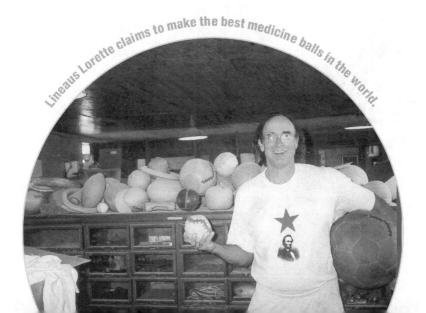

Lineaus Lorette claims to make the best medicine balls in the world.

Paisano Pete, World's Largest Roadrunner

Fort Stockton

Ask former city tour guide Billy Twowalks Kail about the town's 800-pound, 20-foot-long roadrunner statue and you may learn more than you bargained for.

This guy knows his roadrunners.

"He's zygodoctile—he has two toes forward, and two toes back," Kail said. "He is a member of the cuckoo family. He's one of two in the U.S., the other being the rain crow. His main diet is rattlesnakes, baby quail, green lizards, and sparrows. He has an almost serpentine jaw. He swallows everything whole. He's very common to the entire Chihuahuan Desert. The word paisano means 'countryman.' And if you were in Italy, that would be friend."

There's more. His species name is *Geococcyx californianus*. He's called "the clown of the desert." And "he doesn't fly well," Kail said. "He runs fast, flaps hard, and sails like a quail."

And you thought all roadrunners did was taunt Wile E. Coyote.

Former Stockton police detective Sam Esparza's rendering of Paisano Pete, the world's largest roadrunner.

Sandhills Park

10 miles east of Kermit

There are two ways of looking at this, um, interesting location at the intersection of Texas Highway 115 and FM 874—the pessimistic way and the Pollyanna way.

The pessimistic way would be to say that the four concrete picnic tables surrounded by nothing but wind-driven sand make up the most desolate-looking rest stop this side of Saudi Arabia.

The Pollyanna way would be to point out that this would be a great beach, if it only had an ocean.

When you arrive at this spot, you get the feeling you've driven too far. Or that you haven't driven far enough. Each picnic table in the park is covered with a metal roof held up by two brick pillars. The day I visited there were two piles of used tires decorating the park, which is used by off-road vehicles.

A marker in the park informs visitors that they are in Winkler County, formed from Tom Green County in 1887. This was probably done because somebody looked around and noticed there was nothing green out here. So Tom Green would have been a misnomer.

Okay, so there are three scrubby trees here. But they look like they wish they were somewhere else.

THE MARFA LIGHTS

Who knows what causes these mysterious lights that come off and on in the distance? Whatever it is, the city makes hay out of it. About 10 miles east of Marfa on U.S. Highway 90, you'll come to the mystery lights viewing area, a rest stop where you can pull over and look for the lights.

MARFA'S MYSTERY LIGHTS VIEWING AREA, the sign says. NIGHT TIME ONLY. Did they really need to put that notice on the sign? What kind of idiot would go look for lights in the sky during daylight?

Lineaus Lorette of Fort Davis and I went to see the Marfa Lights on a Saturday night in July. When we got there, the viewing area was packed. Dogs were barking and people were yakking. A group of folks were looking at what they were pretty darned sure were the Marfa Lights. Just above the horizon, miles away, round white lights would come on, one at a time. Then they would burn out. Then they would come back on for a while. Then they would disappear again. They'd pop up in various spots.

There are several theories as to what causes the Marfa Lights, which some say come in various colors and sometimes move around. Lineaus believes they are probably a reflection of the stars below the horizon, bouncing off the atmosphere.

Me? I think there's a guy off in the distance showing his vacation slides from Hawaii.

But whatever they are, Marfa plays them up. SEE MYSTERY LIGHTS, said the banner on a motel in Marfa. On Labor Day, Marfa has a Marfa Lights celebration with a parade.

Tourists come from all over to see the lights. "Everybody's seen something different," said Pancho Borunda, who owns Borunda's Bar & Grill in Marfa and has seen the Marfa Lights many times. "In fact, we had some guys in here last night who had come all the way from Houston. They were asking questions like, 'When's the best time to see 'em, and should we bring some beer out there?'"

The answers to those two questions are (1) after dark, and (2) yes.

The Dom Rock

Out in the boondocks near Lajitas

You gotta wonder if Kevin Costner wanted to kill the locations director when he found out he had to hike over a bunch of boulders out near the side of a cliff to film a key scene in his 1985 film *Fandango*.

If you visit the Dom Rock out here, watch your step. It's a long way down to the Rio Grande below.

Toward the end of the movie, which tells the story of five college buddies on their last fling before heading for Vietnam, Costner digs up a bottle of Dom Perignon champagne buried at the base of a rock, which today still has the letters DOM scratched in the side of it. DOM, as in Dom Perignon, get it? The guys end up squirting the champagne all over each other. It's a rite of passage thing.

After a climb like this one, wouldn't you rather drink it than squirt it?

The view of the Rio Grande below is spectacular, so if you really are fixing to waste a bottle of expensive champagne this way, this would be a great place to do it because of the scenery. Then again, maybe you should just drink it.

"It's breathtaking, it's one of the best views of the canyon," said Gina Yates, of Fort Worth, who when we spoke with her had just visited the DOM Rock the day before with her husband, Brian Curbo. People come up here to do their own version of the Costner scene. "There was a bottle, a little split of Christalino, up there. That's what most people do is take a bottle."

Unfortunately, by the time I got to the DOM Rock the next day, the bottle Gina mentioned was empty.

Part of the challenge with the DOM Rock is just finding the thing, since it's not marked on the highway and you can't see it from the road.

Here's how you get to it. Head west out of Lajitas toward Presidio on FM 170. When you get 13½ miles out of town, it's on the south side of the highway at the top of the hill, out amongst all those rocks overlooking the river. Park in the pullover on the south side of the road, across from the sign that says HILL. USE LOW GEAR. Hike about 100 feet toward the Rio Grande and you're there. Be careful, though. It's a long way down to the river. Running shoes or hiking boots are recommended.

Oh, by the way: you might want to buy your Dom Perignon before you get to Lajitas, since it's in the middle of nowhere and about 500 miles from Austin.

The Jersey Lilly Saloon
Langtry

Don't get any wild ideas about finding a beer in this place.

From 1882 until his death in 1903, Judge Roy Bean served both justice and drinks out of this bar, halfway between nowhere and too late to turn back. Judge Bean was the law "west of the Pecos." Bean held court in the saloon or on the front steps. These days the bare wooden building is run as a tourist attraction by the Texas Department of Transportation, which has a comfortable air-conditioned visitor center in front of the old saloon building.

Actually, you can learn quite a bit about Judge Bean at the alleged saloon by reading the historical marker and listening to the sound blurb that plays when you push the red button. When the transcontinental railroad came through this part of West Texas, the Texas Rangers needed someone to corral the drunks. So they made Judge Bean justice of the peace. The closest courthouse was 125 miles away in Fort Stockton.

"He basically fined the drunks and kept the money," said Ginger Harrell, a travel counselor who used to work in the visitor center. "He hung no one. The movies have distorted the facts tremendously. He never hung anybody or killed anybody."

Because there was no jail here, Bean fined the drunks and pocketed the fines. That seems a little unfair, doesn't it? Here's a guy serving drinks in the desert, then busting people for getting gassed. What a setup.

Incidentally, the saloon was named for English actress Lillie Langtry, who Bean admired and for whom he named the town.

The Boot Track Café

Mentone

When I walked into The Boot Track Café late on a Sunday afternoon, it was officially closed. But five people were sitting at a table, drinking beer.

Five people is a crowd in Mentone. The population of Mentone is fifteen. It's the county seat of Loving County, the most sparsely populated county in Texas—664.4 square miles of mesquite and tumbleweed inhabited by fifty-two people. Mentone is the only town in the county. When a stranger shows up, these people notice.

At the Boot Track Café, Charles Derrick does the cooking, and Regena Derrick is the waitress. The Derricks are proud of their chicken-fried steak and hamburgers. These people get sick of city slickers making fun of Mentone.

"If you say bad things, we'll boot your ass out," Charles told me. He was wearing a wonderful, floppy cowboy hat that looked like it came out of the oil patch. In the summer the place has a jar of pickled eggs on the counter. "That's when they drink the most beer," said Regena, explaining the seasonal nature of the pickled eggs.

The place is getting a little fancier as time goes on. "We've got cloth tablecloths now," Regena added.

A cardboard sign on the kitchen door said, simply, grill off. People here will tell you what they think without flinching.

"You ain't been to Kermit?" asked Bo Gunter, one of the people at the table, speaking of the next town over. I said, no, I had yet to be to Kermit. "How the hell are you going to write about West Texas if you ain't been to Kermit?" Bo asked.

At one point the conversation turned to a restaurant on the Mexican border at which Boot Track Café patron Harry Hamner and I had both dined, at separate times. "You know how when you walked in there,

and you didn't see any dogs as you walked in?" Harry asked. "That's because that's what you were eatin'."

"It was pretty good dog, though," I told him.

"I didn't find it too bad," Harry allowed, with a wry smile.

Now That's a Lot of Concrete

Monahans

If you like to plan your vacation around places where you can look at enormous amounts of concrete, this is your town.

The Million Barrel Museum is primarily an ill-fated ugly huge concrete tank built by Shell in 1928 to store oil.

But since it went in, it's been used for other things—like the time in the late '50s when they filled it with water and tried stocking it with trout. The trout died. So what happened to the trout?

"I would say it was a lack of vegetation and circulating water," said Lee Nichols, the museum's curator, caretaker and maintenance man.

Shell built this semi-bowl-shaped monstrosity—the floor alone is large enough to hold five football fields, Nichols says—to store oil because at the time it didn't have enough pipelines to distribute the oil. And this booger went up fast. "A tent city grew up around it," Nichols said. "It was like an army of men. They worked twenty-four hours a day. That's why it only took ninety days to build."

Maybe if they'd taken a little more time to build the tank it wouldn't have started leaking oil so fast. But what really killed the tank as an oil storage unit, Nichols said, was the stock market crash of 1929. The price of oil dropped from $1.75 a barrel to a nickel or a dime, he said. So keeping oil around didn't seem quite so important.

So the tank sat there grey and empty until the '50s when an entrepreneur named Wayne Long bought the thing, at first with the intention

of racing cars in it. "I had an old gentleman come in here, and he's one of the guys who raced in there, and he said they did that three weekends in a row," Nichols said.

The concrete surface was too bumpy for stock cars, though. "It was tearing up their cars, so they stopped," Nichols said.

In 1958, the tank was used as a water park—for one day. Melody Park, named after Long's dog, opened and closed on October 5, 1958.

Plan your next function here.

"Here's a picture of the only boat and ski show that ever took place there, in 1958," Nichols said. "I was an eyewitness to that. I was only eight years old."

The tank had other uses. "In the early '50s they used to square-dance in the tank," Nichols said. "There would be about 150 that would show up on Friday nights. Some of our museum board members did that and remember that." He says Anita Pigman, a member of the museum board, still "vividly remembers" square-dancing in the tank.

In the '70s, Nichols said, some crazy local guys tried to blow the tank up with a bomb, which explains some of the ruts in the floor. "They ended up in wheelchairs from doing drugs; that's the kind of guys they were," Nichols said.

These days the tank, which has an amphitheater on one end, is used for a variety of functions, including high school reunions and concerts. And the local high school kids scribble on the concrete walls—you know, stuff like "Natalie 'n' Gene."

To Be Or Not to Be
Odessa

This just doesn't seem like the sort of town where you'd find a re-creation of Shakespeare's Globe Theatre in London.

As you drive into Midland, Odessa's sister city next door out here in gas and oil country, you see a large sign next to the interstate that reminds you this was the home of President George W. and Laura Bush.

You gotta figure Bush has never read *Twelfth Night*.

There aren't a lot of fuzzy-headed eggheads out this way, where oil is king. In the parking lot of a Mexican food restaurant in Odessa, I saw a bumper sticker on the back of a car that said, IF MARY WAS PRO-CHOICE, THERE WOULD BE NO CHRISTMAS!

Still, Odessa College really is the site of one of only three re-creations of Shakespeare's theater in the world.

"There are some striking differences, of course, one of them being there's a roof on it," said Anthony Ridley, the theater's artistic director. "The other big difference is we have seats in the Globe. Our seating area would be the big old cockpit where the lower classes called the groundlings would stand and watch the plays."

So today's groundlings—the oilfield roughnecks—can sit in comfort in this Globe in plush red upholstered chairs.

This is not to say that the theater doesn't have some local touches. Ann Wilson, the theater's office manager who knows every nook and cranny of this theater, pronounces it "thee-A-ter," which is how you're supposed to say it out in West Texas, regardless of what King Lear might think.

The idea for this theater popped up, Wilson said, when the late Marjorie Morris, a high school English teacher at the time, gave her students an assignment to build models of Shakepeare's Globe. "And when one of her students turned his in, he said, 'Wouldn't it be neat to have a Globe Theatre right here in Odessa?'" Wilson said. Ridley says the theater opened in 1968.

The theater comes with a recreation of Anne Hathaway's cottage next door. Wilson says they had to affix the heavy wooden block that serves as the oven door to the wall for safety purposes. "When they were building it, there was this woman who decided to bake something to see what it was like to bake back then, and she dropped the wooden block on her foot," Wilson explained.

Anne Hathaway's cottage doesn't have a thatched roof for a couple of reasons. For one, the fire marshal wouldn't allow it because of the fire hazard that would create in this dry desert climate. "One little spark would have set it off, just like one little spark from a cannon burned down the Globe Theatre [in London]," Ridley said. "I think that was in

1613, if I was not mistaken. They were firing a cannon for the start of a new play called *Henry VIII*."

Then there was the expense of the thatch. "When they were doing it, they found out they don't grow that kind of material here, and the expense in importing that kind of grass would be astronomical," Wilson said.

On the other hand, just like in Shakespeare's Globe, this theater has three aulde English–style turrets up above the stage known as "the heavens." In Shakespeare's day, characters coming out of "the heavens" were lowered down to the stage by cable.

"We haven't done that because it's kinda dangerous," Wilson said. And characters rising from hell—like the "double, double toil and trouble" witches from *Macbeth*—reach the stage by coming up through a trap door. Little boys touring the theater love visiting the room that represents hell below the trap door. "They like to go down through the trap door that goes into hell, then come up," Wilson said.

Ann Wilson in the Globe Theatre—that's "thee-A-ter" to you.

People come from hundreds of miles away to attend plays here. Of course, way out here it's hundreds of miles away to a lot of places. "In the summer, people traveling will stop here in Odessa just to see the Globe," Wilson said. "A couple of times we've had a reporter from London come to do a story on the Globe."

The guy from London was probably impressed that once a month this Globe features a show of country or gospel music, or a combination of the two. Haggard and *Hamlet*, no place but Texas.

For more information, punch up www.globesw.org or call (432) 580–3177.

It's a Bird, It's a Plane, It's a Really Large Hunk of Iron
Odessa

Out here in the West Texas desert is a great place for a meteorite to land because it ain't going to get much uglier even after something big hits it.

Except for the pump jacks and the scrub brush, there isn't much to look at in the oil patch.

Of course, there was even less going on 63,500 years ago when a 250-ton hunk of mostly iron slammed into the ground at 7 miles a second. That's 25,200 miles an hour.

The Odessa Meteor Crater, 500 feet or so in diameter, was about 100 feet deep at the time of impact. But at its current depth of about 12 feet, this crater, the second largest meteor crater in the U.S., isn't nearly as impressive as it was in its youth.

"After the explosion, about 15 feet of rubble that had blown up in the air fell back in the crater," said Tom Rodman, the attorney and oil and gas man who serves as president of the Odessa Meteoritical Society, the nonprofit organization that runs the Odessa Meteor Crater Museum on Interstate 20, Exit 108. "Then the sand started blowing, and it filled up."

The crater is shallow enough that you can take a walking tour through it without worrying about busting your butt. On the other hand, there is a sign at the beginning of the tour that tells you to watch out for snakes.

This is not to say the crater couldn't have been a lot worse, what with all that space junk flying around out there. "If an asteroid the size of Rhode Island hit, it would be the end of the world," Rodman pointed out.

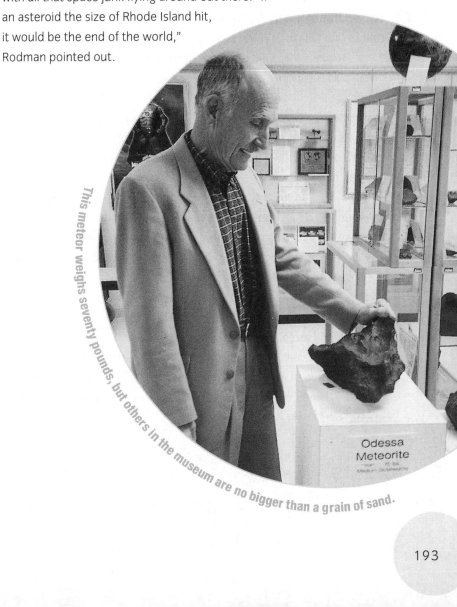

This meteor weighs seventy pounds, but others in the museum are no bigger than a grain of sand.

Odessa
Meteorite

While you're waiting for that to happen, there is plenty to see in the museum, although you could go through the whole thing (maybe we should say the hole thing) in an hour. You can see various chunks of the actual Odessa meterorite, although they aren't exactly sexy in color, since the Odessa meteorite was 90 percent iron.

"On the outside they're pure brown because they're rust," Rodman pointed out. In a way, that's good because that means the meteor chunks don't clash with the area's ubiquitous oil field equipment. On the other hand, if you cut into the same chunks, they're shiny and metallic on the inside.

They're also heavy. In the middle '70s somebody stole the largest specimen from the Odessa meteor—a 105-pound chunk—from the society's earlier museum. And the thieves wouldn't have needed a truck to do it. "A 105-pound meteorite is no bigger than a basketball," Rodman said.

So how did Rodman get interested in meteorites? "Back in 1963 my father owned a ranch that surrounded the meteor crater," he explained. "Our rancher caught a trespasser out there digging up meteorites. So he was arrested for trespassing. Turned out he had about 300 pounds of Odessa meteorites he had dug up."

So what do you do with Odessa meteor chunks? "Sell 'em—they've always been very valuable." Rodman says the stuff will sell for over $100 a pound as collector's items.

Speaking of collecting, Rodman is such a meteor buff that he even has a collection of meteor movie videotapes in a box. His favorite is a film I'd never heard of called, simply, *Meteorites!* "It didn't make a big splash," he said.

NOTREES

Oh, yes there are. So this town of about twenty people is inappropriately named. Although just barely. 'Cause there aren't a lot of trees out here, about 20 miles west of Odessa. The trees in Notrees are kind of droopy looking.

"There's a few elm, and some people have planted some pine trees now," said Jannifer Whitehead, postmaster of the Notrees Post Office. Notrees also has an oil company and a volunteer fire department.

Whitehead said Charles Brown named the town in 1946, after moving here with his family. "He wanted to name the town Judy, after his third daughter," Whitehead said. "But when he sent the name to Austin, they wrote back there was already a town named Judy. So he was looking out the window and noticed there were no trees. So he decided to name the town Notrees."

World's Largest Jackrabbit
Odessa

The best part of this big-eared, 8-foot-tall fiberglass statue, located at Eighth Street and North Sam Houston Avenue, is the jackrabbit recipe on the back of one of the two plaques next to it.

"First, catch your rabbit," it says. "Dress rabbit. Salt and soak in brine, then boil 'til tender. Add pepper to taste. Fill pot with dumplings. Cook 'til dough is done."

It's recipes like these that explain why Kentucky Fried Chicken was invented.

One marker tells about how jackrabbits can do 45 miles an hour, and that they were a "prized" source of food among the Indians.

Hey, if you were a prized food among the Indians, you could do 45 miles an hour, too.

The other marker addresses the 1932 Odessa Rodeo's "World's First Championship Jackrabbit Roping." The alleged event allegedly was won by Grace Hendricks, who beat out several male competitors by allegedly roping a jackrabbit from horseback in five seconds flat.

I'd have to see a video of that before I put much stock in it.

Incidentally, the World's Largest Jackrabbit now has offspring—thirty-six additional jackrabbit statues that went up all over town in April 2004 through February 2005.

"We called it Jackrabbit Jamboree," said Pat Owsley, of the Odessa Convention and Visitors Bureau. "We solicited artists in the Permian Basin area to submit their concept of what they would do for a rabbit. We had a juried show where people selected the ones that they liked."

Among the new rabbits commissioned were Jacks Are Wild (a rabbit covered with playing cards), Hare on a Hog (a rabbit in biker attire, including goggles), and Gusher the Hare (a rabbit sporting a drawing of an oil well). So I guess you could say the jackrabbits are multiplying like rabbits around here.

Seeing the world's largest jackrabbit in Odessa is a hare-raising experience.

Rodeo and Enchiladas
Odessa

Where else but in Texas are you going to find a Mexican food restaurant with a rodeo ring? Nearly every other Sunday from March through October there's bull riding at Dos Amigos (Forty-seventh and Golder, 432–368–7556). You can watch the action from inside the restaurant or out by the ring.

"It's a little out of the ordinary, that's for sure," said Mark Bennett, now a business broker and one of the founders of the place. He tried riding a bull here—once. Eight seconds is a full ride. Bennett figures he made it about five seconds before he got tossed. "I looked back around and that bull looked back around at me, and I learned how those cowboys scrambled over those fences," he said. "I tried it once and that was enough for me. I never did like the thought of getting kicked in the teeth."

Bennett and his former business partner, Ronnie Lewis, opened the place in 1982. When they bought the property, it was a horse stable. The two were in the rental business, and they needed a place to store their salvaged business materials. They weren't thinking Mexican food or bulls. They'd end up in the evening at the place, hanging out. Pretty soon, friends showed up. "Sometimes we'd cook some barbecue, and we'd always buy beer," Bennett said. "And these people kept coming around and hanging around."

A lightbulb went off over these guys' heads. "I told Ronnie that we ought to turn it into a beer garden like the places we went to in Austin," Bennett recalled. "A couple months later, we decided to go ahead and do that. We built a kitchen out of one of the horse stalls and got a table and chairs. And then we hired a cook and the food was good, and people started coming, so we got a beer license, and more people started coming."

One thing led to another, and pretty soon there was bull riding. "We already had an arena because they would train horses here, and there were lots of cowboys that would hang out here," Bennett said. "So one of 'em had the idea that bull rides would probably work. So we connected with a bull riding company that provides bulls and had the first bull ride. That was a big hit. That was probably 1983, I would guess."

Scandal Rocks Chili Cookoff
Terlingua

Don Eastep had no idea he'd win the 37th annual Original Terlingua Frank X. Tolbert–Wick Fowler Chili Cookoff when he turned in a bunch of chili samples he didn't even cook.

"How could you possibly win with a conglomeration of chilis?" a sheepish Eastep said in 2003 after he'd been busted for cheating at this cookoff in the desert, considered the granddaddy of them all. "That was the last thought in my mind—that it would win. And when it did there was nobody who was more shocked."

Eastep, who wasn't even qualified to enter the cookoff, said it all started out as a joke. Posing as his brother, Larry Eastep, who had qualified to cook but didn't attend, Don Eastep took a tasting cup around to the various cooks and got them to toss dollops of their chili into the cup.

Then Don transferred the mix into his brother's entry cup, entered the chili—and won.

Don says that when he was announced the winner from the podium he was "absolutely stunned."

When officials found out what had happened, Eastep had to give back the trophy and other awards.

Eastep was driving back to his home in Illinois when we reached him on the phone for an explanation.

"The bottom line is I should not have done it." he said. "And when they called the winning number, I wish at this instant that I would not have responded."

"We caught the scoundrel, the Benedict Arnold that he is," said Tom Nall, one of the chili judges who was fooled by the entry. "We've got to set up guards on the border to make sure he never comes back."

The Tolbert-Fowler cookoff (817–442–8688) is one of two big chili cookoffs held in Terlingua on the first Saturday in November. The other cookoff, the Chili Appreciation Society International cookoff (888–CASI–HOT), had nothing to do with the 2003 scandal.

Valentine's Day
Valentine

Thanks to the town name, this place is transformed into a veritable Cupid City in mid-February each year.

In 2003 the two-woman post office in this town of 184 got about 19,000 Valentine cards from hither and yon, each one stamped at the post office with an illustration done by Valentine eighth-grader Veronica Calderon. The design showed a cowboy on a horse throwing a rope in the shape of a heart, with the message "Love Station" inside the rope. It marked the twentieth anniversary of the Valentine post office's Valentine's Day stamp program.

So what you have is two gals, stamping thousands of valentines, one right after the other—clonk, clonk, clonk. Isn't that a pain in the butt? "It gets a little hectic, but we enjoy it," said Maria Carrasco, the postmaster. "We get our workout for the year." They probably also get repetitive stress syndrome.

Valentine, Texas, is one of only three towns with that name in the United States, along with Valentine, Nebraska, and Valentine, Arizona,

although there is a Valentines in Virginia. As far as I know, there is no town named Custody Battle, Montana, however.

Ironically, the father of the little girl who made the 2003 Valentine stamp works for the competition—FedEx. Jesus Calderon is also the town's mayor.

To get in on the action, just address and stamp your valentine, put it in an envelope and mail it to Postmaster, Valentine, TX, 79854 by February 5. The post office will postmark your card in red ink and send it on to your significant watchamacallit.

IT'S A JUNGLE OUT THERE

How did Tarzan, a ranching and farming community in a flat place, get its name? According to information available at the little Tarzan post office, the town was founded in 1924 by Tant Lindsay, who later submitted a list of six names for the town.

All of the names were rejected by the Post Office Department in Washington because they were already being used in Texas. Lindsay submitted four more lists, all of them turned down for the same reason.

So for the sixth list, Lindsay sent in six names from the Edgar Rice Burroughs book Tarzan, Lord of the Jungle, which he had just bought for his daughter. The names were Lord, Jungle, Edgar, Rice, Burroughs—and Tarzan.

Washington approved Tarzan.

The John Madden Haul of Fame

Van Horn

There isn't much to do in Van Horn, and the John Madden Haul of Fame doesn't much correct the situation.

Located at 1200 West Broadway (432–283–2066), in the John Madden Room of Chuy's Restaurant, the shrine to Madden has pictures of retired football players Mike Singletary and Anthony Muñoz and the chair Madden sits in when he visits the place to eat his favorite: chicken picado. The chair has Madden's name on the back, like a director's chair. And the table—right in front of the big-screen TV—has a sign on it that tells you that it is RESERVED FOR JOHN MADDEN.

Chuy's owner, Chuy Uranga, said the NFL TV commentator often stops in two or three times a year during coast-to-coast trips in his tour bus. Madden hates flying, so he travels cross-country from one broadcasting job to the next in his own bus.

It's called the "Haul" of Fame, Uranga said, because Madden told him having it in the restaurant "would haul people in here. And it has."

Madden really is a big Chuy's fan. He even mentions the place in glowing terms in his book, *John Madden's Ultimate Tailgating:* "If I stop at my favorite Mexican restaurant (Chuy's in Van Horn, Texas, a contributor to the recipe section of this book), I will take the chicken and the rice and the beans and mix them all up because that was what I did as a kid." In the book you will find Chuy's recipes for tamales, steak picado, and Spanish rice and beans.

Madden has been stopping at Chuy's on his way across America since 1987, Chuy said. The story goes that on one of his trips he was looking for a place that had his two favorite things: football on TV and Mexican food. And Chuy's had both.

The Roy Orbison Museum
Wink

If you wink going through Wink, you'll miss the Roy Orbison Museum on Texas 115. And that would be a shame, because you wouldn't get to try on the late singer's famous prescription sunglasses.

Roy Orbison, he of "Oh, Pretty Woman" fame, may have had a uniquely haunting voice, but his eyes apparently weren't much. If you have average eyes, when you look through his sunglasses, it's kind of like opening your eyes underwater.

The sunglasses, said curator Dorothy Wolf, were donated to the museum by Orbison's widow, Barbara Orbison. Wolf will take a Polaroid picture of you wearing these glasses if you wish. Then, she'll ask you to autograph it, and she'll tack it to the wall. So the one-room museum has a bunch of goofy-looking photos of people wearing Roy Orbison's sunglasses.

Roy Orbison grew up in Wink and graduated from high school here in 1954. Dorothy knew him, even though she said she was old enough to be his mother.

"Well, he was a pretty ordinary, unassuming guy," she said. "He was a humble sort of fella. He was pretty shy, pretty introverted, except for his music. There isn't any scandal about him. The boys would go somewhere, and he'd be the designated driver. And he couldn't see. He was really blind. So they weren't much better off."

At the museum you can see all manner of Roy Orbison memorabilia, including records, photos, high school yearbooks, and a poster from a 1968 movie Orbison starred in, *The Fastest Guitar Alive*.

Roy Orbison planned "to lead a Western Band" and "marry a beautiful dish."

WEST TEXAS

"Doomed effort to turn recording star Orbison into a movie star—with the dumbest title imaginable for a Civil War espionage story!" says the review on this movie from Leonard Maltin's *1998 Movie & Video Guide*.

"My latest acquisition—I've got a traffic sign to put up," Wolf said when I arrived at the museum. "I just had a friend bring me this from Branson, Missouri."

TOW AWAY ZONE—ORBISON FANS PARKING ONLY, the sign says.

Each year the museum holds a Roy Orbison Festival on the weekend closest to Orbison's birthday (April 23). So guess what they call the festival's beauty pageant? The Pretty Woman Pageant. What else could they possibly call it?

If you're interested in seeing the museum, call Wink City Hall at (432) 527–3441. It's by appointment only.

The Wink Sinks
Near Wink

Used to be there was only one Wink Sink, a big hole in the ground off County Road 205 that appeared mysteriously almost overnight in the oilfields between Kermit and Wink in 1980.

But now there are two Wink Sinks—thanks to a second large hole discovered in the ground in May of 2002 about a half mile southeast of the original Wink Sink.

This is a good part of the world for large holes to appear, since it's so flat, making them easy to find. Also, not many people live out this way, meaning it's less likely for somebody to be standing over a large hole when it decides to show up.

Not that you could miss these holes. The first Wink Sink is no slouch in the size department—probably 100 yards wide, said Lee Wilson,

chief deputy for the Winkler County Sheriff's Office. But it's no match for the new crater, which is even more humongous.

"It's quite a bit larger and quite a bit deeper than the other one," Wilson said of the newer cave-in. "It's probably 200 yards by 150 yards wide, and 188 feet down to the water from the surface of the ground, and we don't know how deep the water is."

You can drive right up to the old one and get a good look at it, but the newer one is harder to get to. "They have a fence around the newest one with a locked gate with signs all over it that say 'Keep Out' and 'Dangerous' and stuff like that," Wilson said. "So you can't really get in to see it, except for the pumpers checking their wells, and they might let you in. The newest one, you don't really want anybody in there because that ground is still unstable."

So why are large holes popping up unannounced in this part of the world? "I talked to a geologist and he says there's a fault that runs from Carlsbad Caverns to Senora Cavern, and those two sink holes are on that fault, and it continues to grow," Wilson said. "The geologist that was out here, he said this was the most active phenomenon in the United States today."

So next time you blink, there might be a third Wink Sink.

Frigid Fight Song
Winters

In many places in Texas, we figure it's a cold day if the dog's water bowl freezes an eighth of an inch on the back porch. Chili we know better than chilly, if you catch my drift.

But because of the town name, in Winters they play the cold theme up big. The high school band uses the mellow "Walkin' in a Winter Wonderland" as the school fight song. A song popularized by Guy Lombardo and his Royal Canadians, and it ends up in a Texas fight song?

Actually, the fight part of the song is buried in the middle of the tune. "The song starts out, bump bah bah, dah dah dah dah, real upbeat," said Winters High band director Phillip Mooney. "But about halfway through it goes into an actual fight song."

Winters High, he pointed out, is the home of the fightin' Blizzards. What else?

Even though you wouldn't think people would get real fired up with a song that starts out "Sleighbells ring, are you listenin'?" the song has been used for quite some time at football games here. "I think I heard a recording of the band playing it in the late '40s, and it's pretty much unchanged," Mooney said.

Winters High uses other wintery themes. "Back in the '60s they had a little jazz band called the Snowmen, and they have the Glacier King and Queen," Mooney said. What they don't have is a ski area. And most of the ice comes in a plastic bag. Despite the name, this ain't Colorado.

The town name has nothing to do with the climate. According to *The New Handbook of Texas*, Winters is named after John N. Winters, a rancher and land agent who donated land for the first school.

THE HIGH PLAINS

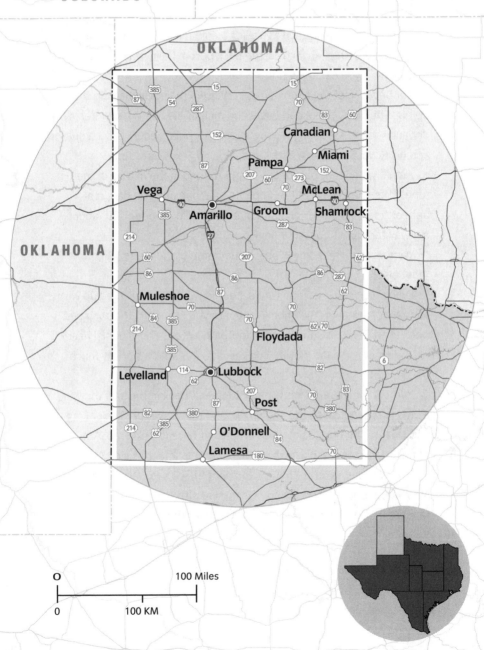

KANSAS

COLORADO

OKLAHOMA

Canadian

Miami

Pampa

McLean

Vega

Amarillo

Groom

Shamrock

OKLAHOMA

Muleshoe

Floydada

Levelland

Lubbock

Post

O'Donnell

Lamesa

0 100 Miles

0 100 KM

HIGH PLAINS

The Dynamite Museum
Amarillo

You're probably wondering why I haven't included an address for this museum. This is because it is not a museum, it has nothing to do with dynamite, and it doesn't have an address.

It was another spacey art project from Amarillo's Stanley Marsh 3, heir to an oil and gas fortune, who owned KVII-TV here and has a taxidermied hog on the floor of his cluttered office in the Bank One Tower.

The Dynamite Museum was an art-sign project that involved Marsh and a bunch of college students he recruited going all over town on Saturdays, putting the signs in people's yards.

Marsh isn't currently working on the project. "I got tired of it, but I might do it again sometime," he said. Still, thousands of the signs are scattered all over Amarillo and the Panhandle. "People move them when they move," Marsh said. "I saw one the other day that was a basketball goal."

"One of the things I've learned about these signs is that I could be a taxi dispatcher if I lose all my money," said Marsh, who with his white hair and mustache looks kind of like Colonel Sanders's crazy brother.

The signs are the same size and shape as highway warning signs, but instead of saying ROADWORK AHEAD or SLOW TO 60, they have messages such as I HAVE TRICKS UP MY SLEEVE, I FOUND A BLUE SPIDER IN THE CORNER AND

KILLED HIM WITH A BROOM, I'LL DO AS I PLEASE, BIG ROCK CANDY MOUNTAIN, and YOU'RE WITH THE BAD BOYS NOW, BABY.

Marsh and his college-kid recruits got the sayings from a variety of sources. "Books, novels, deejays, Hank Williams, Shakespeare," Marsh said. He says most of the kids who helped him make and distribute the signs are creative types. "I don't think we've ever recruited anybody who didn't want to be a rock star or a famous author," he said. "We've never recruited anybody practical who wanted to learn about cement."

You knew them when you saw them. They traveled in a caravan of vehicles that included a pink '59 Caddy; a flatbed truck with a buffalo head on the back, hauled by a van with a merry-go-round horse on the roof; a van completely covered with "God Bless John Wayne" bumper stickers; and another van with a couple of yard geese riding on top.

Why the geese? "I spent too much time trying to find my car after coming out of the movies," Marsh said.

This sign business all began after Marsh saw a bunch of signs near a railroad crossing that he thought were depressing—among them ROAD ENDS 300 FEET. So he put up his own sign—ROAD DOES NOT END. Marsh says he did this because "art should be taken out of museums and put out where the public can see it, where it surprises you, like in the supermarket or in the underpasses around the corner."

Lightnin' McDuff
Amarillo

This sculptor makes a living making art out of junk. "The majority of 'em are 100 percent recycled, or close to it," said Lightnin' McDuff, a slow-talking, ponytailed, lanky drink of water. "These deer—the legs are made out of new steel, but the bodies and the heads are old farm discs, and the antlers are pitchfork tines."

Lightnin', who gets his inspiration from reading and visiting junk-yards, pointed out his prices are less than many other sculptors' "because what you're buying here is my imagination and my work, instead of expensive material.

"I go to scrap iron yards, garage sales, farm auctions," he said. "Every once in a while, some farmer will call to say, 'I've got a bunch of stuff out behind here, why don't you come by and haul some of this stuff off?' And I do."

The parts become art and get a price tag. Lightnin' said his works run $150 to $200 and up.

Lightnin' said his most popular works are his deer and buffalo. "I was raised working with livestock as a kid growing up," he explained. "So you'll find a lot of critters here. And the thing is, I don't have to feed and water 'em every day." The buffalo that used to decorate his studio was made out of the ends of propane tanks, along with some steel rod for eyebrows.

Perhaps Lightnin's best work was his pet, the *Maniac Mutt,* a nasty-looking junkyard dog made out of scraps from other art projects. Light-nin' kept the *Maniac Mutt* chained in the back of his truck at 508 South Bowie (806–376–5045). "A fella with a gimme hat on his head and a flatbed truck needs a bad dog in this part of the world," Lightnin' said. "I had to keep him chained 'cause he likes to jump out and eat the hub-caps off of Mercedes. That's his favorite snack."

The bad news is the *Maniac Mutt* is no longer in the back of Light-nin's truck since it was sold to a guy in Arizona.

The good news is that since then Lightnin' has built several other similar mutts, although he says people keep snapping them up. So he remains muttless.

POETRY IN MOTION

If you're in the mood to be put on, you can't miss this one, south of Amarillo.

"I met a traveler from an antique land/ Who said: Two vast and trunkless legs of stone/Stand in the desert," it says in the poem "Ozymandias," by the immortal English poet Percy Bysshe Shelley.

So just to tweak everybody's nose, the wild and wacky Stanley Marsh 3 commissioned Amarillo sculptor Lightnin' McDuff to build two large, trunkless legs of concrete reinforced with steel: one 24 feet high and the other 34 feet high. The legs get a lot of attention. "People go out there sometimes and paint his toenails," Marsh said. "And I understand there have been three marriages out there."

The legs may not be standing in the desert, exactly, but they are standing behind a barbed-wire fence all by themselves in a pasture off Interstate 27 at Sundown Lane, south of Amarillo. You can't miss them. They're the only big concrete legs with large feet out there.

The work, like the poem, is called *Ozymandias*. Why did Marsh pick this poem? "It's a poem about the futility of building monuments, so, of course, I built a monument to it," he explained. The legs come with a phony Texas historical marker Marsh concocted to further muddy the waters.

The marker says that Shelley penned his poem at this location in 1819 when he and his wife, Mary Wollstonecraft Shelley, the author of *Frankenstein*, "came across these ruins" while they were "on their horseback trek over the great plains of New Spain."

Almost everything on this marker is complete and utter horse doots. My favorite part is the paragraph at the bottom of the marker

that explains why the legs have no face.

The marker says, "The visage (or face) was damaged by students from Lubbock after losing to Amarillo in competition." The marker goes on to say that the face will be replaced, and if you want to see the original, you can find it at the Amarillo Museum of Natural History.

There is no Amarillo Museum of Natural History. But Marsh said people call all the time, trying to find it.

Incidentally, unknown pranksters painted gym socks on the legs. Marsh didn't do the work, but since he liked it, he took credit for it.

If you build it, they will come.

The Big Texan Steak Ranch

Amarillo

If you've ever had a hankering to consume a piece of meat the size of a double-wide, this is the restaurant for you.

If you can finish off the seventy-two-ounce top sirloin in an hour or less, it's yours for free—if you can also down the baked potato, shrimp cocktail, dinner roll, and salad that come with it.

So what is it that gets them? "It's the croutons," joked Bobby Lee, one of the owners of this restaurant off Interstate 40's exit 75 (806–372–6000). Since 1960, about 69,000 people have tried to complete the meal, and about 7,400 of them have been successful. (The other 61,600 suffered from gas.) "It's about the size of a catcher's mitt," Lee said of the steak.

Not everyone who has accomplished the task has been a load. Lee says a ninety-five-pound reporter from the *Wall Street Journal* ate the whole thing. But he didn't say if that weight was before or after.

The fastest time ever was turned in by former Cincinnati Reds pitcher Frank Pastore, who finished up in under ten minutes in 1984. Too bad the game of baseball doesn't move that fast.

To get this steak for free, you have to finish it in an hour or less.

Danny Lee, Bobby's brother and an owner, said every once in a while someone will make practical use of the steak deal, which costs $75 if you can't eat it in the prescribed time. He said one guy who ordered it was taking his sweet time eating it, but ordered a dozen extra rolls. "He said, 'I'm going all the way to California, and I wanted to make some sandwiches,' " Danny recalled.

It hasn't all been fun and games at the Big Texan Steak Ranch, though. In October of 2003 George, the restaurant's pet 8½-pound rattler, got loose from his cage in the gift shop. This presented a thrill for management since the restaurant was open at the time and they really didn't want George crawling up some tourist's leg.

"There was a pretty good crowd," Bobby Lee said. "Thank God we found it. We found it in about twenty minutes. That was the longest twenty minutes of my life."

George was put down and has since been replaced in the gift shop by another rattler, yet to be named.

Then in 1998 there was the escaped convict from Indiana who shot himself to death in room 223 of the restaurant's motel after the police came and surrounded the place. "It was a big deal; they brought a SWAT team out and everything," Bobby Lee recalled. He says ever since that event there has been "weird stuff going on in that room."

"We're thinking of shutting it down," he said. "People say they hear noises at night and the door to the room will just open. And right around the holidays is when it's the worst, like Christmas and Thanksgiving."

Homer's Backyard Ball

Amarillo

Living proof that Texans think it's wasteful to not make use of the entire animal comes to us from the Make-A-Wish Foundation of the Texas Plains annual calf fry cook-off fundraiser. A calf fry, you see, is a fried calf testicle.

What do they taste like? "When they're trying to get somebody to eat 'em who doesn't know what they are, they tell 'em it tastes like chicken," said Sharon Bertrand, Make-A-Wish's former wish-granting coordinator.

Homer's Backyard Ball started out as a fairly small event in 1997 in agricultural engineer Travis Homer's backyard. Back then it was just a party with a bunch of guys. Make-A-Wish got involved in 2000, and the event grew. Now it's billed as the World's Largest Calf Fry Cook-off.

In 2002 the cook-off raised $30,000 for Make-A-Wish, Travis said, and 3,000 people showed up. Bands play into the small hours. Sounds like everybody had a ball.

So how do you cook a calf fry? "Most of 'em just deep-fry 'em on electric grills or gas grills, like a propane cooker," Travis said. "They just heat up some grease and batter 'em with flour or cornmeal or anything they kinda want to batter them with. Then they just fry them in the grease until they float and pull them out."

Some folks like 'em, some don't. "[It's] more calf fries than you can stomach lookin' at," said Christie Montgomery, a Make-A-Wish worker. "I'm not from Texas. I'm an Eastern girl, and I about died."

Cadillac Ranch

Near Amarillo

Bankrolled by eccentric millionaire Stanley Marsh 3, this ranch in a field next to I–40 is where ten vintage Cadillacs are buried nose down in the ground, with their tail fins thrust toward the sky.

Established to outline the history of changes to the Cadillac tail fin, the display is the Panhandle's answer to the Statue of Liberty. It's what you go look at when you're up this way.

"You can't drive by it when there's not somebody out there," said Jackie Anderson, who worked for Marsh's investment company. "And there'll be Germans or Japanese, tourists from all over the world."

In 1998 the Caddies were decorated for the holiday season. "We just painted 'em like Christmas trees," Anderson said. "Green, with tinsel and ornaments and all kinds of stuff."

Check out the Cadillac Ranch, a line of ten Caddies buried in a dirt field.

Arnold Burgers
Amarillo

Trying to commit suicide by cheeseburger? Stop here. "We make just about any size you want," said Gayla Arnold, the owner of Arnold Burgers, at 1611 South Washington Street (806–372–1741). The biggest one? "Now we have a 24-inch burger," she said. "It's about eighteen to twenty pounds give or take. It will feed about twenty to twenty-five people." That burger costs $41.77. Then there's the ten-pounder. "That's on an 18-inch bun, so it's larger than a large pizza around." This model runs $25.77. On the other hand, "It feeds fifteen teenagers," Gayla said. Not bad. That's only $1.72 a teenager.

"We also do designer burgers," she added. "We make heart-shaped ones, Texas-shaped ones, Christmas tree–shaped ones." One of the Texas-shaped burgers has a 12-inch bun and feeds six ($19.77).

Even some of the burgers built for one aren't exactly Lean Cuisine. "We've got a triple meat [for $6.27], which has three patties of about three-fourths of a pound each," she said. "We have a lot of people that eat those, mainly men."

Did Oprah Winfrey stop in here when she was in Amarillo for her beef defamation lawsuit? "No, but her crew did eat with us," Gayla said. "They were very nice people."

The burgers are almost as big as the tiny white building they're cooked in. The place has eight tables. Out front a painted sign showed three burgers with legs, running. I like the sign in the little parking lot that posts the hours: 9 A.M. TO 5:45 P.M. MON. TO FRI. MOST OF THE TIME.

HiGH PLAiNS

Concrete Yard Collection
Canadian

Bobby Gene "Pig" Cockrell's well-endowed concrete Dallas Cowboys cheerleader didn't stay naked long.

These days she's got on hot pants, a tank top, and boots.

"My neighbor and my wife put some clothes on her," said Pig. "They didn't think that would look too nice out in the front yard."

So what'd Pig think of her? "It looked pretty good to me," he said.

Most of the concrete items Pig makes and puts in his yard aren't risqué. There are twenty-six sculptures in all. Pig's favorite is the cowboy outhouse scene. You see the wooden outhouse and the reins from the horse leading into the outhouse. But you don't see the cowboy.

"It looks just like the cowboy rode up to the outhouse and run in and held the reins so his horse wouldn't run off," Pig said.

He's also got a buffalo, a two-headed dragon, and a concrete family from outer space.

"I've got three aliens—a mamma, a pappa, a baby, and an alien dog—and I've got a flying saucer on top of it," Pig said.

Pig began making concrete yard art in the mid-1990s. So what got him started? "Oh, I dunno, I couldn't fish and hunt all the time, so I had to do something else," he explained.

GOD WORKS IN MYSTERIOUS WAYS

In August 1993 twenty people who had taken off from the small town of Floydada were found naked in the same car after it hit a tree in Vinton, Louisiana.

Darrell Gooch, the current police chief in Floydada and an officer at the time, said it all started when one of the group came home from the military.

"He had a religious calling from God, telling him that the end of the Earth was coming, and Floydada was where the initial disaster was going to start from," he said.

So why did they take off their clothes? "The same one said the devil was in their clothing and all their possessions," Gooch recalled. "That's why they ended up in Louisiana as naked as jaybirds."

Gooch said the car the people were stopped in was "a little maroon Grand Am." News accounts said there were fifteen adults in the car, and five children in the trunk. And no pants anywhere.

The incident has brought a certain amount of fame to Floydada, although not necessarily the kind a chamber of commerce chairperson would relish.

"Even after all these years, we still get teased about being from Floydada," Gooch said.

Really Big Cross

Groom

"I just wanted to advertise for our Creator in a bold manner. That's about as bold as you can get," said Steve Thomas, mid-fifties, a structural engineer from Pampa.

No kidding. The 190-foot-tall steel cross Thomas put up on the south side of I–40 is so big that you can see it up to 20 miles away. This cross, lit up at night, was billed as the largest cross in the Western Hemisphere, until a 198-foot steel cross at Interstate 57 and Interstate 70 at Effingham, Illinois, was completed in July of 2001.

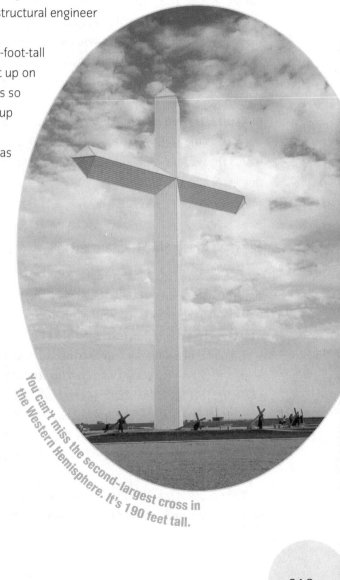

You can't miss the second-largest cross in the Western Hemisphere. It's 190 feet tall.

"There's one other cross larger and that's in Spain," Thomas said, speaking of a 500-foot-tall masonry cross 60 miles north of Madrid, built by Francisco Franco. Being a dictator, Franco probably didn't have to use his own money. Thomas, however, spent $500,000 of his own money to build this cross.

This is not just a cross. It is a cross complex with a big parking lot that will accommodate eighteen-wheelers, the stations of the cross done in bronze, even a gift shop with indoor plumbing.

"We get 1,000 or 2,000 a day stopping, and 10 million a year go by," said Thomas, head of an outfit called Cross of Our Lord Jesus Christ Ministries. He said he put up the cross to combat "X-rated stuff, period, not just on the highways," as well as alcohol and gambling. In other words the cross is lit up at night in hopes of keeping people from getting lit up at night.

Blessed Mary JMJ Restaurant
Groom

Jim Moraniec's Blessed Mary JMJ Restaurant, at 701 North Front Street (806–248–0170), has a decorating scheme that fits in with the big 190-foot cross just down the road. Each of its twelve tables has a sign on it with a name of a different apostle. The Judas table did cause a stir, however. "I took his off 'cause it was creating a situation," Jim said. "I had someone that sat there, saw it on the table, and threw it on the floor."

Jim runs the place with his wife Carolyn. Before opening the restaurant, Jim worked as a greeter at the big cross. "People are searching and sometimes you can just say one word," Jim said. "It doesn't take no big thing."

You pay what you think the meal is worth at Jim's place. You just stick your money in the jug by the front door. Jim puts $50 in the jug so

people can make their own change out of the jug. "It's pretty big," Jim said. "It's about two foot tall, and it's just a pickle jar, I guess. Right by the front door. It's got an angel on each side of it."

The pricing method is a kind gesture, but apparently it isn't making Jim the money he would like to donate to charity. He said the first year he lost $24,000. "The second year we almost broke even," he added. "We were $5,000 down. That's close."

If you short Jim, though, don't think you're getting away with it. "I've got a picture of Jesus that follows you," Jim said. "Jesus' eyes follow you. It's on the front wall."

If you go, Jim recommends the enchiladas. "My enchiladas are special," he said. "They're made with ground chuck and I use the best cheese and they're just delicious and everyone likes 'em. I served a tour bus about a month ago and most of 'em took enchiladas. And of the whole group—there was forty-four of 'em—there wasn't a handful of food thrown away."

The Sky-Vue Drive-In

Lamesa

If you come to this Truman-era drive-in movie theater, you've got to hit the snack bar and try the sandwich known as the Chihuahua. But bring a towel.

"It's messy, but it's good," said Lamesa native Charles Beckmeyer. "I don't know what all it's got in it, but it'll run down both arms when you start eating it."

Beckmeyer was at the drive-in on a Saturday night to see *Blue Hawaii* with his wife Mary. It was classic car night at the drive-in. So they were sitting behind their '54 candy apple red Chevy two-door hardtop in a couple of lawn chairs.

Going to the Sky-Vue Drive-In in Lamesa is like stepping back to 1950.

The Chihuahua, invented by former Sky-Vue owner Skeet Noret in 1951, is two fried corn tortillas filled with chili meat, one whole jalapeño, shredded cabbage, onion, and a special pimento cheese. So how'd it get the name?

"They were testing it one night out here," said Sam Kirkland, the current owner, who began working at the drive-in as a soda jerk in the mid-1950s. "Two Spanish girls walked by, and one of 'em had on tight pants. And this Spanish boy said, 'Oh, Chihuahua.' "

The Sky-Vue opened in 1948, and I doubt if it looks much different today than it did back then. Remember those two tall sheets of tin you had to drive between to get into your drive-in theater back home? Well, the Sky-Vue has those two sheets of tin.

HiGH PLAiNS

"Eighty percent of this place is original—we just paint it and keep it running," Kirkland said. The Sky-Vue even has the obligatory playground area—merry-go-rounds, slides, swings—up front by the screen. The night I visited, the playground was full of energetic children zipping about.

One thing that has changed: no car speakers. These days you tune in the sound on your car's FM radio. "About half of 'em were stolen," Beckmeyer figured. "There wasn't many cars in town that didn't have a Sky-Vue speaker in the back."

Another change: Kirkland doubts if people neck in their cars as much as they used to, because there are places other than the drive-in where you can suck face these days.

"We call the back row out yonder the passion pits," Mary Beckmeyer said. "Back in the early 1950s, they nearly had to have it censored. About half the teenagers in town were back there."

"Shoot, I just drove right down here in the front row," Charles Beckmeyer bragged.

"Oh, I'll bet you did not," Mary told him.

WHAT'S YOUR MAJOR?

OK, kids, no fair looking at each others' work. Here are some of the questions on this semester's country-and-western music final:

1. True or false. George Jones was loaded when he hit that bridge.
2. Fill in the blanks: Let's go to Luckenbach, Texas, with_____, _____, and the _____.
3. What doesn't fit in this grouping: trains, mamma, gettin' drunk, pickup trucks, TGI Friday's?

Actually, I just made those questions up. But you really can get an associate of applied arts degree in country-and-western music from South Plains College, a junior college in Levelland. Because it's both country and western music, I guess that would make it a double major. Either way, South Plains College was the first college in Texas to offer a degree plan specifically for country-and-western music, said John Hartin, retired chairman of the creative arts department and a country music performer himself. Hartin founded the program in 1975.

"The students who leave here are fully equipped to go out and compete in the music business, whether it be as a performer, sound engineer, or the camera part of it," said Tammy Amos, department secretary (806–894–9611, ext. 2281). I wonder if that means they teach them how to ride cross-country on a Greyhound bus.

Seriously, the program has three full recording studios—among them the Tom T. Hall Recording Studio and the Waylon Jennings Recording Studio. Students can take private lessons on a variety of instruments, from mandolin to upright bass.

The school's alumni include Lee Ann Womack, Natalie Maines of the Dixie Chicks, Heath Wright of Ricochet, and Ricky Turpin, fiddle player with Asleep at the Wheel, among others.

Buddy Holly's Footprints

Lubbock

There's a Buddy Holly Center, a Buddy Holly statue, Buddy Holly's Grave, and a Buddy Holly Avenue.

The town is proud of its native son, the rock 'n' roll pioneer of "Peggy Sue" fame who died in a plane crash on February 3, 1959, near Clear Lake, Iowa. The Buddy Holly Center is a museum dedicated to the man who brought us "That'll Be the Day" during his short (eighteen-month) but revolutionary career. Located in the renovated Fort Worth & Denver Railroad Depot at 1801 Avenue G (806–767–2686), the museum had its grand opening in early September 1999.

The centerpiece of the museum? Connie Gibbons, Lubbock's former cultural arts director, figures it would be either Buddy's Fender Stratocaster guitar or Buddy's signature black glasses frames, which have a large case all to themselves. The frames were found at the site of the plane crash.

Also in the museum are one of Buddy's school report cards, his Cub Scout uniform, and his fly rod. "He loved to fish and hunt," Gibbons said. The gift shop has Buddy Holly baseball caps, Buddy Holly T-shirts, and it used to have sheet-music boxer shorts.

Was the music accurate on the boxer shorts? "I don't know—we could get a piano and try," Gibbons said.

If that's not enough Buddy Holly stuff for you, you can check out the Buddy Holly Statue, in Buddy Holly Plaza, between the Holiday and La Quinta Inns on Avenue Q between Seventh and Eighth Streets. The gravesite is at the city cemetery, 2011 East Thirty-first Street. And Lubbock High School, at 2004 Nineteenth Street, has a display case in one hall full of Holly artifacts, as well as a picture of Holly that's hanging over his homeroom door.

If you visit the high school, please be sure to check in at the principal's office. Buddy Holly probably wouldn't have bothered to do that, but you should.

THE HE'S NOT HERE SALOON

"I've never seen trouble in here. Have you?" Tom Shirey, in a sleeveless undershirt, asked the guy sitting across the bar from him.

"Yeah. It's a bar," the other guy said.

Yeah, it's a bar with a great name. One of the big nuisances bartenders face is wives calling bars to find their husbands. To fix this problem, Margaret, last name unknown, but a former bartender here, came up with the name the He's Not Here Saloon for this two-pool-table bar in Lubbock.

When you call (806) 747–3848, the bartender picks up the phone and says, "He's Not Here."

"They used to have a sign up, IF YOU'RE HERE, IT'S 50 CENTS A CALL. IF YOU'RE NOT HERE, IT'S A DOLLAR, or something like that," said Tom.

The He's Not Here, at 3703 Avenue Q, opens at 7:00 in the morning every day but Sunday. "And it's usually full by 8:00," Tom said.

The He's Not Here probably would open at 7:00 A.M. on Sunday, too, if it wasn't illegal in Texas to sell alcohol before noon on Sunday.

By the way, the He's Not Here lives up to its cranky name. As the name indicates, they really don't want to be bothered with phone calls. On one day I called the place five times and got hung up on by the female bartender all five times. "Call back in the morning," she said. So I did. Fortunately, she wasn't there. But somebody else was and actually spoke to me.

Stubbs Statue

Lubbock

Like most states, Texas is loaded with statues of generals, tycoons, and politicians. Finally, we get a statue of somebody who did something crucial for humanity—the barbecue man.

The 7-foot bronze of Christopher B. Stubblefield, who everybody called Stubbs, stands at the site of his original barbecue joint at 108 East Broadway. The statue, by Santa Fe sculptor Terry Allen, shows Stubbs as he often was—in overalls and a cowboy hat, holding a plate of ribs.

Stubbs opened his barbecue joint in the late 1960s, and it soon became a favorite hangout for musicians. Joe Ely and Jesse Taylor started a Sunday night jam session in the place. Artists such as Muddy Waters, Tom T. Hall, and Linda Ronstadt also would show up to play and eat.

In the early 1990s, Stubbs appeared on David Letterman's show and fed barbecue to the studio audience. Stubbs had Letterman eating out of his hand, according to John Scott, who went into business with Stubbs in the 1990s and is one of the owners of Stubb's Barbecue in Austin.

"Stubbs just did so well," Scott recalled. "David Letterman said, 'How did you get interested in the art of barbecuing?' Stubbs said, 'My daddy said I was born hungry, so I had to cook.' It just cracked Letterman up."

Stubbs may be gone, but you can still see his face on his statue and on the bottles of his barbecue sauce, which is sold in an estimated 35,000 to 40,000 grocery stores around the world.

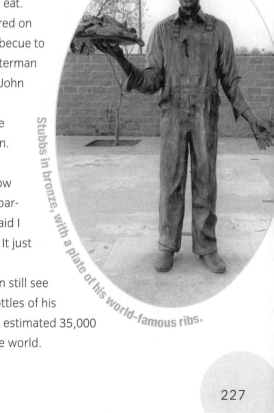

Stubbs in bronze, with a plate of his world-famous ribs.

The Goodart Candy Company
Lubbock

Round peanut patties are as much a part of Texas culture as the turkey buzzard and armadillo roadkill.

"Some people call 'em peanut rounders," said Fred Borden, former general manager of the Goodart Candy Company. You can't go into a convenience store in Texas without running into peanut patties. They have a red color like no other—similar to a bruise. They're sweet enough to draw ants at 1,000 yards.

And this little company of sixteen employees, located at 335 East Fortieth Street, makes an average of 20,000 of them a day during peak season, Borden said. That's a lot of peanut rounders.

And it's not just people who are eating them. Ron Harbuck, Goodart's vice president, says a rancher from Big Spring named Sonny Anderson uses the peanut patties as bait when he goes hunting for bears in New Mexico.

Sonny, Goodart said, comes by the peanut patty plant "every couple of months" and collects floor scraps for his hunting trips and ranching needs. "He said the biggest bear they got last year was one going to the peanut patties," Harbuck said. "You just kind of put it out some place and the bears kind of come to it. He feeds it to his cows the rest of the year."

Doesn't feeding bears and cows these things constitute cruelty to animals? Anyway, if you see some pink bear poop the next time you're picnicking in the woods, now you know why.

"I sell it to deer hunters, too, on occasion," Harbuck added. "It's pretty expensive bait, but I hear it's quite good."

Peak season for peanut patties is summer. "The hotter it gets, the better we do," Borden said. Why? "They don't melt. You don't go in a 7-Eleven when it's 110 degrees and buy a Snickers."

Eating peanut rounders is no way to stay trim. Borden said he gained about twenty pounds the first three months he worked at Goodart. So he quit eating them.

"It's kind of fun watching the new employees eat them all the time," Borden said. "Then after about a month, you don't see them eat them anymore."

The formula is simple enough. Peanut patties are made out of corn syrup, sugar, peanuts, salt, water, and food coloring. "It's cooked in copper kettles at 100 pounds per batch," Borden said.

It's a regional product, so they're not sent to, say, Maine. "If you put 'em on the shelf up there, they don't sell 'cause nobody would know what they were," Borden said. He figured about 70 percent of the company's peanut rounders are sold to Texas stores, and the rest go to Oklahoma, Arizona, New Mexico, "and a little bit in Missouri."

Devil's Rope Museum
McLean

This museum devoted to barbed wire is pretty sharp. But it's in the same building as the Route 66 Museum—at 100 Kingsley—for a darned good reason.

"We get 16,000 to 18,000 people going down Interstate 40 each day, and when you see 'Barbwire Museum,' you don't just hit your brakes," said Delbert Trew, supervisor of both museums. "But when you see Route 66 Museum, that's a different deal."

The building where these two museums coexist used to be a brassiere factory called Marie Fashions. So visiting either one should be an uplifting experience. And under the circumstances, I guess it makes sense that the building houses a pair of museums.

The museum exists as a place for barbed wire collectors—there are about 500 of them in the United States, according to Trew—to display their collections. There certainly are plenty of kinds of barbed wire to see in this museum. "There are over 530 patented barbed wires, and we've collected approximately 2,000 variations of those 530 patents," Trew said. In the museum you'll find displays of barbed wire used by planters, barbed wire made for railroads, and barbed wire used in war. Or, in other words, war wire. In Texas, of course, this would be pronounced *war war*.

"Then there are just the plain old machine screwups, where the machine was worn or missed a lick somewhere, and some people collect those things," Trew said.

There is also barbed wire art in here, including *A Real Sharp Stetson*—a hat made entirely from barbed wire.

"The hat was made by a hippie in Taos, New Mexico, but we didn't get his name," said Trew, who also makes barbed wire art, like the barbed wire jackrabbit and the life-size coyote you'll see in this museum.

You can trade barbs with Trew by calling (806) 779–2225, www .barbwiremuseum.com).

The Route 66 Museum
McLean

A chunk of Route 66 still runs through McLean. Up the road from the museum, located at 100 Kingsley (806–779–2225), you'll find an ancient restored Phillips 66 gasoline station. The museum, put together by the Old Route 66 Association of Texas, starts out on a high note with a series of Burma Shave signs by the entrance:

DON'T STICK YOUR

ELBOW OUT SO FAR

IT MIGHT GO HOME

IN ANOTHER CAR

BURMA SHAVE

This could have happened on old Route 66. On the day of my visit, Creed and Wanda Lamb were working as volunteers in the museum. Creed Lamb began running the Lamb Funeral Home in McLean in 1956 and sold the place in 1998. Wanda says Route 66 used to be a real booger. "When we first moved here we had a funeral home, and it was just terrible how many wrecks they had," she said.

If you ask me, the highlight of this museum is the depiction of the 66 Cafe that used to be located on Route 66 in McLean. The re-creation is vintage 1940s or 1950s. You've got a little four-stool counter, dishes set out, and a lunch special board that tells you BLTs were forty cents. You want to know how dated this joint is? The place even has a cigarette machine.

Among the artifacts you'll see in the museum are some speakers from an old drive-in movie, a life-size doll of a sailor hitchhiking next to a Route 66 sign, and a key from Room 3 at the old Coral Courts Motel. The message by the day or by the hour can be found on this key. So, like the song says, people really did get their kicks on Route 66.

Hanging from the ceiling of The Route 66 Museum is an old road sign that says 19 MILES TO MCLEAN, TEXAS. THE UPLIFT TOWN. The sign, found in a ditch north of town and restored, refers to the fact that McLean was once the home of the aforementioned brassiere factory.

May I take your order?

National Cow-Calling Contest

Miami

Contestants shoot for noise, not for style.

"It's pretty loud," said the late Katie Underwood, director of the Roberts County Museum, who entered the cow-calling contest herself a few times. She said three judges are stationed from a half mile to a mile away from the platform where the contestants perform their cow calls.

"And whoever they can hear the loudest at that distance is who wins," she said. "It's volume. We don't actually have cows running to town when we do this."

The unique annual contest, held the first weekend in June, has been going on since 1949, according to Underwood. "We're the only one that does this in the state of Texas, I know. But we're pretty sure we're the only one probably worldwide."

The reason this contest goes on here is that Roberts County (population 550) is cattle country, so people are calling their cows anyway. "Oh yeah, course they do it every day on a daily basis, because we're right in the middle of ranching," Underwood said. "They still get out of their pickups and call cows when they're feeding. They practice every day."

There are five divisions—children's, men's, women's, grandmothers', and grandfathers'. Sometimes, each division will have as few as three entries, and sometimes as many as twenty.

National Mule Memorial
Muleshoe

The offspring of a jackass and a mare helped plow these parts, so what better way to pay tribute than by building a life-size fiberglass statue of the animal?

"It's a tribute to the hard-working animal that helped start this area," said Susie Pierce, former economic development director for the city of Muleshoe. She was talking about the National Mule Memorial, located at Main Street and U.S. Highway 84.

Of course, if the name of your town is Muleshoe, what else could you put up to advertise yourself? A statue of a gigantic land crab? I don't think so.

Dan Blocker Bust

O'Donnell

The bronze bust of the big guy who played Hoss Cartwright on the TV Western *Bonanza* can be found on a pedestal right across the street from the museum with the Dan Blocker room.

"Nearly everything is right across the street in O'Donnell (population about 1,000)," said Gustene Bairrington, city secretary.

Dan Blocker grew up here. His parents ran the Blocker Grocery. That explains the bronze bust, done by noted sculptor Glenna Goodacre, who also did the Vietnam Women's Memorial.

The O'Donnell Heritage Museum has a pair of Blocker's boxing gloves, a *Bonanza* lunch box, a photo of Blocker's fourth-grade class, and other Hoss Cartwright memorabilia.

"We even have his Scout pants that he wore when he was probably eleven to twelve years old," said Elaine Pearson, a museum board member.

Now in regards to Blocker's Boy Scout pants—they're big for an eleven- or twelve-year-old. Actually, they're big for a forty-year-old. Come to think of it, Blocker's Scout britches may be big enough to house a Cub Scout troop. So how large are they? "Lord, I don't know. They're big," Bairrington said. "They look to be at least a 46, 48 maybe, but I couldn't tell you for sure."

The Blocker bust reads: "Thanks to film, Hoss Cartwright will live. But all too seldom does the world get to keep a Dan Blocker."

Musical Welding Job

Pampa

Welder Russell "Rusty" Neef's 150-foot-long steel score of the chorus to Woody Guthrie's "This Land Is Your Land" is so accurate that a musician could read it like a piece of sheet music. And without as much eye strain. The treble clefs are 12 feet high.

"It is musically correct," said Neef, who spent about 400 hours in 1993 creating the work, which can be found in front of the M. K. Brown Civic Auditorium on Hobart Street, or Texas Highway 70, which runs through the town of Pampa. "You could play it or sing it or whatever, if you knew what you were looking at."

Neef admits he wouldn't know what he was looking at. "I know nothing whatsoever about music," said Neef, a welder since 1946. "That puts me in a very awkward place." So he had Wanetta Hill, a music teacher in the Pampa school system, arrange the score for him in the key of G and 4/4 time.

The reason a Guthrie song was picked for the project? Neef said the folksinger lived in Pampa in the late 1930s and early 1940s. Neef didn't know him well. "But I remember seeing him on the streets," he said. "And he spent some time here. In fact, they like to brag this is where he started writing his music. I don't think that's correct, but it makes a good story."

Neef is proud of his project, which he said should last for eighty to one hundred years because nothing but the best materials were used. "This paint that was put on here was $125 a gallon," said Neef, who spent a little over $18,000 of his own money to build the Guthrie chorus, which he presented to the city. "There wasn't anything on there that was cheap."

If you can read music, you can play Russell "Rusty" Neef's steel score to the chorus of Woody Guthrie's "This Land is Your Land."

Neef said he made the work to leave something behind to honor his father, George Herman Neef, who started the family's welding shop here in 1936. And it's certainly colorful.

"I thought it was so attractive that I lighted it with red, white, and blue lights," Neef said. "It is a patriotic song, so the first section is red, the second one is white, and the third one is blue."

Beard-Growing Contest

Shamrock

The man you have to watch out for in town during the annual beard-growing contest is the Chief Fuzzer. If you don't have a beard on your face, he can have you thrown in the Barefaced Jail.

"Now the whole key is you have to grow the beard," said David Rushing, chairman of the St. Patrick's Committee and the chamber of commerce in this town of about 2,300 on Route 66. "It's $5.00 for the permit. We have the jail on a flatbed. It's a regular old steel jail cell. Some of the welders here in town built it several years ago. If you don't buy the permit, you end up in the jail until you buy it, or you've been in there long enough to grow the Donegal."

Contestants begin growing their Donegal beards—an Irish beard trimmed along the chin line—after they shave clean on January 1. Then they let their beards grow out for the contest, held the Saturday closest to St. Patrick's Day. Right before the contest, they trim their beards into the Donegal shape. Several of the same faces compete again and again.

Richard Smith, who owns the Route 66 Inn here, said he enters only every ten years to give everybody else a fighting chance. He's won several times. "I think just about every time except the time they imported one from down around Austin somewhere and he beat me out," Smith added.

Smith is speaking of Scotty McAfee of Austin, who entered the contest one year for the filming of a documentary about the contest, called *Growin' a Beard*. "I've always, you know, had no problem growing hair," McAfee said. In the documentary he is shown trimming his beard as he says, "This is like trying to cut down the Muir Woods with a Weedeater."

ROY WARDLOW
"PAINTS IT GREEN"

RICHARD SMITH
"ENTERS EVERY TEN YEARS"

BILL HOWE
"TAKES LITTLE GREEN PILLS"

BEEF AND PIE PRODUCTIONS PRESENTS

GROWIN' A BEARD

A MIKE WOOLF DOCUMENTARY

with

SCOTTY McAFEE
"THE HAIRY OUTSIDER"

...ck's Day face-off in a small Texa...
...ck, Texas Beard Growing C...

Music THE GOURDS • Art Di...

The beard-growing contest in Shamrock is now the subject of a funny documentary.

The beard-growing contest is to celebrate Shamrock's Irish heritage. Two pieces of the Blarney Stone from Ireland can be found in town— one in the lobby of the Irish Inn Motel and the other in the city park. But it's not all Irish during the St. Patty's Day celebration.

"We're adding something new this year," Rushing said. "We're adding riding lawnmower races. That's completely different."

Dot's Mini Museum
Vega

"When You Get Here, You're Half Way There," it says on Dot Leavitt's business card. Halfway there, as in halfway between Chicago and Los Angeles on Route 66.

Dot's tiny museum, a collection of what some people might refer to as junk, sits next to her modest red stucco house a few blocks off Route 66, at 105 North Twelfth Street (806–267–2367).

There is no particular theme to this museum, even though Dot has been inducted into the Route 66 Hall of Fame. The museum doesn't dwell on that subject alone. In fact, it doesn't really dwell on any particular subject. It features a calf dehorner, a sundial, and a pair of blue suede shoes still in the box.

"This is a package of old Bravo cigarettes they invented down in Hereford out of lettuce leaves," Dot said. "The men didn't like the lettuce much, so they quit makin' 'em." Sure enough, on the back of the cigarette pack, it says these nicotine-free butts are made out of "a variety of lettuce." Heck, why smoke 'em when you can throw Thousand Island on 'em?

"This is a hand grenade," Dot said. It was a disarmed hand grenade. Where did she find that? "I don't remember for sure. A garage sale, I think."

POST

It is not true that every house in Texas has an oil well in the yard. On the other hand, Post, at the intersection of U.S. 84 and U.S. 380, is the kind of town where people are glad to see the price of gasoline go up. Oil wells are so prevalent that you can sometimes see them operating on the Garza County Courthouse lawn. In March of 2006, there were sixty-eight producing wells in the city of Post.

Ah, but it was not always this way. In the past, instead of oil, it was bedsheets and pillowcases. The town of Post was founded in 1907 by eccentric wealthy man C. W. Post, the creator of Post Cereals. Post started the town with the utopian idea of building a model self-contained community.

Post began operations out here when it was buffalo and Indian country. He started by buying about 333 square miles of prairie land. Then he had small farmhouses built and sold them to settlers who wanted to grow cotton.

Post spent $650,000 to build the enormous 444,000-square-foot Postex Cotton Mills, a bedsheet and pillowcase manufacturing plant that had its own cotton gin, boiler operation, and weaving room. The plant was completed in 1911. The farmers living in the little farmhouses would grow the cotton and provide it to Postex. The plant employees would make the sheets.

"It was the first facility that grew the cotton, brought it in to be processed, and made the product, all under one facility," said Charles Barker, former manager of the town's Old Mill Trade Days. "And marketed the finished product." The plant, later taken over by Burlington Industries, operated until 1983.

J. B. Shewmake of the town of Tarzan said his dad worked at the sheet factory in the 1920s, and that a tongue twister on this order was posted on one of the plant walls:

"I slit a sheet, a sheet I slit,

Upon a slitted sheet I sit.

I'm not a sheet slitter, or a sheet slitter's son,

But I'll slit the sheets 'til the sheet slitter comes."

Say that out loud without screwing up, and you could get yourself a radio job.

Post's stamp can be found all over the town. The beautiful red-brick streets are Post's work. Post's statue is in front of the courthouse. The local paper is called (what else?) the *Post Dispatch*.

Incidentally, Old Mill Trade Days, with 100 to 140 vendors, take place at the old Postex plant Friday through Sunday the first weekend of each month. So, if you're lucky, you might be able to buy one of the old bedsheets made by the plant. But I couldn't find that tongue twister.

SOUTH TEXAS

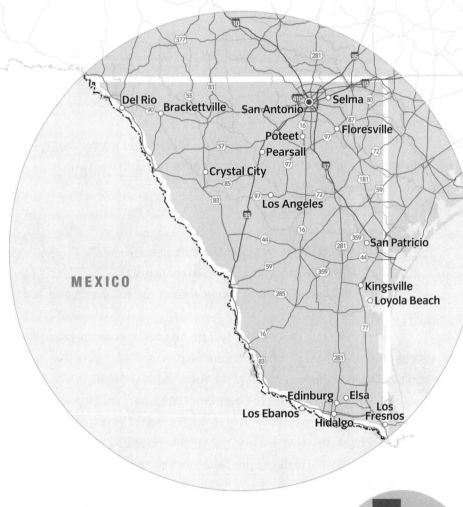

Del Rio
Brackettville
San Antonio
Selma
Poteet
Floresville
Pearsall
Crystal City
Los Angeles
San Patricio
MEXICO
Kingsville
Loyola Beach
Edinburg
Elsa
Los Ebanos
Los Fresnos
Hidalgo

0 100 Miles

0 100 KM

SOUTH TEXAS

Alamo Village
Brackettville

Everything has a price—including the Alamo.

OK, so we're talking about a re-creation of the famed Texas shrine rather than the real thing. But in 2003 Alamo Village, where John Wayne made his movie *The Alamo* in 1959, was put up for sale. Virginia Shahan, the owner, put a $6.5 million price tag on the village and the fake Alamo; she wanted $11 million for both the complex and 11,000 acres of ranch land.

You get a better feel for what the Alamo must have been like by visiting the fake one, constructed for the John Wayne flick, as opposed to the real one in downtown San Antonio. That's because this Alamo is out in the boondocks. And the real Alamo is in the middle of the big city. If the Mexicans decided to invade the real Alamo today, they wouldn't be able to find a place to park.

The Alamo that John Wayne built.

On the day I rode into town at Alamo Village, there was trouble in the cantina. Again. There's trouble every day in the cantina. Pete, the blond cowboy, and his goober sidekick Ortho were hassling the homesteader, who was trying to mind his own business at the bar.

"You know what, I think there's some poultry in that old boy's family tree—pluck, pluck, pluck, pluck, pluck," Pete said, putting his thumbs under his armpits and flapping his arms to imitate a chicken.

Later, the homesteader shot Pete and Ortho dead, but it's all in a day's work at Alamo Village, home of daily shoot-out shows in summer for the tourists. It's also the world's largest outdoor movie set. The Alamo re-creation and three-fourths of the accompanying Western town were made out of 1.25 million adobe bricks. You've got old hotels, a sheriff's office, an Indian store, a stage depot, a John Wayne museum, and a parking lot for people coming here from Nebraska or wherever.

Alamo Village still gets plenty of use. Since 1959 hundreds of feature films, TV movies, miniseries, music videos, documentaries, and commercials have been shot here. Some you've heard of, like the TV miniseries *Lonesome Dove*. And some you haven't, like the kung fu Western *Once Upon a Time in China and America*.

Several entertainers have gotten their starts here from performing in the daily western shows for the tourists. Country singer Johnny Rodriguez began his entertainment career here playing Ortho.

The place is off FM 674, about 7 miles north of Brackettville.

SOUTH TEXAS

The Brinkley Mansion

Del Rio

You might want to call this place a quack house.

That's because the man who built it, Dr. John R. Brinkley, was perhaps the most colorful and successful quack in the history of the United States.

Brinkley invented the so-called goat gland operation. During his bizarre and checkered career, it was estimated he performed the surgery on more than 16,000 men. For $750, Dr. Brinkley would take the testicle from a Toggenberg goat, sliver it up, then insert a sliver into his patient, which would allegedly cure prostate problems and enhance the patient's sexual performance.

Brinkley started the goat gland surgeries in the late 1920s, about the time he moved to the small border town of Del Rio. By the late 1930s Brinkley had advanced that technique to an injection of fluid. He also sold a line of patent medicines—Nos. 1 through 45, each designed to cure a different ailment.

Brinkley moved to Del Rio so he could build himself a radio station with an extremely powerful signal out of Mexico. The office of XER (the station's call letters) was in Del Rio, but the transmitter was across the Rio Grande in Via Acuna, where it couldn't be regulated by the U.S. government. In the 1930s Brinkley would go on the air, talk about religion and politics, sell pieces of the cross of Jesus Christ, and push his medicine. He also was depositing $3,000 a day in the bank just from the sale of his $1.00 little red paperback book, *Dr. Brinkley's Doctor Book*.

On the air, Brinkley would invite his listeners to come see the show of an evening at the Brinkley House on Qualia Drive, with the two Dancing Waters fountains in the front. People would gather in the five-acre park across the street. The water colored with lights would shoot 40 feet into the air, go into a mist pattern, and perform other tricks to the

sound of Brinkley's 1,063-pipe organ. For the amusement of onlookers, Brinkley's exotic animals—penguins, rare giant Galapagos tortoises, and flamingos—would be released from their pens to roam the grounds.

At one point, to gain accreditation, Brinkley visited Benito Mussolini, the Italian dictator, who got him an honorary degree from a medical school in Rome.

By the late 1930s people began suing Brinkley, who tried to dodge the bullet by dividing up the estate among his family members, including his wife, Minnie Telitha Brinkley, and son, John "Johnny Boy" Richard Brinkley III. Brinkley died in 1943. By the early 1970s, attorneys suing the family had chewed up all of the money. So Johnny Boy killed himself.

Incidentally, the mansion, at 512 Qualia Drive, is owned by a private family and isn't open to the public. But you can drive by and look.

Virgin Mary on Camaro

Elsa

Our Lady of General Motors?

Dario Mendoza was doing some body work on his maroon 1982 Chevy Camaro on a Wednesday evening in 1993, when the Virgin Mary appeared on the panel behind the left rear tire.

Personally, to me it looks like a stain in the Bondo, but what do I know? I got thrown out of Sunday school.

Five or six months after the vision of the Virgin appeared, Mendoza's brother-in-law, Santiago Quintero, began building a shrine around the car. It's still there, and so is the car.

A tiny altar sits in front of the rear panel of the car.

The shrine is basically a cinder block garage with red carpet, a ceiling fan, and fifty or so folding chairs for the faithful, who come by to look on a daily basis. It was built with $3,000 in donations given by visitors.

A little altar covered with flowers sits in front of the Virgin on the car. A glass of water rests on the altar. After a local newspaper photographer took a picture of the scene, the Virgin Mary is said to have showed up in the glass of water.

You can see the photo, framed, resting on the driver's side rearview mirror of the Camaro.

On the hood of the car, the family has placed a photo of the Virgin Mary appearing in a tree trunk in nearby Brownsville.

THE OTHER L.A.

"Ruby's Lounge. Los Angeles, Texas. Home of Rattlesnakes, Coyotes, Cowboys & Mexicans," says the bumper sticker advertising the only business in Los Angeles.

"That's the coldest beer in town," joked Ruby's Lounge owner Robert Jiminez, handing me a beer. No doubt about that. It's the only beer in town.

This is not at all like the L.A. where they make the movies. The population is seven, and Jiminez is one of the seven. Jiminez, formerly an accordion player with a band called Los Nuevos, has had Ruby's Lounge for fourteen years. He bought the beer joint and dance hall from Ruby Gebert, who owned the place for twenty years.

Los Angeles is located at the intersection of Texas 97 and FM 469, but you might not notice it when you get there. Sometimes people take the sign. The landscape is scrub brush and prickly pear cactus. A bit down the road a deer ran in front of my car.

SNAKES WANTED, says a poster on one of the windows of Ruby's Lounge, where people dance to live music Friday and Saturday nights.

"If it's in the woods, and there is a market on it we buy it," the poster says. Jiminez said the guy who put up the snakes poster shows up in his parking lot every so often. Jiminez's customers sell him live lizards, raccoons, snakes, and tarantulas.

"There's lots of rattlesnakes," Jiminez said. "Sometimes they'll get inside the building."

But unlike the other Los Angeles, at least there's no smog.

Another Peanut Heard From

Floresville

Nearby Pearsall may have what it claims to be the World's Largest Peanut, but Floresville also has a large peanut statue—on the Wilson County Courthouse lawn, with its own spotlight.

About 5 feet tall, the peanut presents an interesting counterpoint to Lady Justice on top of the courthouse, holding her scales and wearing a blindfold.

The peanut has no such trappings. It is brown and has no face.

Designed by local builder Richard Ullmann, the peanut harkens back to a day when many peanuts were grown around these parts. The town has a weeklong Peanut Festival in the second week of October, at which a King and Queen Peanut are selected. The queen gets the exotic name of Queen Tunaep.

"The first time I saw that I thought, 'What is that poor girl's name?' " said Gwen Fluitt, former

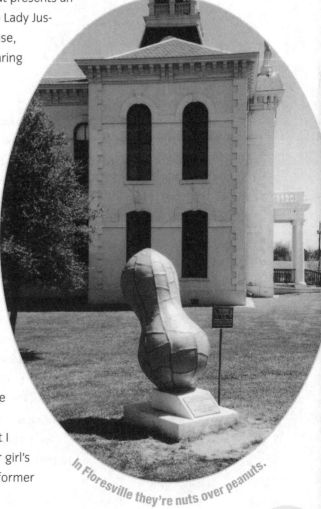

In Floresville they're nuts over peanuts.

executive director of the Floresville Chamber of Commerce. "When I realized it was 'peanut' spelled backward, I said, 'OK,' because I didn't think any parent could be that cruel."

The king doesn't get off any easier. "The king is 'goober' spelled backward," Fluitt added. "Reboog or whatever. And when they appear at special functions, the king is always wearing a cowboy hat covered in unshelled peanuts, which is kind of peculiar looking."

World's Largest Killer Bee

Hidalgo

The small town of Hidalgo on the Mexican border was the first in Texas to be visited by the deadly bees as they migrated north.

So to take the sting out of the situation, the city erected a 9½- by 10- by 21-foot statue to these pests. It's big. It's yellow. It sits on a flower bed in front of the public library. Maybe it's pollinating the flowers.

The killer bees reached Hidalgo on October 15, 1990, according to the sign on the World's Largest Killer Bee.

"There was some concern on what kind of negative effect it was going to have on the Rio Grande Valley," said Joe Vera III, city manager. "I like to say we made lemonade out of lemons. We get thousands who come by every year to have their pictures taken with the bee. It turned a negative into a positive."

Vera said the statue cost the city $16,000 to $17,000. That's a lot of honey.

The killer bees reached Hidalgo on their march north in 1990.

SOUTH TEXAS

The Graves Peeler Hall of Horns
Kingsville

It's real quiet in the separate room out behind the John E. Conner Museum, where they store and display what Graves Peeler bagged while hunting. This is because all of the animals in here are dead.

It's a close, tight room with a low ceiling, and just about every square inch of wall space is covered with heads of critters, parts of critters, or whole critters. We're talking over 250 mounts: full bears, bear rugs, a golden eagle, deer heads (some of them pairs of heads with their antlers tangled together), mountain goats, bighorn sheep, antelope, cow horns, javelina, and my personal favorite, one half of a moose.

The moose is taxidermied in such a way that when you look straight at it, it looks like a whole moose. But when you look from the side, you'll notice the back end is missing. It's as if the moose was sawed in half with the butt end tossed out. The two front legs are there; the back legs and back body are not. So what happened to the rest of the moose?

"I've had that question asked a lot of times," said Joe Dominguez, who managed the front desk of the museum (361–593–2810), located on the campus of Texas A&M University-Kingsville.

If you want to see the Peeler collection, you have to ask at the front desk. Then somebody will grab the keys, take you back there, unlock the door, and let you in. "We used to keep the door open, but we had kids from the school who would fool around," Joe explained.

Graves Peeler was a Texas Ranger, a cattle-brand inspector, a rancher, and a hunter. He shot his first white-tailed deer at the age of eight. That would have been in 1894. He lived until 1977, and he hunted all over North America. "Real good shot," Joe said. "I heard he could hit a deer from his horse."

Joe said that when Peeler's dad, a sheriff, was killed by three bad hombres, Peeler caught up with two of them and killed them in a gunfight. Later, the third one wrote Peeler from Louisiana, telling him that he was ailing and that he wanted to return to Texas to die.

"He said, 'Yeah, you can come down here, but if you don't die, you know what's gonna happen—I'm gonna kill you myself,' " Joe said. The man came back to Texas and, fortunately for him, died before Peeler could get him, Joe added.

There are all sorts of stories that indicate Peeler was a man's man. He hunted game in Mexico to feed men building the Mexican National Railway. He worked to save Texas Longhorn cattle from extinction. He loved dogs. When a friend got bit by one of Peeler's dogs at Peeler's ranch, he asked Peeler whether the dogs had been vaccinated.

"He said, 'Ah, these dogs have bit about ten to fifteen people and nobody died yet, so don't worry about it,' " Joe said.

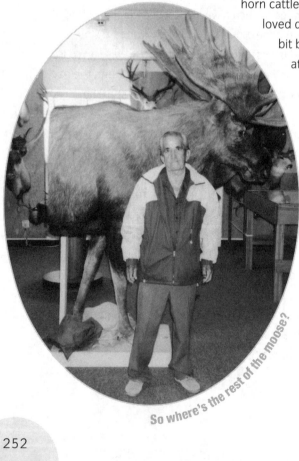

So where's the rest of the moose?

Hand-Pulled Ferry

Los Ebanos

Want to cross the Rio Grande River into Mexico in an unusual and old-fashioned way?

Well, then, come to this small border town and ride the Los Ebanos Ferry, the last hand-pulled international ferry in the Western Hemisphere. A rope tethered on both banks runs from one side of the river to the other. A crew of four or five guys pulls the ferry across, hand-over-hand.

You could pitch a rock from one side of the river to the other at this location. The trip takes about four minutes.

Growth has come to Los Ebanos, 2 miles south of U.S. Highway 83 on FM 886. The ferry holds more cars than the original that opened for business in 1950. The old ferry could hold two cars, but the current ferry can transport three cars. It costs $1.50 to take your car across, and that includes the driver. Additional passengers are charged 25 cents apiece.

Who uses this unique ride? Mostly families visiting each other in Mexico and the United States. "And the winter Texans [people from up north who spend winters in Texas] like to come see it," said a U.S. Customs agent. "I guess it's a novelty to see a ferry like this."

Hey, will you lend a hand?

ALAMO SHUFFLE

If it wasn't for the Daughters of the Republic of Texas, the Alamo in San Antonio might still be a liquor store instead of the state's busiest tourist attraction.

The Alamo went through quite a few changes after it was sacked by Santa Anna on March 6, 1836.

In 1849 the U.S. Army leased the property from the Catholic Church and turned it into a depot. In 1877 Honore Grenet bought the Long Barracks adjacent to the Alamo chapel, leased the chapel, and turned the Long Barracks into a mercantile. The structure had towers, was known as Grenet's Castle, and had wholesale liquor. "But we don't talk about that very much," said Carl McQueary, former director of the Museum for the Daughters of the Republic of Texas in Austin.

In 1882 Grenet died, and in 1886 the Grenet property was sold to Charles Hugo and Gustave Schmeltzer, who, by the early 1900s, were fixing to retire and were looking for a buyer.

In stepped the De Zavala Chapter of the Daughters of the Republic of Texas, which began holding fund-raisers to try to raise the $65,000 it would take to purchase the option on the property. But they couldn't raise the money. Meanwhile, a hotel syndicate from back East was courting Hugo and Schmeltzer to buy the property. So it was looking like the Alamo would be turned into a hotel— until the charming and beautiful Clara Driscoll, a member of the Daughters of the Republic of Texas, stepped in.

McQueary said Driscoll had one other thing going for her. "She had a potful of money," he explained. She was a cattle heiress.

Driscoll put up the $65,000 to buy the property, and the Daughters opened the Alamo to the public in 1908 after a massive cleanup job. Sixteen wagonloads of rubbish had to be removed to put the place back in shape, McQueary said. One wonders how much of that was empty wine bottles.

Little Graceland

Los Fresnos

Simon Vega thinks so much of Elvis Presley that he's named his house, located on Highway 100, Little Graceland. It says so in red letters over the garage door of Vega's little house.

If you say anything nasty about Elvis, Vega is liable to get all shook up. He's all goo-goo about the King.

"Very polite, very gracious. He would take a picture with anybody," said Vega, a retired high school teacher, who served in the Army with Elvis from 1958 to 1960 in Freiburg, Germany. Vega displays pictures of himself and Elvis together in his Elvis museum (956–233–5482). There's no admission fee to the museum, but Vega takes donations.

Every year Vega adds a Graceland-style "tribute" to Elvis to his house. Check out the white gate with the green musical notes out front. Then there's the stone wall like the one at Graceland that people come by and sign.

Vega isn't shy about this. An official state sign on the highway in front of his house identifies the place as LITTLE GRACELAND. Vega has collected so much Elvis stuff that he had to build a museum for it above his garage. Lighted display cases show off decorative Elvis plates, an Elvis doll dressed in an Army uniform, sunglasses like the ones Elvis wore when he met President Nixon. Vega even has Elvis's good conduct medal.

"I asked him for it; he said, 'Yeah, go ahead. I'll get another one,' " Vega said.

A highway sign on Vega's front lawn reads TUPELO 85. The arrow on the sign points toward a doghouse-size replica of Elvis's birthplace in Tupelo, Mississippi, that Vega is building in his side yard.

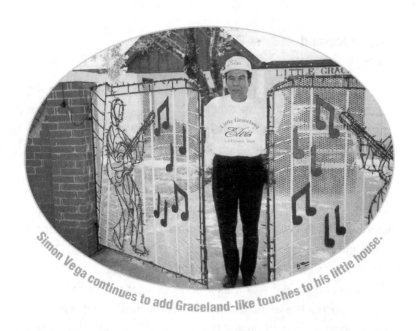

Simon Vega continues to add Graceland-like touches to his little house.

The names of Elvis's songs are set in concrete slabs next to Vega's house. Shoot, Vega even wrote a tribute song to Elvis and had it recorded on a 45 rpm record he'll gladly play for you in his museum:

"Oh hail to Elvis Presley
You were called the greatest king.
You were called early to heaven,
But your music we will sing."

Every August Vega throws an Elvis festival for Elvis fans at his house to honor the day Elvis died. Thousands of people show up, including a bunch of Elvis impersonators who carry on in an Elvis kind of way.

"We had nine last time," Vega said. "They come from all over the state. They do their show. They sing. We have a big stage now and a big tent."

Off with His Hat

Loyola Beach

You'll probably find more hat hair inside the King's Inn seafood restaurant (361–297–5265) than anyplace else in Texas.

Hat hair is a condition that befalls Texans when, after wearing a baseball cap or cowboy hat for an extended period of time, they are suddenly forced by rules of etiquette to remove their topper. At the King's Inn, which has perhaps the best fried shrimp in the known world (lightly breaded so you can still see the pink through it), you aren't allowed to wear your hat inside.

This is salt-water fishing country. So at the King's Inn, I imagine you get a lot of guys who take off their hats after they leave the boat, and their hair sticks out funny all over the place. As far as I can tell, it's OK to eat with your fingers at the King's Inn. I know I did and nobody hit me over the fingers with a ruler. But lose the lid, or you will go hungry.

The hats on and off inside the house debate rages on in Texas. Some say it's Texan to wear a big hat inside. "I think all the real Texas heroes have done that, like Davy Crockett and Hank Williams," said Texas gubernatorial candidate and writer Kinky Friedman, who I suspect keeps his hat on in the shower. But the Ware family, which runs the King's Inn, agrees with former Houston Oilers football coach Bum Phillips, who never wore his cowboy hat inside the Astrodome because his mama told him to take his hat off in the house.

"That comes from another generation," said King's Inn owner Randy Ware of the no-hats-on policy. "We stood up at the National Anthem and didn't fidget. If they don't like it, they're welcome to leave."

Ware said the hats-off policy came from his parents, Howard Cottle Ware and Alta Faye Ware, who took over the restaurant in 1945 and were sticklers for manners.

"She was pretty feisty," Randy said of his mother. "I can remember her going out in a wheelchair, confronting people."

Funny thing is the king shown on the King's Inn sign out front is wearing a crown. Then again, he's not in the building.

World's Largest Peanut

Pearsall

Ironically, the World's Largest Peanut, which really isn't all that large, sits in front of Randall Preston Produce, a potato business, on Oak Street.

"Several people come through just to see the peanut," said Juanita Burell, with the Pearsall Chamber of Commerce. "They'll come to the chamber and ask where it's at and if it's accessible."

The town may have the World's Biggest Peanut, but it has a Potato Festival instead of a Peanut Festival.

"We do grow quite a bit of potatoes here," Juanita said. "In fact, Frito-Lay buys all the potatoes. It's sixteen hours from the field into a bag of chips. It doesn't take 'em long, that's for sure. But we still do produce quite a bit of peanuts."

The reason the peanut is here, of course, is that Pearsall is in a peanut-growing area. PEARSALL, TEXAS—WORLD'S LARGEST PEANUT—55,000,000 LBS. MARKETED ANNUALLY," it says on the peanut's concrete base.

SOUTH TEXAS

World's Largest Strawberry
Poteet

In Texas, if we don't have the largest plant growing naturally, we just build one and call it the world's largest. We will stop at nothing to be biggest, doggone it, in the Lone Star State.

The World's Largest Strawberry weighs 1,600 pounds, stands 7 feet, 3 inches tall, is mostly red, and sits right in front of the Poteet Volunteer Fire Department, where it doesn't clash with the fire trucks.

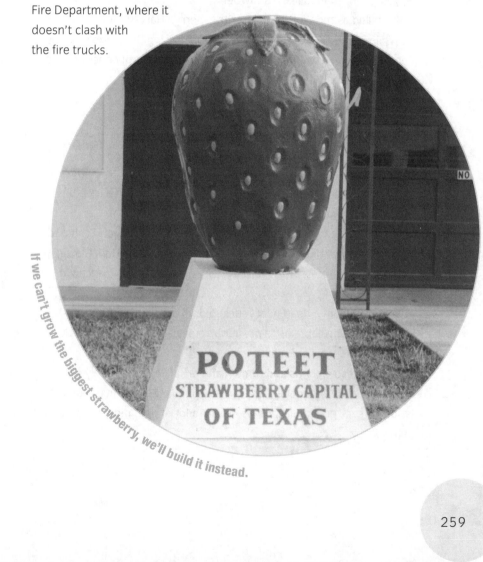

If we can't grow the biggest strawberry, we'll build it instead.

POTEET STRAWBERRY CAPITAL OF TEXAS

According to Nita Harvey, coordinator of the annual Strawberry Festival here in the Strawberry Capital of Texas, the World's Largest Strawberry is made out of "some kind of plaster."

The World's Largest Strawberry is among several other world's largest-growing item statues to be found around Texas.

The World's Largest Strawberry is part of a set of huge strawberries here—the other one being the town's 130-foot-tall water tower, which is, you got it, shaped like a strawberry.

It's billed as the World's Tallest Strawberry," Harvey said.

While in Seguin, you'll have a hard time missing the World's Largest Pecan, because it weighs 1,000 pounds, is made out of concrete, and sits in the Guadalupe County Courthouse square.

Chupa Cabra
Rio Grande Valley

This devil-like creature comes to your ranch at night and sucks the blood out of your goats.

Chupa cabra means "goat sucker" in Spanish. The legend came to the Rio Grande Valley and Mexico via Puerto Rico, said Mark Glazer, an anthropology professor at the University of Texas–Pan American in Edinburg.

Any evidence of dead goats sucked dry? Not really, said Glazer, who describes chupa cabra as "a pseudo-zoological entity, much like the Loch Ness monster or Bigfoot.

"All of these legends and rumors and urban legends simply go around as a rumor mechanism," he explained. The reason the monster is said to suck goats, Glazer says, is that a lot of goat meat is consumed in the valley.

Such scary stories are common to the region. "This area already had a big bird," Glazer said of a chupa cabra predecessor. "It's supposed to be a huge prehistoric bird flying around."

The looks of chupa cabra changed as the story migrated. "In Puerto Rico it looks like a space alien, with big eyes and a triangular face," Glazer said. "In Puerto Rico, in its earlier forms, it's basically said to be a pet left over by aliens. So to survive on Earth, it sucks goats' blood."

As chupa cabra tales moved into the Rio Grande Valley, the creature began to look like a demon about 3 feet tall. And its diet became more varied.

"People began to see them at ranches attacking not only goats but chickens as well," Glazer said.

In Mexico, chupa cabra took on its most humorous face. The joke going around was that the biggest goat sucker of all was former Mexican President Carlos Salinas de Gortari. There were even chupa cabra T-shirts available that showed Salinas's head on chupa cabra's body.

The Alamo City
San Antonio

It's not hard to tell from looking in the business listings of the San Antonio phone book that San Antonio might be known as the Alamo City.

Starting with the actual Alamo, located in downtown San Antonio, you've got about four pages of names that start with Alamo. Just about any kind of business you can imagine in this city uses Alamo as part of its name.

Having trouble sleeping? Call the Alamo Sleep Center & Respiratory Equipment. Trying to stop an itch? Then call the Alamo Area Dermatology Associates. Getting run out of town? Call Alamo Mayflower.

Davy Crockett might have had a hard time figuring out what some of these businesses are for. Imagine Crockett walking into the Alamo Acupuncture & Chinese Herbal Clinic.

Then you've got the Alamo Area Speech Language & Swallowing Services, Alamo Strip-A-Dancer, Alamo Bail Bonds, Alamo Backhoe Service, Alamo Bathtub Refinishing, Alamo Bone & Joint Clinic, Alamo Paper Tube Co., Alamo City Bed & Breakfast Hotline, Alamo City Tall Club, Alamo Dog Obedience Club, Alamo City Mortuary Service, Alamo Shaver & Appliance, Alamo Mold Inspection, and Alamo City Paranormal, just to name a few.

The Wooden Nickel Historical Museum

San Antonio

How many times a day does museum owner Herb Hornung hear the old joke about not taking any wooden nickels?

"Sometimes between twenty and thirty times a day," said Herb, a retired Air Force technician and a wooden nickel expert who has been collecting wooden nickels since he was a kid. "And the other one is, do we have any round tuits?"

The answer is, yes they do have a "round tuit" available. The Old Time Wooden Nickel Co., Herb's wooden nickel manufacturing company, makes and sells about five million wooden nickels a year, including the round "tuits," wooden nickels with "tuit" printed on one side and the message "Do It When You Get Around To It!" on the other.

If you want to know about wooden nickels, Herb is your guy. He can tell you all about how the "don't take any wooden nickels" expression got started. It popped up in the 1930s when fair customers in Chicago redeemed wooden nickels for fair fare. On the last day of the fair when the nickels were about to expire, people would remind one another to

"not take any wooden nickels," since they were about to turn worthless. Or so they thought. Actually, these tokens would become collectors' items.

"Course, the people who couldn't cash them in were the real winners, 'cause these are worth between $5.00 and $10.00 now," Herb said.

Herb's museum has about 1.5 million wooden nickels on hand, with about 10,000 of them on display. He'd show off more of them, but the place is small and cluttered. He has wooden nickels ordered as business cards by Henny Youngman, Jack Paar, and Red Skelton. He has wooden nickels good for "One Free Salad" at Pizza Hut. And he has political wooden nickels, like the one touting Jimmy Carter for president.

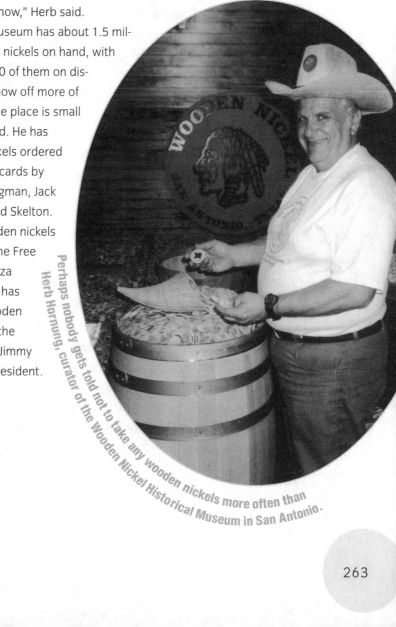

Perhaps nobody gets told not to take any wooden nickels more often than Herb Hornung, curator of the Wooden Nickel Historical Museum in San Antonio.

Herb's factory makes wooden nickels for all kinds of customers: bands named Wooden Nickel ("I think we're up to about six; we just added two more in the last year," Herb said), bars and restaurants named Wooden Nickel, motorcycle clubs, golf courses, Moose Clubs, casinos, even orthodontists.

Orthodontists? "Well, they work with kids," Herb explained. "What are you going to give kids? A business card?"

Then there's the World's Largest Wooden Nickel that Herb built out of lumber. It sits outside near the front door. You shouldn't take this one, either, because it'll give you a hernia. It's more than 13 feet in diameter and weighs 2,500 pounds.

The Wooden Nickel Historical Museum (210–829–1291) is open from 10:00 A.M. to 3:00 P.M. Monday through Friday, and nights, weekends, and holidays by appointment only. Visit the museum's Web site at www.wooden-nickel.net.

The Esquire Tavern
San Antonio

Looking for that early morning eye-opener? Then hit this downtown saloon—home of the longest standing bar in Texas, said former bartender Brian Dickerson—at 9:00 A.M. for a cold beer or a mixed drink.

The Esquire, on the famed River Walk, at 155 East Commerce Street (210–222–2521), used to open at 7:00 in the morning. But they stopped doing that. "People were getting drunk too early," Dickerson explained. Heck, Dickerson added, some of the people who had been out all night were coming in drunk at 7:00 in the morning. So they pushed the opening hours back to a more respectable 9:00 A.M.

SOUTH TEXAS

The lovely dark wood, nearly-69-foot-long bar has no bar stools. That's why Dickerson called it the longest "standing" bar in Texas. The bar top can hold 5,972 bottles of Lone Star beer. The Esquire is a very nice establishment with copper ceilings. It's an antique. It opened up in 1933, a year before Prohibition ended.

I suspect the historic aspects of the Esquire are lost on some of the early morning patrons, however.

This is a great place to drink beer. The old-timey feel of the saloon makes you want to stay all day long. And some people do. "We have people who come here from open, and they'll stay here six or seven hours," Dickerson said. Prices are low; you can get a mixed drink for $2.00. And the green-and-pink neon Esquire sign out front has a festive feel to it.

Paseo del Rio Mud Festival
San Antonio

The Paseo del Rio Mud Festival—as the name implies—is held on the swanky River Walk, the most visited tourist attraction in Texas. They do things with mud at this January festival—like throw it at one another.

Greg Gallaspy, formerly the executive director of the Paseo Del Rio Association, which puts on the festival, referred to it as "mud malarkey."

In the 1999 version, teams of students from Incarnate Word University and the University of Texas at San Antonio got on barges in the San Antonio River in shorts and T-shirts.

"We did two three-minute rounds, and people picked up the mud off the barge and slung it at each other, while people were sitting there eating dinner and having their drinks on the River Walk," Gallaspy said.

Gallaspy explained why the festival adopted the mud theme. "Each year for maintenance purposes the city lowers the river and completely drains it so they can clean it out and pull out all the Coke machines and all the chairs that float down the river."

Over the years, other events have included children sliding into a vat of mud and people throwing mud at photos of politicians.

"They don't do that anymore," said Charlie Leiva, the association's events director. What a missed opportunity. What good's a mud festival if you can't throw the mud?

Barney Smith's Toilet Seat Art Museum
San Antonio

This museum consists mostly of toilet seat lids decorated by Barney Smith, a retired master plumber now in his eighties.

At last count, Smith had 769 toilet seats and lids in his garage at 239 Abiso Avenue in the San Antonio suburb of Alamo Heights (210–824–7791; www.unusualmuseums.org/toilet). Each item has a different theme. Some themes are more serious than others.

The latest decorated toilet seat added to the museum, Smith said, is a number called The Pooch Parade, honoring a dog walk held in Alamo Heights.

"They start at the swimming pool and they walk for several blocks," Smith said.

Deceased hornets are glued to one toilet seat and lid combination. "Please open slowly, do not disturb," reads the message on the lid. Lift the lid and you see the bugs underneath.

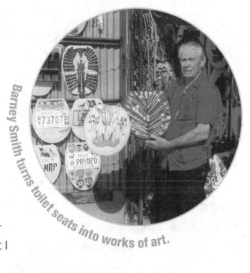

Barney Smith turns toilet seats into works of art.

"These are yellow jackets," Smith said. "One of them stung me on my head, and I just said, 'I'll put you on my toilet seat.' " Now that's what I call a payback.

Another lid has a photo of Miss America on it. (Miss America probably didn't figure she'd end up being so honored, right?) Another toilet seat lid is covered with dog tags (from dogs, not soldiers), and still another is decorated with somebody's collection of swizzle sticks.

Smith selected toilet seats as his motif because he has connections in the plumbing supply business who give him damaged toilet seats they can't sell. He said the neighbors don't complain because the garage museum hasn't attracted a lot of tour buses.

Ironically, the museum has no bathroom. "I got plenty of toilet seats, but no toilet," Smith admitted.

POPEYE STATUE

The town of Crystal City is 48 miles northeast of the Mexican border and a long way from the ocean. So why is a cartoon sailor standing on top of a can of spinach in front of city hall?

Simple. The sailor who gains strength from eating this particular vegetable is shilling for the spinach industry in this town, which bills itself as the Spinach Capital of the World.

"We have a proclamation signed by then–President Ronald Reagan," said Christina Flores, the city's former finance director.

It's hard to imagine two towns fighting over spinach, but Crystal City isn't the only place to claim the spinach capital title. "Alma, Arkansas, says they're the Spinach Capital of the World," Flores said. "They have a large-size balloon type of a Popeye. It's similar to the real Popeye in the cartoon strip, but it doesn't quite do the job the way ours does."

Flores said the Crystal City area isn't growing near as much spinach as it did in the 1930s and '40s. Still, the city has a Spinach Festival on the second weekend in November with a spinach cook-off and a Spinach Queen pageant. Crystal City's Popeye statue has been standing since 1937. Popeye ate his spinach because it was good for him. But he's also smoking a pipe. Seems at cross-purposes, doesn't it?

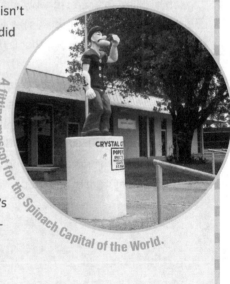

A fitting mascot for the Spinach Capital of the World.

SOUTH TEXAS

Buckhorn Saloon & Museum

San Antonio

Who says Texans brag too much? If it wasn't for Texans running their mouths, this collection of over 1,500 horns and animal mounts wouldn't exist.

The "world's greatest collection of horns and antlers" started in 1881, when patrons of the Buckhorn Saloon, who were at another downtown location in San Antonio at the time, started boasting about the critters they had bagged while hunting. Albert Friedrich, the saloon's founder, told his customers, in so many words, "Dandy. Let's see what you've got."

"They'd brag about how big their horns were, and he'd say, 'Bring 'em in,'" said Kristi Engelman, the museum's former sales manager. Engelman said Friedrich would give his patrons free beer and whiskey in exchange for allowing him to display their hunting trophies in his tavern. You've got gorilla, elephant, zebra, moose, rhino, buffalo, anteater, mouflon ram, water buffalo, an oceanic sunfish, giraffe, a giant sea turtle—just about everything except the neighbor's poodle. "There are over 520 different species represented,"

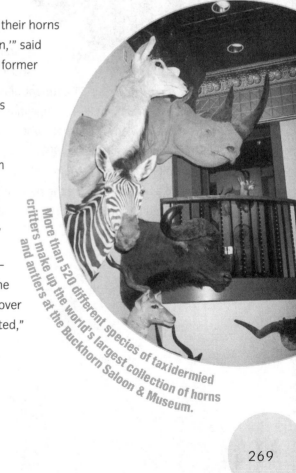

More than 520 different species of taxidermied critters make up the world's largest collection of horns and antlers at the Buckhorn Saloon & Museum.

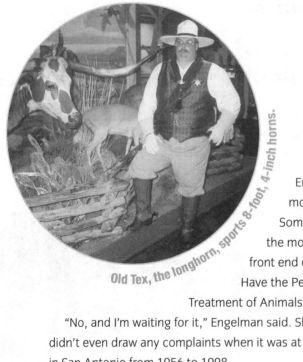

Old Tex, the longhorn, sports 8-foot, 4-inch horns.

Engelman said. Some mounts are full-bodied. Some are heads. Some, like the mountain goat, are just the front end of the animal.

Have the People for the Ethical Treatment of Animals been by lately?

"No, and I'm waiting for it," Engelman said. She said the collection didn't even draw any complaints when it was at the Lone Star Brewery in San Antonio from 1956 to 1998.

The wolf in the Alaska Room looks live enough to pet. They should rig it up to a battery to scare the pants off the children.

The museum is at 318 East Houston Street (210–247–4000; www.buckhornmuseum.com).

SOUTH TEXAS

Pig Stand No. 29
San Antonio

If it wasn't for the Pig Stand chain, Americans might never have figured out how to eat in their cars.

The chain claims to be the world's first drive-in. A bunch of Pig Stands—along with this one, back then at a nearby location—popped up the 1920s. At one point there were Pig Stands coast to coast. Now just eight are left, all in Texas.

If you don't start oinking after you visit this place at 1508 Broadway (210–222–2794), you're not paying attention. Ceramic and plaster pigs decorate the interior. One pig is in cowboy clothes and another in over-alls. A red and green neon pig—a 6-foot-long, 4-foot-tall number made in 1924—hangs from the ceiling. It's one of the oldest neon signs in the nation. I recommend the Pig Sandwich combo: a sliced pork sandwich on a bun with fries and slaw. You might also try the chocolate malt, named the best in San Antonio by *The Current*, a local weekly paper.

The Pig Stand makes a lot of claims about having the first this and the first that. Kathy Racicot, former manager of Pig Stand No. 29, says the Pig Stand introduced curb service, onion rings, Texas toast, fluores-cent and neon lighting at restaurants, and chicken-fried steak.

Wait a minute. The Pig Stand invented chicken-fried steak? That's a pretty major claim, lady.

Kathy amended that to say the Pig Stand introduced the chicken-fried steak sandwich. I said that wasn't quite such a tall brag. "Still counts," she said. "And onion rings was a biggy." Yes it was.

Really Big Fake Cowboy Boots

San Antonio

These boots—billed as the biggest cowboy boots in the world—weren't made for walking. But they weren't made for living in, either. On the other hand, the 40-foot-tall boots installed at the North Star Mall at San Pedro Avenue and Loop 410 by Austin artist Bob "Daddy-O" Wade are so big that a wino once moved into one of them.

Wade, who makes large art out of polyurethane, says a cowboy had kicked a hole in one of the boots, making it possible for someone to move in.

"At one point I got a call claiming that the boots were on fire," Wade recalled. The reason for the smoke? A homeless guy had taken up residence in one of the boots and was doing a little cooking inside.

"He was heating up hot dogs with Sterno," said Wade.

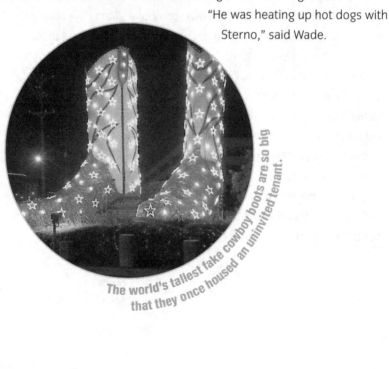

The world's tallest fake cowboy boots are so big that they once housed an uninvited tenant.

The homeless guy was booted out. (I'd like to get the name of the heel who evicted him.) "They should have left him," Wade said. "They messed up. The tourists would have loved him."

Certainly the boots are big enough to serve as a condo. Wade said the boots are 30 feet from toe to heel. "We figured out they will hold 300,000 gallons of beer each," he added.

In June 1999, going to the mall to see the big boots was named one of "The 10 Dumbest Things to Do in San Antonio" by the *New York Daily News*.

Coincidentally, the mention was made shortly before the San Antonio Spurs booted the New York Knicks square in the butt in the NBA finals.

World Championship Rattlesnake Races
San Patricio

So what's the big tip on how to get a rattlesnake to race?

"Just don't make 'em mad," said the late Larry Belcher, an eighteen-wheeler driver from Alice who won this annual event three times with his rattlesnake, Sleepy. "If you make 'em mad they're gonna curl up and try to bite you."

Some people, as Belcher did, bring their own snakes and race them. Other race snakes are provided by snake hunter, milker, and collector Don Bennett of Colorado City.

The rattlesnakes race in lanes. The course—about 80 feet long—is lined. To get the rattlesnakes going, racers tap the ground next to the their snakes with 5-foot-long plastic tubes called "go-gitters."

"That vibration of the ground will make them move," said Jim Dulaney, president of the San Patricio Restoration Society, the event's sponsor.

The races have been going on every year since 1972. They're held to celebrate St. Patrick's Day. As we all know, St. Patrick drove the snakes out of Ireland. Get it?

Sometimes the rattlesnakes move briskly. Sometimes they just sit there and goof off. "We put in a new rule that if it takes over fifteen minutes, the one that's ahead is declared the winner, because the people start getting bored," Dulaney explained.

Each racer is assigned a handler who has a spring-loaded snake-grabbing tool. If the snake strays out of the lane, the handler grabs it by the neck and puts it back on course.

No contestants have been bitten so far, although some of the handlers have been nailed.

Bob and Nan Herndon, Fried Rattlesnake Booth Operators
San Patricio

If you go to the San Patricio rattlesnake races, try the fried rattlesnake meat at the booth run by Bob and Nan Herndon of Aransas Pass. The Herndons have been running a snake meat booth at various rattlesnake festivals around Texas for about forty years.

"I think it tastes closer to chicken than anything else," said Bob Herndon, who has been messing with rattlesnakes for more than sixty years. "Somewhere between frogs' legs and chicken."

Herndon is right about the flavor, but rattlesnake meat is considerably bonier than chicken or frogs' legs. You have to nibble around the structure of the snake.

In past years at the Herndons' booth you could get your Polaroid picture taken with a stuffed rattlesnake around your neck for $5.00.

"It started off as a joke and turned into a business," Herndon said of the booth. "You'd be surprised who'd like to have their picture taken

with a mounted snake that looks pretty realistic."

Herndon's fascination with rattlesnakes began in 1942, when as a boy he saw a mounted rattlesnake for sale in a Western Auto in Kingsville. The price on it was too high, so young Herndon went out and killed his own snake and stuffed it with sawdust.

"Some things you're born with—climbing mountains or fooling with snakes or whatever," Herndon said. "You're born with it and it stays with you until the day you die. And you don't know why."

Herndon said that he "made headline news" in 1974 when he "was bitten by a supposedly frozen rattlesnake that I brought out of the deep freeze."

The snake had been in the freezer about sixteen hours, Herndon said. But it snuggled up with the two other rattlesnakes in the freezer and stayed alive.

When Herndon went to cut the rattlesnake to skin it and mount it, it nailed him on the left wrist. The scar is still ugly. He was in the hospital three days.

"I don't blame the snake," Herndon said. "I would have bit somebody, too, if some-body had started cuttin' on me when I was still alive."

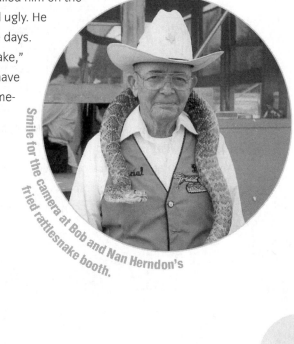

Smile for the camera at Bob and Nan Herndon's fried rattlesnake booth.

Justice Is Served
Selma

This doesn't exactly come under the category of what goes around comes around. But it's close.

In the 1960s and '70s, one of the most feared stretches of highway in the state of Texas was Interstate 35 as it ran through Selma, a small town on the northern outskirts of San Antonio. Selma police ran a notorious speed trap.

No telling how many people got hauled into the old, Alamo-shaped Selma City Hall building that still sits next to the highway. It was such a widely known speed trap, in fact, that it led former State Rep. Bennie Bock of nearby New Braunfels to push through a law limiting how much money Texas towns could keep from speeding tickets.

If you didn't get a ticket in Selma, you were either lucky, parked, or out of gas. It was that bad.

" 'Take it slow in Selma,' that's what they said," recalled Roger Moore, an Austin advertising guy who, way back when, got a speeding ticket in Selma.

People like Roger now have a reason to go willingly to the old building. In March of 2003, the old Selma City Hall building became a Hooters. The waitress staff in this Hooters is particularly scenic, since Selma is close to Texas State University in San Marcos, known as having the best-looking coeds in the known world.

"You know, that's called the old full circle," Moore said when he heard about the recent development. "I like it. That's great. It's a better Hooters than it was a City Hall, I can tell you that."

SOUTH TEXAS

Word is the place used to have a holding cell on the second floor. Nowadays the place has a decorative jail in the dining room. Hooters management is making the most out of the building's legacy. I lined up a bunch of Hooters gals in front of the jail and took their picture.

The Selma speed trap was so legendary that it even got mentioned in Steve Earle's song, "Guitar Town":

"There's a speed trap up ahead in Selma town
But no local yokel's gonna shut me down. . . ."

THE GULF COAST

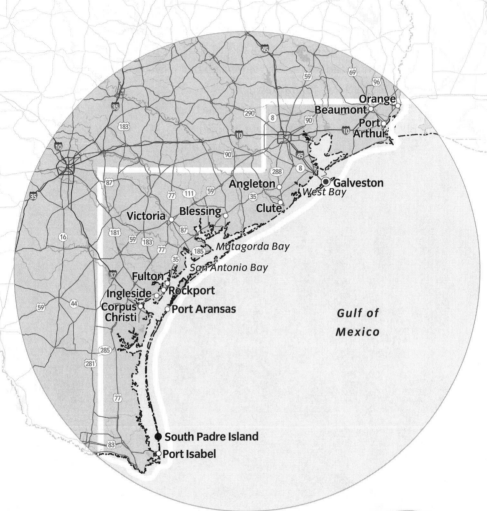

LOUISIANA

Orange
Beaumont
Port
Arthur

Angleton
Galveston
West Bay
Blessing
Clute
Victoria
Matagorda Bay
San Antonio Bay
Fulton
Rockport
Ingleside
Corpus
Christi
Port Aransas

Gulf of
Mexico

South Padre Island
Port Isabel

0 100 Miles
0 100 KM

GULF COAST

House like the Alamo
Near Angleton

It was the late Ken Freeman's dream to build a house that looks like the Alamo.

But when he tried to sell it, for some reason he never found a taker. The house, located at 400 Creekside in Holiday Lakes, was on the market for four years. You'd think folks would jump at the chance to live in the Alamo.

"Not everyone wants an Alamo, but people are really fascinated by it when they come," said Deborah Freeman, Ken's widow. "You just have to be a different sort of person to adapt to, 'My house is the Alamo.' A lot of people asked me, 'Why did you let him do it?' That was his legacy. He just adored it. 'I'm going to build it.' That's all he talked about. 'I'm going to build it.' And he did."

"Actually, the front's a façade," Ken Freeman said in 1999 when he talked about the place. "It looks like a two-story but it's only a one-story."

Freeman, a brick mason by trade, began building the house in the late 1980s, with a second house on the property that looks like the Alamo barracks. His aunt, Billie Starr, who has since passed on, lived in the barracks.

This all started when Freeman and his hunting buddies began listening to a soundtrack of John Wayne from the movie *The Alamo*.

"I got sentimental about Texas, and I said I got four doggone lots cleared out in the woods, and I'm gonna go home and build the doggone thing," Ken said.

His friends held him to the promise and, shortly after, he began building his house.

A lot of people come around and shoot pictures. "This has been a landmark for the town since he built it," Deborah said.

The Big Bopper
Beaumont

Is there an American over the age of fifty who doesn't remember these lyrics?

"Chantilly lace and a pretty face
And a ponytail hanging on down.
A wiggle in the walk, and a giggle in the talk,
Make the world go round."

Those words were written in a car headed from Beaumont to Houston by the late Jiles Perry Richardson, aka the Big Bopper, according to John Neil, now retired, who used to have an ad agency in Beaumont called John Neil Advertising.

In the late 1940s, Neil and Richardson worked together at KTRM-AM in Beaumont. Richardson was the night DJ (known as the Night Mare), and Neil was the engineer.

In the 1950s the Big Bopper's "Chantilly Lace" would make it to the top of the charts. That it got there was a fluke.

"He wrote that song on his way to Houston to record 'The Purple People Eater Meets the Witch Doctor,' " said Neil. See, the Big Bopper had to come up with a B-side for the 45-rpm record he was about to record. "The Purple People Eater Meets the Witch Doctor" was the A-side. So he wrote "Chantilly Lace" for the B-side. And that's the one that hit the charts.

Neil recalls the Big Bopper fondly. "He was kind of a laid back fella. He couldn't sing, and he couldn't play the guitar. But he could put on a show," said Neil. "He wore this zoot suit, and when he got off the stage you could almost wring that suit out."

Neil's father Jack founded and ran the radio station. He'd be trying to write his newscast in the station's studio A, while J. P. was attempting to play the guitar and piano.

"And Daddy would say, 'Goddamn it, J. P., put the goddamn guitar down and go out and get yourself a beer or something,'" Neil remembered, "And J. P. would go down to the Quality Cafe and get a beer."

In 1959, the Big Bopper died in a plane crash near Clear Lake, Iowa, with Ritchie Valens and Buddy Holly. The people at the station were devastated when they found out. "Daddy just laid his head down on the desk and started cryin'," Neil said. "And that was the first and only time I ever saw my daddy cry."

At the funeral, Neil remembers a photographer working for *Life* magazine who brought along a couple of teenage gals to use as props.

"He had them draped over J. P.'s casket crying, to take a picture of him," Neil said. "He thought it would make a good picture, but he couldn't take the picture 'cause we kept his camera."

THE EYE
OF THE WORLD

The late John Gavrelos's life was just eat, sleep, work, carve, eat, sleep, work, carve.

The Greek immigrant and restaurateur spent 1923 to 1948 carving hundreds of biblical scenes, scenes of Americana, and famous temples from around the world out of produce crates, plywood, and old cigar boxes.

These days the collection—called The Eye of the World—is all mixed in together in a display case in the back of the restaurant Gavrelos founded, Lone Star Steakhouse Seafood & Grill, at 6685 Eastex Freeway (409–898–0801) in Beaumont. The display case is probably 25 feet long and 3½ feet deep. It runs the length of a long, skinny room that has nothing else in it.

Behind the glass, you've got camels, palm trees, little men, angels, Roman soldiers, scenes with names such as "Cain Kills Abel," "The Temple at San Sofia," and "The Tower of Babylon."

"There's a whole little city back there," said another John Gavrelos, one of the owners and the great-nephew of the carver. "It starts with Adam and Eve, the Parthenon, little churches from Louisiana. He's got notable figures in there like Betsy Ross. It's a neat little deal."

Gavrelos says his great uncle, who came to America in the early part of the century, got the idea to carve these scenes from another of his jobs.

The late John Gavrelos spent a quarter of a century carving biblical scenes, temples from around the world, and American history scenes out of produce crates, old cigar boxes, and plywood. Shown here is another John Gavrelos, the artist's great-nephew.

"He worked at a chocolate factory when he was young," Gavrelos said. "And he was fascinated with the molds he saw. And he thought if it could be done in candy, it could be done in wood."

The display has been in the back of the restaurant since 1959, although about a dozen of the larger pieces spent 1996 on loan at the American Visionary Art Museum in Baltimore.

World's Largest Fire Hydrant
Beaumont

I just had to ask: Do folks walk their dogs around the World's Largest Fire Hydrant, located outside the Fire Museum of Texas? "Uh, no," said Susan Lanning, the museum's director. Then what's the matter with them? If I lived in Beaumont, if I didn't have a dog I'd go get one just because of this artwork.

Walt Disney Co. built the 24-foot-tall fiberglass fire hydrant to promote its *101 Dalmatians* movie, which explains the hydrant's black and white–spotted paint job. Disney "did this whole media event," Lanning recalled. "They had over 100 firefighters dressed up in their turnout gear carrying dalmatian-spotted umbrellas, and they did a dance routine." They were, she said, local firefighters.

The fire hydrant actually works. "It shoots water out of the top like a sprinkler system," Lanning said.

It would take one heckuva poodle to do justice to this, the World's Largest Fire Hydrant.

The hydrant may not attract a lot of beagles and their owners, but it does bring a bunch of people with cameras and may be the most photographed attraction in town. "The fire hydrant—it's like our giant ball of twine," said Timothy Kelly, editor of *The Beaumont Enterprise*, the town's daily newspaper. "I've watched minivans pull up, people jump out and take a picture, then move on. It's pretty funny." He said it isn't unusual for Disney to put up promotional stuff around these parts. He recalled a fabric Great Wall of China that Disney constructed in nearby China, Texas, to promote the movie *Mulan*.

"It was humongous," said China City Secretary Jerry Howard. "I forget how long that thing was. It was at least 100 to 200 feet long."

The Fire Museum of Texas (409–880–3927) is also the headquarters of the Beaumont Fire Department.

Mr. Willard
Beaumont

Texas oil wildcatter Mr. Willard has led a tough life for a robot.

Not a slick man, he wears a slouchy black hat and overalls as he stands next to his old-fashioned cable tool rig. Crickets and birds sing as he begins his story.

"I reckon you could say I was whelped in the oil patch," Mr. Willard begins. He tells how Ma died of typhoid in the spring. He and Pa faced a dim future.

"Things looked kinda bleak when a fella struck oil a few miles down the road," Mr. Willard says. "It kept us in milk and beans. But we weren't of a mind to complain."

After that job played out, Mr. Willard and Pa landed work at Spindle-top, the January 10, 1901, gusher near Beaumont that shot 100,000 barrels of oil a day into the air for nine days and became synonymous with the expression "oil boom."

"Pa just kept on grinnin' while all that oil rained down on him like happiness from the sky," Mr. Willard says.

Ah, but things turned sour for Mr. Willard. Pa got blown off the top of a rig by an oil fire and was killed. Mr. Willard remained philosophical.

"It's like he always said," Mr. Willard tells his audience. "Nobody ever got hurt fallin' off a rig. It's hittin' the ground that kills yah."

Still, Mr. Willard promised he would continue exploring for oil through hell and high water. "Folks say, and I know, wildcattin' is boom or bust, and for sure it's mighty hard work either way," Mr. Willard confides. "But if we don't hit it here, there's a helluva lot of Texas that doesn't have holes punched in it."

Mr. Willard is a robot that tells history at the Texas Energy Museum, 600 Main Street (409–833–5100), in Beaumont. His plaster face serves as a movie screen for a 16-millimeter film that makes it look like his lips are moving.

Mr. Willard is a slightly salty cuss. Bill Nelson, a former volunteer at the museum, said one visitor complained to a worker about Mr. Willard using the word "helluva."

Nelson said the worker told the guy, "You're lucky he didn't spit tobacco on you."

GULF COAST

Hotel Blessing

Blessing

"She ain't makin' no more breakfast," the waitress in the high-ceilinged dining room said. I had showed up just a little bit late. Helen Feldhousen, who owns the restaurant in the old hotel (built in 1906), came out of the kitchen and amended that.

"We got pancakes and bacon and that's it," she said.

My timing was all off when I hit this town, founded in 1903 by Jonathan Edwards Pierce, brother of infamous cattle baron Abel Head "Shanghai" Pierce (1834–1900). I was too late for the full breakfast and too early for the buffet. What's really a blessing in Blessing is the lunchtime spread.

"Today, we have Christmas dinner," Helen said. No kidding? In the middle of June? "Turkey, dressing, roast beef, and ham," Helen went on. "And all the vegetables—squash, broccoli, black-eyed peas, sweet potatoes, or yams." The lunch buffet is served every day of the year but Christmas.

They don't come much more down home than the Hotel Blessing at Tenth Street and Avenue B. Helen runs the restaurant, but the hotel is run by the Blessing Historical Foundation. For reservations, call (361) 588–9579.

The Great Texas Mosquito Festival

Clute

It's held the last Thursday, Friday, and Saturday in July to honor the huge mosquito population here in Clute (www.mosquitofestival.com).

"We still have a tremendous amount of them," said Dana Pomerenke, director of the Clute Parks and Recreation Department, speaking about the bug population in December. "They ate me up last night in my own yard."

The festival highlights are a mosquito-calling contest, a Ms. Quito beauty pageant, and a mosquito leg look-alike contest. "You don't do a costume," Pomerenke said of the leg look-alike contest. "It's your legs, so it's usually the most skinny, hairy legs that win." The event is held in Clute Park, home of Willie Manchew, a 25-foot-tall inflatable mosquito.

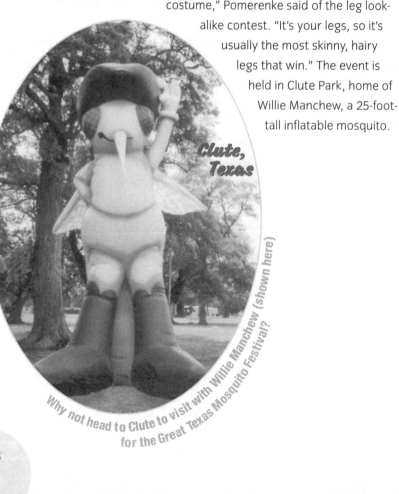

Clute, Texas

Why not head to Clute to visit with Willie Manchew (shown here) for the Great Texas Mosquito Festival?

The Selena Statue

Corpus Christi

We do a great job of honoring our deceased music icons in Texas when they die young and tragically. Lubbock has the Buddy Holly statue, Austin has the Stevie Ray Vaughan statue, and Corpus Christi has a bronze statue of hometown gal Selena, the beloved star Tejano singer who was murdered by her fan club president.

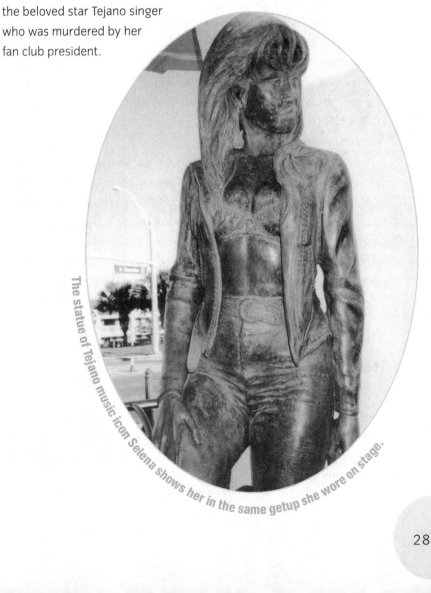

The statue of Tejano music icon Selena shows her in the same getup she wore on stage.

Yolanda Saldivar shot Selena in 1995 at the Days Inn on Navigation Boulevard. In Corpus, Selena is regarded by some almost as a religious figure. On the day of her funeral, the city's daily newspaper, the *Corpus Christi Caller-Times*, ran a special section, with a photo of her in her casket on the back page. To bring closure, the five-shot, .38 caliber Taurus revolver used to murder Selena was cut into about fifty pieces and dumped into Corpus Christi Bay.

The statue, set up under a gazebo, is a good likeness of Selena. But the face is solemn.

The artist, H. W. Tatum, "did a couple of features," said Dusty Durrill, who built the gazebo site. "We had two heads. One, she was smiling, and one, she was solemn, and the family wanted the solemn head." The smiling head is on display at the Corpus Christi Museum of Science and History at 1900 North Chaparral.

Just about any time you go by the statue, located on the sea wall on North Shoreline Boulevard at Peoples Street, you'll see people visiting it. At about 7:00 on a chilly Sunday morning, Troy Price from Alabama had come by to take a picture of the Selena statue for his fourteen-year-old son back home. The kid is a big fan.

"You never know how big she could have been," Price said. "Not many performers are known by their first name only, and she was already there. You got Madonna. And Elvis. Everybody knows who Elvis is."

The Fulton Mansion

Fulton

"The kids coming in here, they're all screaming 'cause it looks like the Munsters," said Charlie Cook, retired tour guide for this spooky-looking Second Empire French home built in the 1870s by Longhorn cattle magnate George Ware Fulton.

People in town think this place is haunted. The story I heard from the locals is that one of Fulton's daughters died young, so she prowls the mansion at night.

"They say she stands up there in the window," said Melanie Vaughan, a former employee in the nearby Boiling Pot seafood restaurant. Melanie said she saw the ghost in the bathroom when she was a kid. "I swear I saw the ghost in the bathroom, but I believe in that kind of stuff," Melanie said.

Charlie Cook pointed out that neither of Fulton's two daughters died young. Annie and Hattie both lived to a ripe old age, he said. There is no ghost, but don't try to tell that to the locals.

"We've got people in this community, they still think this house is haunted," said Buck Spurlock, formerly a park ranger here. The Texas Parks and Wildlife Department operates the renovated mansion, at 317 Fulton Beach Road (361–729–0386), as a tourist attraction. "I've been in here at night, and it does squeak a little bit."

Maybe Lillian "Big Mamma" Davidson started the ghost rumors. The Davidson family of San Antonio bought the Fulton Mansion after George Fulton died in 1893. Big Mamma lived in the place from 1907 to 1943, Charlie said.

"The Davidson kids would invite their friends in this house, and Big Mamma would dress up as a ghost and scare them to death," Charlie said. "She would go to the high school and tell ghost stories about the place."

Then there is the fact that the place sat around empty, collecting dust and spider webs for years, until the state began restoring it in 1976.

It probably doesn't help, either, that the marker out front of the house says George Fulton died on October 31, 1893—Halloween. That's a mistake, Charlie said. George Fulton really died October 30.

Maybe the state made the mistake on purpose to attract tourists. Either way, if you're going to tour the place, bring your own ghost.

Hu-Dat

Fulton

If you're a Texas Longhorn football fan who breaks out in a rash from looking at Texas A&M Aggie sports mementos, don't eat here.

This spotless, reasonably priced Chinese-Vietnamese seafood place at 61 Broadway at Fulton Beach Road (361–790–7621) is owned by Phong Nguyen, uncle of Dat Nguyen, the former Texas A&M All-American football player who went on to play linebacker for the Dallas Cowboys.

Dat Nguyen's parents, Ho and Tammy Nguyen (pronounced Gwin), came up with the name for the restaurant. Dat, by the way, won college football's 1998 Lombardi Trophy, the trophy that goes to the nation's top college lineman.

Dat may be one heckuva tackler, but the word is he didn't tackle a lot of chores at this restaurant when he was growing up.

"No, he just eats," said Canh Nguyen, Dat's cousin and the former restaurant manager. Sounds like my kind of guy.

You can't get to the dining room without wading through the Aggie paraphernalia in the front room. On display are the maroon jersey Dat wore in the Alamo Bowl, along with various trophies and plaques. If you go out by the highway, you'll see the big billboard, showing the huge, full-color photo of Dat in his Aggie football gear, along with the message, "Welcome to Rockport-Fulton. Home of Dat Nguyen."

After you get past the Aggie gauntlet-shrine in the lobby, the dining room is peaceful, decorated with large Asian fans and a waterfall painting. On the other hand, while I was trying to enjoy my beef, spring roll, and shrimp over noodles, a boy who looked to be about ten years old busted through the dining room, wearing a maroon and white Texas Aggie T-shirt. No justice, no peace.

Giant Crab and Shrimp

Galveston

"People rarely remember our name, but they do remember it's the restaurant with the crab on the roof," said Rick Gaido, director of operations for Gaido's, perhaps the best seafood place in the state, at 3900 Seawall Boulevard, on the Seawall in this beach town.

So to attract customers to Casey's, the restaurant next door, at 3800 Seawall Boulevard, which is also owned by Gaido's, they put up a large pink shrimp. The crab has been up for years, while the shrimp is a fairly recent addition. "We thought with Casey's the same thing might happen. They might recognize it as the place with the shrimp on the roof," Rick said.

Actually, the shrimp isn't on the roof. It's on a pole. It's big and pink and has bulging eyes. "A lot of people think it's a crawfish," Rick said. Yeah, well, a lot of people aren't from Louisiana. The crab is a blue-claw crab with a sign on it that says it was CAUGHT IN GALVESTON BAY. As big as it is, if it had been caught in Galveston Bay, scientists would have to check the bay for nuclear radiation.

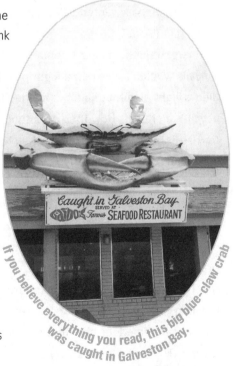

If you believe everything you read, this big blue-claw crab was caught in Galveston Bay.

"We'll say it's real, and you'd be surprised how many people believe it," Rick said.

You can call Gaido's or Casey's at (409) 762–9625.

"WRONG WAY" CORRIGAN

Perhaps no man in America brings the word "whoops" to mind as strongly as the late Douglas Corrigan, a Galveston native son. Corrigan was supposed to be headed in his single-engine airplane from New York to Long Beach, California, on July 17, 1938, but ended up landing in Dublin, Ireland, twenty-nine hours after taking off.

Corrigan was born in Galveston on January 22, 1907, according to Shelly Henley Kelly, former assistant archivist with the Rosenberg Library in Galveston. In May 1908, Corrigan won a cute baby contest in Galveston. At age fifteen, he changed his name from Clyde Groce Corrigan to Douglas Corrigan, after actor Douglas Fairbanks.

But the name change was all for naught, because after he got going in his plane all bassackwards, he would be called Wrong Way Corrigan for the rest of his life.

Corrigan had wanted to fly across the Atlantic like Charles Lindbergh did. (In fact, Corrigan had worked as an aircraft mechanic for Lindbergh.) But his plane was such a heap of junk, Kelly said, that flight officials wouldn't give him a flight plan to cross the big pond. So he filed a flight plan that had him headed to California.

"It's a crate, is how they described it," Kelly said of Corrigan's 1929 Curtiss-Robin airplane. "This guy had his door held shut with baling wire. And he didn't have many instruments. He had two compasses, and that was it."

After ending up in Ireland, Corrigan blamed his equipment. "His excuse was one of the compasses froze up and broke, and the other one was broken 180 degrees," Kelly said. Corrigan was sent back to the United States by boat.

The goof didn't stop Galveston from bringing Corrigan back to town on August 26, 1938, for a ticker-tape parade. The Galveston airport was renamed for him, though Kelly says it might have been just for the day. There was even a song about Corrigan written and published by Eloise Drake of Galveston. The song was called, "If Your Compass Is Turned Around."

GULF COAST

Col. Bubbie's Strand Surplus Senter

Galveston

So how much money did Meyer Reiswerg, aka Col. Bubbie, owner of the world's largest army-navy store, make by providing 1,500 U.S. Army uniforms for the Steven Spielberg movie *Saving Private Ryan?*

"I've been to New York four times this summer," Col. Bubbie said at the time. "I put $100 bills in each ear, and they [New Yorkers] didn't bother me in the least."

Col. Bubbie said the action for him these days is renting uniforms to theater and movie production companies. But he also did some serious business during the terrorist alert of February 2003.

"We're the king of gas masks," he said. "We've been selling them out the kazoo. When it rains, we sell a lot of raincoats. When there's an orange alert, we sell a lot of gas masks."

The store, at 2202 Strand (409–762–7397), has stuff from the Iraqi army, Indian Army turban-style hats, USSR Navy shirts emblazoned with the old hammer and sickle emblem, East German Army combat pistol belt sets for $39.95, grenades with their working parts removed, entrenching tools, and French Foreign Legion hats. There are items available from about sixty different armies and forty navies.

Floor to ceiling surplus.

Col. Bubbie has so much army and navy stuff that not only is it piled from floor to ceiling in the store, but it also fills the second and third floors, a warehouse next door, and about six other warehouses.

"If at first you don't succeed, just add more crap to the inventory," Col. Bubbie said. There are combat boots, Russian World War II mess kits, seventy-one kinds of camouflage, bugles, patches, billy clubs (labeled "Alabama lie detectors"), and dummy artillery shells.

"A lot of people like these," Col. Bubbie said of the artillery shells. "A lot of kids give them to their mothers on Mother's Day for a set of earrings."

He can sound crusty, but the colonel is a pushover for a fuzzy face. He has several cats—including Lover Boy—who live in the store, and the day that we visited he had just taken in a kitten from the animal shelter. "I'm glad I went over there or he would be glue this morning," Col. Bubbie said. He rigged up a tiny "available" sign to a key chain and put it around the kitten's neck.

"A lot of people come in here just to play with the cats," Col. Bubbie said. "A lady came in the other day and said, 'Your cat let me pet him for fifteen minutes.' And I said, 'That doesn't make you anything special. The last guy who came in made love to him.' "

The Flagship Hotel
Galveston

Big is usually well received in Texas, but there are exceptions. When a couple of extremely well-endowed 50-foot-tall synthetic plaster mermaids went up on the side of the hotel on the Seawall in the summer of 1999, some locals got their noses out of joint.

"Some people have complained about the fact that they are nude," said Sergio Pineda, who designed the artwork for the hotel, which is built on a pier out over the Gulf of Mexico, at 2501 Seawall Boulevard

(409–762–9000). "But what I have claimed as the artist is that this is art-work that portrays a mythical figure that gives Galveston very much its own essence, the connection of mankind to the sea, and the fact that Galveston derives its fate from the ocean and always has."

Besides, the mermaids could win if you entered them as a tag team in the wet T-shirt contest on the beach next to the hotel.

Pineda said he had no intention of putting duds on the mermaids, regardless of the flap. "I don't see how you can dress up a mythical fig-ure and give her some Western-type clothing," he said.

This is not to say everyone in Galveston was up in arms over the half-fish, half-babe masterpieces. "Some people may be offended by it but others, let's see, are actually amused by it," said City Manager Steve LeBlanc. I asked him what he thought about the $20,000 mermaids. "Uh, personally, as the city manager, don't ask me that kind of question, I have no comment," he said.

Look at the bright side. The art makes it easy to give directions to the hotel. Not that it was hard to find in the first place. The Flagship claims to be the only hotel in North America built over the water. Now it has a couple of mermaids, who are really built, built over the water.

Super Gator Swamp Tours
Orange

"Swampy. Everybody calls him Swampy," said Stan Floyd, the owner of the airboat swamp tour business on the north side of Interstate 10, just before you cross over the Sabine River into Louisiana.

Swampy is made of Spanish moss. He's big and hairy. Every day is a bad hair day for Swampy. He sits out front of Floyd's place and serves as a greeter. Floyd is Swampy's Dr. Frankenstein. See, Floyd made Swampy.

"He's over 10 feet tall," said Floyd, who also builds and sells airboats and has an RV park on his property. "He has an electric motor in him, and he moves. He has a Chevrolet flywheel for a heart."

In March of 2006 Swampy was under repair.

"He got bent over by the Hurricane Rita that hit us," said Gwen Tallant, who works at the business. The good news is that Swampy is no longer alone. "We've got a lady swamp monster with him, a smaller one, so he has a wife," Tallant added.

The children love Swampy. "I've had grandmothers tell me they tell their grandkids they'll take them down here, if they'd quit crying and eat their breakfast, to see Swampy," Floyd said.

Every day is a bad hair day for Swampy.

Floyd's business is on the banks of Cypress Lake, which leads out to the Sabine River. In the 1980s Floyd had an airboat building business in Houston. Then the oil bust hit, taking his business and his marriage of twenty-six years with it. In 1990 he started over by buying this property, which at the time had nothing on it but a gas station.

"I knew with I–10 at the front door, and 10,000 acres of swamp marshes at the back door, I could make a living," he said.

On one of Floyd's one-hour airboat tours, you'll see snakes, turtles, fish, gators, birds, and nutria—a kind of large rat. Floyd said he doesn't see nearly as many nutria as he used to. This is probably because the Cajuns are sneaking over from Louisiana and using them in their gumbo.

If you visit Floyd, you're going to see gators, either on the tour or on the property. When I visited, he had five gators inside a chain-link fence. Floyd sells marshmallows so you can feed them.

You can call Stan Floyd and Swampy at (409) 883–7725.

Castles in the Sand

Port Aransas

So what kind of event do you suppose would attract an artist who goes by the name of sandy feet (small s, small f)?

Would you believe a sand castle contest?

Ms. feet, whose real name is Lucinda Wierenga (so you can see why she might change her name to feet), is a regular entrant at Texas Sand-Fest, the annual competition on the beach here that attracts over 300 sculptors. And if there's anything the artists really hate, it's a beer-drinker who likes to kick things over—that, and high water.

That's why event organizers pick a date that avoids busy weekends, and waves.

"It's either March or April, and it's determined by the tide," said Dee McElroy, SandFest director. "We avoid Easter, we avoid spring break, we avoid the summer rush. So within that narrow window we check a year in advance. It has to be the lowest tide so we can have the beaches wider and there's no threat to the sculptures."

Sandy Feet, a master sand sculptor from South Padre Island, is a prime example of why SandFest selects its dates so carefully. Several years ago one of her works was the victim of a storm, which raised the water level at the beach and took out one of her artworks.

"It just kind of melted," McElroy recalled.

Ms. feet was on her toes, though, and managed to turn a bad situation into a humorous yet sandy tour de force.

"Well, I had started off building just a big castle, but after the destruction occurred, I carved a spring-breaker flailing around in the middle of the castle and it had a bunch of empty beer cans," feet recalled. "And I titled it 'Irresistible Force Meets Immovable Object.' So it turned out OK."

That sort of thing is all in a day's work for sand castle makers. "That's what you've got to do is be creative, because the sand isn't always cooperative," said feet, who has a book out called *Sand Castles Made Simple*. "You have to go to Plan B and sometimes Plan C. And Plan C is almost always a sea turtle."

SandFest's sculptors enter in three categories: amateur, pro-am, and masters. From the latter group you'll see all sorts of intricate and amazing artworks made of sand and water, some of them as high as about 12 feet: Pope John Paul in his robes and his tall pope hat, three curious monkeys (one with a mike, one with earphones, the third looking through binoculars), a sand likeness of the tapestry that shows the dogs sitting around a table playing poker.

"A lot of them do people, a lot of them do architectural buildings like castles, some go for the real whimsical approach, which is a real crowd pleaser," McElroy said. "Some have more profound sculptures, conveying a message. Some are more artsy in their approach."

"Dogs Playing Poker"

Message in a Bottle

Port Aransas

Tony Amos uses the money he makes selling the junk he finds washed up on the beach to help fund the animal rescue operation he runs.

Those pelicans, hawks, sea turtles, and other injured animals eat plenty. Look in Tony's walk-in freezer and you'll see a large cardboard box of frozen rats he ordered wholesale to feed the carrion eaters he's rescued. Have you priced frozen rats lately? So it's fortunate that he finds some oddball stuff on the beach to make a little extra money.

"You name it, I've found it," says Tony, the oceanographer who runs Animal Rehabilitation Keep (or the Ark), an agency of the University of Texas Marine Science Institute that rehabilitates injured critters for release.

He says he's even found an ice-cream maker. "Yes, it is bizarre. In fact, the stuff on the beach is quite bizarre."

He's even found one of those yellow plastic dealies from Carnival cruise lines that tells people to be careful because the floor is slippery.

Every other day since 1978, Tony has surveyed 7½ miles of the beach on Mustang Island to record what he sees. His office is filled with hundreds of notebooks that document the number of dogs, people, cars, helicopters, and various species of birds he spots on each trip. He records relative humidity, salinity, beach erosion, and the high-tide line. On Friday, January 20, 2006, Tony made his 3,758th "beach observation."

While there, he collects all the junk people have thrown overboard.

Then he has an annual yard sale so he can feed Barnacle Bill, the loggerhead turtle who is missing two limbs, Goofy, an injured pelican, and that rat somebody left in a box outside.

Last year Tony's sale made $3,900. In amongst his stash of found stuff is an ironing board. Maybe somebody aboard ship got tired of working on laundry and tossed it into the drink. Then there's the

wooden statue of a guy who appears to be enjoying some wacky tabacky. That's one of the art objects that floated up.

"It's a man smoking a ganja pipe, I think," Tony said. "It's Jamaican, I think."

Tony also finds lots of messages in bottles. "I've found over 100. People put them in the most amazing things." One message stored in a large soda jug says, simply, HELP!!! PLEASE, THESE PEOPLE ARE ORDERING ME AROUND. THEY ARE DRIVING ME CRAZY, COME AND GET ME!!!! The message, written on a sheet of white paper, includes a crude hand-drawn outline of Alabama, along with an X showing the writer's location near the Alabama coast, and a circle somewhere out to sea, marked YOU.

"Some of them are basically hoaxes and say, 'Help, I'm stranded on a desert island, send booze,' or something," Tony said.

Sometimes they're for real, though.

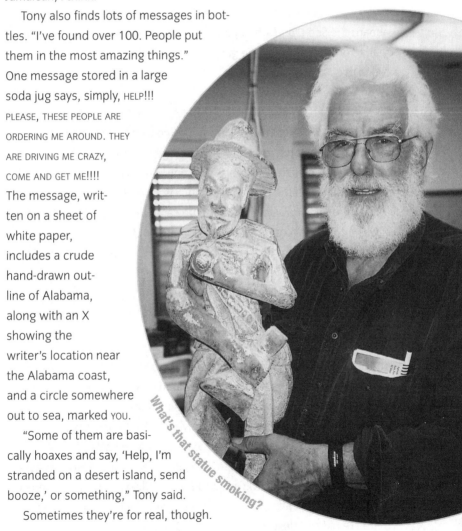

What's that statue smoking?

"Perhaps the most intriguing was one that I found probably four years ago from a German cruise vessel called the *Sea Cloud*," Tony said. Tony says that every year the 374-foot sailing ship stops somewhere near the equator en route to Barbados to let the passengers toss bottled messages overboard. One year Tony found a message from a guy aboard the *Sea Cloud* who operates a hotel on a barrier island off Germany. Tony got ahold of the guy, who invited him to his hotel on the island of Sylt for a vacation.

So Tony took him up on it.

"It was great," Tony recalled. "He put me up in this wonderful old hotel and we had this wonderful jolly German time with bratwurst and beer."

About a year later Tony found a message in a bottle from the same ship, which Tony figures is pretty amazing, since where the *Sea Cloud* stops to dump off the bottled messages is more than 4,000 miles from Mustang Island. This time the message came from a guy from Boston. "I was never able to contact the man," Tony said.

Too bad. He might have gotten some clam chowder out of the deal.

Short On Ties, Long on Hats
Port Aransas

The first thing you notice when you walk into Shorty's beer joint (823 Tarpon Street, 361–749–8077) in this island beach town is that every square inch of ceiling is covered with gimme hats.

The second thing you notice when you walk into Shorty's is that every square inch of ceiling is covered with gimme hats.

For you Yankees in the audience, a gimme hat is a ballcap that advertises a business, such as Olsen Auto Body in Clearwater, Florida, one of the hats you'll see attached to Shorty's ceiling. Many of the hats up there are old and dusty, so no telling if Olsen Auto Body is still hammer-

ing out dents. Regardless, these sorts of ballcaps are often given away to customers as ads. Hence the name "gimme" hat.

Actually, the hats on Shorty's ceiling aren't all technically gimme hats. One carries the message, BET YOU MINE'S LONGER THAN YOURS. Maybe it's a redfish reference. Maybe some guy is bragging about his catch. After all, the joint attracts a lot of fishermen.

So how many hats are stapled to the ceiling?

"I'd say right at 2,000," said Rose Smithey, eighty, the owner, who everybody calls Miz Rose. How does she know how many hats she's got on display? No, she didn't count them. She says that somebody from the nearby University of Texas Marine Science Institute counted the hats in a section of her ceiling, and from that made an estimate.

Miz Rose says people bring their hats in and donate them, but there's not much room left for more hats, even though she gets about three new ones a week. "Yeah, we've probably got enough room for ten or twenty, maybe forty, I

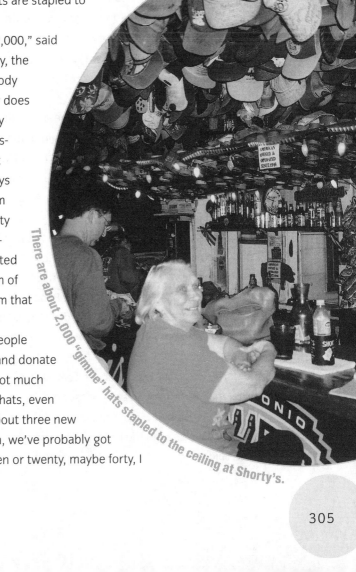

There are about 2,000 "gimme" hats stapled to the ceiling at Shorty's.

don't know," she guessed. Occasionally a new space for yet another hat opens up.

"The staples fall out and they fall on the floor," Miz Rose said.

Shorty's gets its name from Miz Rose's mother, the late Gladys "Shorty" Fowler, who was real short and opened up Shorty's in 1946. "Well, my stepfather named my mother Shorty, so it was Shorty's Place," Miz Rose recalled. "He was 6-foot-2 and she was 4-foot-11. Actually, 4-foot-10½. I don't want to stretch her."

Either way, nobody knew Shorty's real name, which is the way Shorty wanted it. "Her grandkids didn't even call her Granny," Miz Rose recalled. "If they called her Granny, they ran."

By the way, Miz Rose is only 4-foot-11. So the bar's name remains appropriate.

Shorty's dress code is nonexistent. The only critter wearing a tie in here is a deer head mounted on the wall with two ties wrapped around its neck. Only a dead deer can get away with a tie in this joint.

"If anybody else comes in here [with a tie on] we all shut up because we think it's a lawyer or the TABC [the Texas Alcoholic Beverage Commission]," Miz Rose said.

You can buy beer while standing outside the building by sticking your head through one of the two front windows. The bartender will come over and serve you through the open window. Don't try to bring your dog inside, though. This will set Miz Rose to barking at you. The place has had problems with too many dogs inside before. "No dogs allowed inside and no barking dogs on the porch," says the sign on the front door.

And don't bring your kids in, either. Leave the children outside with the terrier mix. NO RUG RATS AFTER 6 P.M. says the sign over the jukebox.

Still, it's a festive place with Christmas lights hanging over the bar—all year long. "We change the lightbulbs to kinda match the season," Miz Rose said. "For Valentine's we're gonna change 'em to red."

Almost forgot to mention that Shorty's is across the way from the Homeland Security office. Miz Rose says that occasionally some of the people from that office come over and have a cold one. You gotta wonder if Shorty's attracts any suicide drunks.

MATILDA THE DUCK

Matilda, a taxidermied mallard, has a duck call inserted in her butt. Blowing the duck on your initial visit is a tradition at the Buckhorn Saloon at 2816 Main Street in Ingleside, frequented mostly by personnel from the nearby naval station.

"The first time they come to the Buckhorn, they have to blow the duck," said Bob Hardy, the owner. "And we give them a card that says they blew the duck. And they carry that card with 'em so they don't have to do it again."

They keep the duck on the bar.

Sometimes new patrons are a little reluctant to pick up the duck and honk. "It's just a horn," he said. "It's got a piece of heater hose sticking out that you wrap your lips around and blow. Some people, you've got to do a little coaxing to get them to blow it."

Fortunately, this tradition isn't going on next to a U.S. Marines base. If it were, somebody would eat the duck.

The Tarpon Inn

Port Aransas

If you want to see tarpon scales, stay at this old hotel (361–749–5555), at 200 East Cotter, which opened in 1886.

It's been a tradition over the years to take a scale from the tarpon you caught, write your name, your hometown, and the size of the fish (if it's worth bragging about) on it, and affix it to the wall in the lobby.

The right wall as you walk into the lobby is entirely covered with these signed tarpon scales. Penny Jones, the former desk clerk, said she heard there are about 3,500 fish scales in all. You can read the scales on the wall and see who caught what. J. C. Blackwood of Midland caught a 6-foot-7-incher on June 9, 1950. Ginnie Hills of Bloomfield Hills, Michigan, caught a 5-foot-3-inch tarpon on July 17, 1946. Franklin Delano Roosevelt caught a 5-foot-1-inch tarpon on May 8, 1937. Because FDR was president, his scale rates a frame, on the back wall, along with a couple of photos of him landing the fish.

The Tarpon Inn is a quaint old barracks-shaped building. You can sit on the long front porch in a rocker and hear the fishing boats in the waterway.

JANIS JOPLIN'S SCHOOL DAZE

Yes, the 1960s rock singer with the ballsy voice actually had a slide rule in high school.

And if it wasn't for Sam Monroe, president of the Port Arthur Historical Society and Lamar State College, Port Arthur, you might not be able to see it.

In the 1980s Monroe, who went to Thomas Jefferson High in Port Arthur with Joplin, led the drive to get a Joplin exhibit going. Today, you'll find it in the Music Hall in the Museum of the Gulf Coast, 700 Proctor Street, Port Arthur (409–984–6445).

Monroe said he had some trouble getting the job done. Some people in town didn't think honoring Joplin, who died of a drug overdose at twenty-seven, was a good idea "because of her lifestyle and the manner in which she died," he admitted. "But we made the case with the people that her career was so significant that she should be recognized."

Monroe said the Joplin tribute is the only one in Texas. Along with Joplin's slide rule, you'll find Janis Joplin's senior yearbook, awards Janis won for outstanding achievement in art and English at Woodrow Wilson Junior High, a birthday note fourteen-year-old Janis wrote to her mother to invite her to dinner at Luby's, one of her performing outfits done by Nudie of Hollywood, even a replica of Janis Joplin's ragtop Porsche.

It has a big smiling sun on the back end and is quite psychedelic.

Monroe knew Joplin fairly well. They went to kindergarten together, graduated from Thomas Jefferson High School in 1960 together, and though they didn't date, they did double-date.

"Janis was multidimensional," Monroe said. "I think she was a little bit ahead of her time." She was not a follower. There was an all-gal drum and bugle corps in high school called The Red Hussars.

"Every female student wanted to be in the Red Hussars," Monroe said—except Janis. "She had a large cadre of friends, but she did not want to be part of the mainstream."

World's Largest Fly Rod and Reel

Port Isabel

Avid fly fisherman and retiree Tiney Mitchell attributes his building of the 71-foot-4½-inch-long fly rod to opening his mouth at a directors' meeting of the Laguna Madre Fly Fishing Association.

"When the guys got done batting the breeze about how they could get some publicity and get some people to come down here from Dallas and Houston to fish with us, I opened my mouth and said, 'I know what. Let's build the world's largest fly rod and reel,' " said Tiney, eighty-seven. "And of course I was appointed a committee of one."

At first Tiney and his next-door neighbor and buddy, Leroy Addison, who helped with the project, intended to build the rod out of aluminum flag poles. But the *Guinness Book of World Records* folks said that wouldn't work because it wouldn't be authentic.

"When we got the letter from *Guinness,* we had to back off and go to fiberglass," Tiney said. Leroy found a company in Wichita, Kansas, that manufactures fiberglass tubing. The company donated the material for the rod. So Leroy and Tiney built the rod—as well as the big tarpon—in Leroy's driveway.

The big fish can be seen leaping out of the water just off Pirate's Landing Fishing Pier here. It is arranged in such a way that it looks as though it is about to be hooked by the gigantic fly rod, which is set up next to the fishing pier building. "The tarpon is 20 feet long and its mouth is wide open and the fly is out in front of it," Tiney said. "It appears the tarpon is jumping out of the water after a fly."

"It's made out of fiberglass sheeting," Leroy said of the fish. "We took marine plywood and made the backbone, then we made the ribs out of two-by-two wood."

The project began in 1997, and the fly rod—now certified by *Guinness* as the world's largest—was erected in 1999. The reel is 4 feet in diameter and like everything else on this rod, it's to scale and it works.

The operation of the fly rod would require the combined strength of two dozen strong men or one large Texan, according to the sign in front of the fly rod. By the way, Tiney spent a lot of his own money on the project. But he's not sure how much. His wife kept the books.

"She won't tell me," he said.

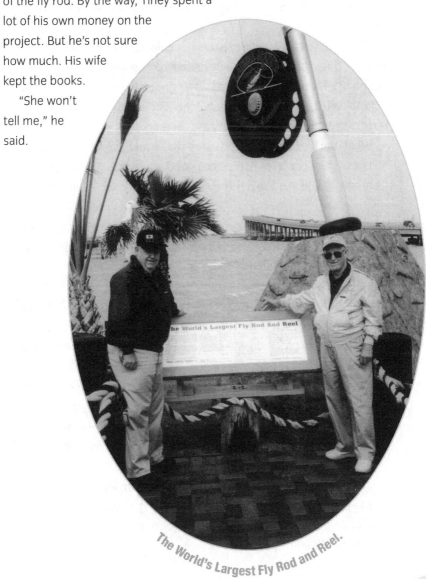

The World's Largest Fly Rod and Reel.

The Boiling Pot

Rockport

Don't wear your best clothes to the Boiling Pot, because you may have to burn them.

The main reason to come to this place, located on Fulton Beach Road, is the Cajun Combo: a blue crab, a half pound of shrimp, a half pound of sausage, new potatoes, and corn boiled in Cajun seasonings. Your table is covered with white butcher paper. A waitress comes to your table with a pot and dumps the contents on top.

When the place was located across the street, it had a floor drain. It still has a bare concrete floor. It has good groceries. It is not formal. It is as messy as you want to be. They bring you a wooden mallet to pound on the crab.

"That's the good thing," said Dot LeBlanc, the owner and the inventor of the Cajun Combo. "You can get right off your boat and come in and eat." The place is across the road from Fulton Harbor.

The waitstaff will bring you a little plastic cup with a wedge of lemon to clean off your fingers. "People still drink the finger bowl," Dot said. "They think it's a tequila shot. You can tell the ones who have never been here. They pick it up and say, 'Here's a toast.' This is not a restaurant. It's an entertainment center."

The Boiling Pot is a good place to hear local bull. Melanie Vaughan, who used to work here, said there used to be a guy named Peg Leg who lived around here. Being named Peg Leg, naturally he had a wooden leg. Melanie said Peg Leg would take an ice pick and stick it into his wooden leg as a joke for children.

One night, the story goes, he picked the wrong leg.

The place also supports the arts. They bring a cup full of crayons to your table. You get to draw on the butcher paper. They hang the customers' works on the walls.

Really Big Tree

Near Rockport

Located at Goose Island State Park off Texas Highway 35, about 12 miles north of Rockport, the Goose Island Oak, certified as the largest live oak in Texas, is a panhandler. Over 1,000 years old, the tree—with a trunk circumference of 35 feet, 1¾ inches—hits people up for spare change.

It does this with the assistance of a corny poem—perhaps I should say acorny poem—displayed on a sign near the tree. Next to the sign is a Texas Parks and Wildlife Department donation box.

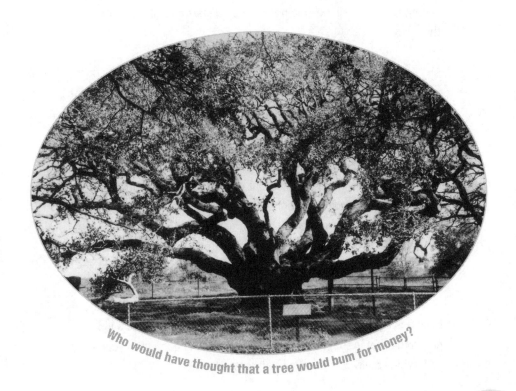

Who would have thought that a tree would bum for money?

Here's some of this sappy poem:

"Yet through all the seasons, sorrows, bitterness and beauty
All of the history I have withstood and witnessed,
There had been one thing I could not do.
I could not grow dollars, or silver or gold.
Will you help me, standing here before me?
Then we both may grow old, together.
As old friends should.
One of flesh, one of wood."

Get a job. Actually, in a weak moment I gave the tree fifty cents.

I like the wooden sign set in the ground in front of the tree. It says, simply, BIG TREE. Well, no kidding! You could start a furniture store with this thing.

Capt. Billy's Wife's Place
Rockport

Great name for a fresh take-out seafood joint, huh?

"It started out as a joke," said Perry Bullman, wife of Capt. Billy Justus Bullman, a shrimper and tugboat operator. She said she and her husband and a bunch of his shrimping buddies were sitting around, chewing the fat, trying to think of a name for the place.

"He said, 'I know, honey, we'll name it after you,' " Perry said. "I said, 'What?' And he said, 'We'll call it Capt. Billy's Wife's Place.' But it has caught on. So what started out as a joke has been profitable for us."

The name also turned out to be accurate. About two days after the Bullmans signed the papers to buy the place, Capt. Billy got a job running a tugboat in the Marshall Islands. So he was gone for a year and a half. Which really made it Capt. Billy's Wife's Place.

The decor is as striking as the name. The building, on Texas Business 35 (361–729–5980), is painted in startling, knock-your-eye-out green. "They wanted something that sticks out," said Ken Davis, Capt. Billy's nephew. "I think it's called International Green. They narrowed it down to three: International Green, International Orange, and International Pink. And he didn't like the pink, and she didn't like the orange, I don't think."

The small dining area in the front room has a sign on the wall that says, DON'T TRY TO DROWN YOUR SORROWS IF SHE CAN SWIM. A plastic pelican in the window greets visitors.

Brown food rules here. On the menu are fried oysters, fried shrimp, and fried clam strips. The business keeps growing. The place has progressed from two Fry Daddies to two or three larger Fryolators.

It would be all right to show up in here in your bathing suit. "Last week I got a call from a guy in San Antonio," Ken said. "He said, 'I've heard so much about you. Do I need to make a reservation?' I felt like saying, 'Yeah, and a coat and tie is required.' "

The Shark at the Door
South Padre Island

If you want to get into the Jaws souvenir shop to buy your beer bong so you can get loaded fast on the beach here at spring break, you've got to walk through the shark's mouth.

The front door is a big, artistic, faux fish with a pink tongue and lots of teeth. In other words, to enter the store you have to become bait. Some might find it tacky, but it's probably a step up from the big sign in the souvenir shop window next door that said, LADIES SWIMSUITS 60 PERCENT OFF. Then there's the sign on the nearby causeway bridge that reads, WATCH FOR PELICANS WHEN FLASHING.

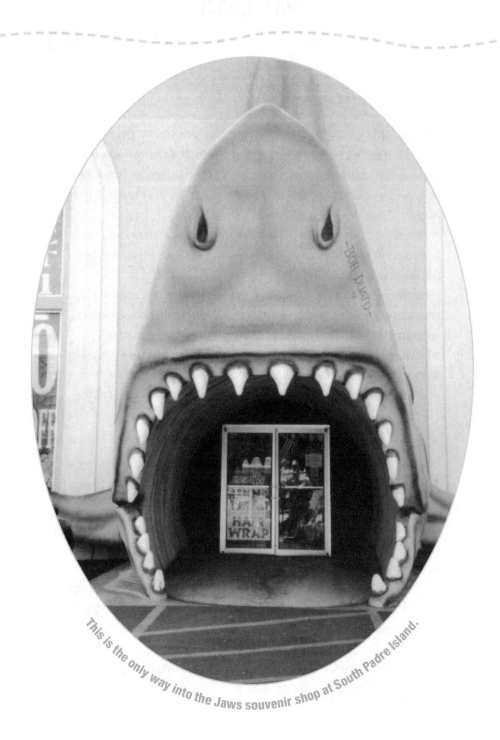

This is the only way into the Jaws souvenir shop at South Padre Island.

South Padre Island is where the college kids come to party, so Jaws has all manner of stuff on sale that helps get the job done. The beer bong is nothing but a big funnel that you can pour beer into. Plastic tubes attach to the funnel, and kids put a liplock on the ends of the tubes and start inhaling suds.

"Actually, that one, you can make it for four people," said Sylvia Arguelles, a Jaws employee, as she hooked up a couple of tubes to the funnel to show how it would operate. "All this kind of stuff for spring breakers, it's popular. The faster they can drink, the more they like it."

The shark entrance provides a popular photo opportunity for tourists. People are constantly driving up to the front of the store and taking a picture of it.

"Wow—every five minutes," said Seila Ania, whose uncle owns the store. "You can stand right here and check." In about two seconds a woman with a camera appeared in front of the store. "Here you go," Seila said. "Told you. You don't need to wait."

Big Nose Collection
Victoria

OK, so the late Henry J. Hauschild Jr., an art and rare book collector, didn't have a collection of actual noses. What Hauschild, who died in 2005 at the age of ninety, did have was a collection of art depicting the noses of prominent people throughout history. Hauschild, former chairman of the Victoria County Historical Commission, visited museums in sixty-five countries the world over, collecting paintings, prints, and pictures of faces and the noses that come with them. He figured he had about 300 noses.

The works hung all over his home at 210 East Forrest Street. Many of the noses are on faces you have heard of before. My favorite is the

print of Rasputin framed in a toilet seat over the bathtub. Hauschild found the picture in Russia.

"A friend of mine collected Hapsburg chins, and do you know what Yoko Ono collected?" Hauschild asked. "She collected derrieres. But I wanted something a little different. Do you know anybody else who collects noses?"

Hauschild assisted in managing the Hauschild Music Company, which used to be in the building next to his house, for thirty-five years. His father and grandfather founded the sheet-music business, which operated for ninety years. In the late 1980s, Hauschild discovered a new interest—physiognomy, the study of faces. Hauschild went to the University of London, made a list of thirty-nine books on the subject, and began reading up.

He began to notice how prominent people have strong, prominent noses. He said you can tell a lot about a man by looking at his nose. "I can look at you and tell if you're a dumbkopf, sympatico, or lying," he said. Everywhere you looked in his house was a work of a prominent person with a prominent nose.

He said he had four major areas of interest: the noses of intellectuals, aristocrats, musicians, and great lovers.

Henry J. Hauschild Jr. traveled the world collecting art of famous noses.

"Some of the world's greatest lovers had strong noses," Hauschild said. "Take John Barrymore. He had the perfect nose." Hey, with his kind of money, he may have had the perfect nose job. Who could tell?

"My best collection is the Turkish sultans," Hauschild said, as we toured his home, which could have doubled as an art museum. "When I was in Turkey, the head of the biggest museum in Ankara said a whole series of Turkish sultans had huge noses, and I have eleven of them." The Turkish sultans decorated the living room. And, yes, they have some impressive beaks.

"That's Thomas Paine," Hauschild said, pointing out a picture of the American Revolution–era writer, whose face looks like it has been attacked by a squash. "He's a hero of mine. Now, here's Mozart. He had a large nose. And here's Mozart's mother. She has a huge nose."

Yeah, but what about my nose?

"I think you're pretty ordinary," Hauschild said. "I don't think I'd have you on my list."

INDEX

INDEX

INDEX

INDEX

INDEX

INDEX

INDEX

INDEX

INDEX

INDEX

INDEX

About the Author

John Kelso has been a humor columnist with the *Austin American-Statesman* in Austin, Texas, since 1977. He received an award for humor writing in 2005 from the National Press Club. He lives in South Austin with his wife, Kay, daughter Rachel; dogs Harry, Ziggy, and Belle; cats Bitsy, Nutmeg, Oreo, and Scooter; and a bunch of other neighbor cats who hang out in the garage.